Martin Kippenberger

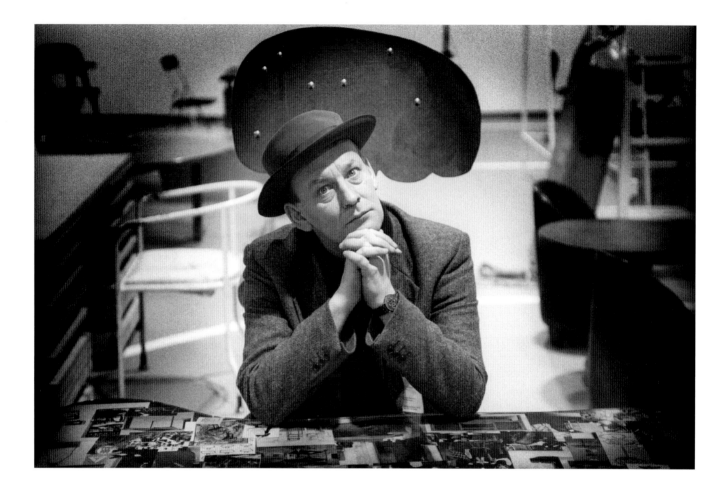

Martin Kippenberger

Edited by Doris Krystof and Jessica Morgan

With contributions by
Daniel Baumann
Susanne Kippenberger
Doris Krystof
Jessica Morgan
Gregory Williams

Tate Publishing

Supported by Tate International Council

First published 2006 by order of the Tate
Trustees by Tate Publishing, a division of Tate
Enterprises Ltd, Millbank, London SW1P 4RG
www.tate.org.uk/publishing

on the occasion of the exhibition
Martin Kippenberger, Tate Modern, London
8 February – 14 May 2006
and touring to
K21 Kunstsammlung Nordrhein-Westfalen,
Düsseldorf
10 June – 10 September 2006

British Library Cataloguing in Publication Data
A catalogue record for this book is available
from the British Library

ISBN 1-85437-620-9

Distributed in the United States and Canada by Harry
N. Abrams, Inc., New York

Library of Congress Cataloging in Publication Data
Library of Congress Control Number: 2005933810

Catalogue design by Peter B. Willberg
at Clarendon Road Studio, London
Printed and bound in Belgium by Die Keure

Cover: Martin Kippenberger, *Einer von Euch,
unter Euch, mit Euch* / One of You, Among You,
With You 1979 (no.108)
Frontispiece: Martin Kippenberger, Museum
Boymans-van Beuningen, Rotterdam 1994
© Vincent Mentzel

Contents

Supporters' Foreword

Tate International Council is delighted to support the first major retrospective exhibition in the United Kingdom of the extraordinary work of the German artist, Martin Kippenberger, one of the most significant and influential artists of his time.

The International Council is a forum that brings together major international collectors and patrons of art. Council members form a highly valued global network in support of Tate. The International Council played a pivotal role in the realisation of Tate Modern, and continues to assist Tate in numerous ways. The Council has supported other major exhibitions including *Ellsworth Kelly* – 1997; *Wolfgang Tillmans* – 2003; *Sigmar Polke: History of Everything* – 2003 and *Joseph Beuys; Actions, Vitrines, Environments* – 2005. Further projects supported include acquisitions, education and the International Council Bursary, a curatorial project researching and establishing collections from specific geographic regions.

Elena Foster
Chairman, Tate International Council

Foreword

Having refused the notion of a retrospective during his lifetime, this exhibition organised by Tate Modern and K21 aims to be both an introduction to Martin Kippenberger's work and an in-depth study of the central tenets of his practice. It is the first museum exhibition of his work in Britain, and consolidates the growing discourse surrounding his work following recent European exhibitions. Familiar and the lesser known aspects of his production are present, including rarely seen paintings, sculptures and works on paper from a number of private collections. With references, subjects, and sources as wide-ranging and diverse as his production, Kippenberger's oeuvre draws from popular culture, art, architecture, music, politics, history, and, not least of all, his own life. He was an exceptional appropriator – adopting, transforming, challenging and occupying his subjects with incisive criticism, self-deprecating humour, vulnerability, and pathos. A larger-than-life figure whose work and life were inextricably linked, Martin Kippenberger's extraordinary achievement and legacy extends beyond his production of painting and sculpture, into the realm of social relations, building a network of artists and friends from all fields and contexts that connected his life to the lives of others, and those lives to each other.

We would like to thank the curators, Doris Krystof, Curator at K21 and Jessica Morgan, Curator, Contemporary Art at Tate for their research and selection of works that convey the full scope of Kippenberger's extraordinary practice. Tate Modern and K21 are delighted to further develop our relationship as collaborators to bring the exhibition to Düsseldorf, in the heart of the Rhineland, the region where Kippenberger established himself and regularly left, but to which he constantly returned from his travels.

The Estate Martin Kippenberger and Galerie Gisela Capitain has been unstinting in support of the exhibition. Gisela Capitain's generosity in providing access to the archive, contacts, and information has been invaluable for the exhibition and catalogue. In this she has been tirelessly supported by Regina Fiorito, who has incisively fielded questions regarding the extensive list of works included, and Margarete Jakschik, who took charge of supplying images for the catalogue. Ben Borthwick, Assistant Curator at Tate Modern, has worked enthusiastically with Morgan and Krystof to deliver the exhibition at Tate Modern, assisted by Erica Papernik whose work as an intern was invaluable.

In addition to the Estate Martin Kippenberger and the artist's family members, we are particularly grateful to the private lenders, many of whom were close friends, associates and colleagues of the artist and from whose collections the majority of loans come.

We are fortunate to have catalogue essays from Susanne Kippenberger, who perfectly balances the personal and anecdotal with a view of her brother's life and work, and Gregory Williams, whose insights into Kippenberger's humour are a welcome contribution. Fiona Elliott's translations capture the ambiguity of language that so fascinated Kippenberger. Nicola Bion and the team at Tate Publishing have managed the catalogue with their usual expertise, and Peter Willberg's elegant design sympathetically echoes Kippenberger's own extraordinary publications.

Special thanks go to Sheena Wagstaff, Head of Exhibitions and Displays and colleagues whose input has been vital, including Stephen Dunn and Stephen Mellor who handled the

registrarial and contractual issues, Rachel Barker, Rosie Freemantle and Elizabeth McDonald in Conservation, Phil Monk and the art handling team, in association with Uli Strothjohann, one of Kippenberger's former assistants, whose involvement has been crucial. The exhibition has been supported by Tate's International Council and we are most grateful for their generosity.

Following his untimely death in 1997, the persona of Kippenberger gradually recedes and the complexities of the painting and sculpture become increasingly influential. Interest in his work among artists, students, collectors and museum publics is now at an unprecedented level, making this exhibition an important opportunity to reflect on his achievements as an artist and his continued impact on contemporary art.

Vicente Todolí
Director, Tate Modern

Martin Kippenberger (1953–1997)

Doris Krystof and Jessica Morgan

To date there has not yet been a comprehensive Martin Kippenberger retrospective in either the UK or Germany. In view of this, Tate Modern and K21 have jointly developed the concept for a survey exhibition of Kippenberger's complex oeuvre. One of the most significant and influential artists of his time, Kippenberger produced a remarkable and richly prolific body of work from the mid-1970s until his untimely death in 1997 at the age of forty-four.

At the heart of this exhibition is the famous yet rarely seen masterpiece, Kippenberger's large-scale installation, *The Happy End of Franz Kafka's 'Amerika'* 1994. This arrangement of around fifty tables and chairs placed on a green soccer field can be read as the theatrical setting for the mass interviewing of prospective employees described by Franz Kafka in his posthumously published novel, *Amerika*. Kippenberger's installation materializes in furniture form only Kafka's vision of the aspiring applicant and discouraging interviewer, separated by a table, while metaphorically presenting the artist's life and work as one massive social sculpture formed through interaction and accumulation, and defying singular interpretation. The work itself contains not only examples of classic twentieth-century furniture, but remnants from previous exhibitions, other artists' work and flea-market acquisitions.

Anticipating the later reception of his work, Kippenberger once declared that he was the ultimate embodiment of the art of the 1980s. His artistic thinking – drawing on Punk and New Wave, Neo-Expressionism and appropriation art – manifests itself in his extraordinarily prodigious output, from paintings, objects, installations and multiples to books, posters and cards. Kippenberger's vast oeuvre draws on popular culture, art, architecture, music, politics and history, as well as his own life, where no subject was sacred. Many of these works deal mercilessly with political topics from the last decade of the Cold War; above all his works are characterised by their wit and powerful, Actionist elements, which have their roots in Kippenberger's highly communicative, even performative personality. Since his sudden death abruptly halted his obsessive urge to produce, it has become increasingly clear to what extent ideas and concepts determined Kippenberger's approach, and the degree to which he engaged with the critical-analytical impulses that emerged around 1970 such as institutional critique, site-specificity and process.

Taking this conceptual leaning in Kippenberger's work, as well as *The Happy End of Franz Kafka's 'Amerika'* as the point of departure, the various strands of the exhibition reflect Kippenberger's own selected exhibitions and themes. With *Lieber Maler, male mir* [Dear Painter Paint for Me] 1981, *Heavy Burschi* [Heavy Guy] 1991 and the *Installation der Weissen Bilder* [Installation of the White Paintings] 1993, the spotlight turns to Kippenberger's idea of delegating the act of painting to others.

Confrontation and exchange with other artistic positions, as well as different forms of collaboration, are very much the hallmarks of Kippenberger's artistic praxis. In collaboration with visual artists such as Michael Krebber, Ulrich Strothjohann and Merlin Carpenter, but also with critics such as Diedrich Diederichsen and Jutta Koether, Kippenberger created a body of work which is itself a finely woven mesh of allusions and

associations. For Kippenberger, art became an all-embracing life system. Establishing family and clan relationships served to demarcate and form his own identity in the art-world jungle of the prosperous 1980s, and the prevailing elaborate processes of inclusion and exclusion.

Given the constant artistic interpretation and processing of his own firsthand experiences, Kippenberger has all the attributes of a late twentieth-century figure. Through his elaborate biographic construction, he engages with the fault lines of his own persona in as much as he adopts a wide variety of roles. Kippenberger, who once referred to himself as a 'salesman', developed a completely new image of the artist, far-removed from the clichés of creating meaning and realising visions. Scattered through his work like leitmotifs, his themes revolve around finding a place for oneself, making contact and establishing position. In the face of the transcendental embellishments to art and culture that were flourishing in German art in the 1980s, Kippenberger created a distinctly anti-metaphysical body of work that adeptly operated within the very heart of the art business. His work articulated the essentials to life – *Miete Strom Gas* [Rent Electricity Gas], to quote the title of his first museum exhibition in 1986 – and the coyly modest wish that people might later mention that Kippenberger had been 'good mood'.

Kippenberger's outstanding artistic position and his profuse output, where visual opulence and lucid reflection go hand in hand, no doubt account for the many exhibitions of his work since his death. Over the years these exhibitions have variously focused on different genres or media, as in the exhibition of self-portraits at the Kunsthalle Basel and the Deichtorhallen in Hamburg (1999), or the presentation of drawings at the Kunsthalle Tübingen (2003–4). Major exhibitions, notably in Karslruhe and Vienna/Eindhoven (all in 2003), have started to reflect the sheer wealth of the material and have set thematic accents, such as the significance of place in Kippenberger's work. This exhibition, conceived for London and Düsseldorf on the basis of a specially selected overview of the work, is intended as a survey of the contents of the various forms of communication Kippenberger offered the viewer. In the spirit of his saying 'one of you, among you, with you' – which tripped so easily off his tongue in the early years – we see a body of work that defines art as a social system and communication as the basis of human existence.

The catalogue that accompanies this exhibition, with its slightly more detached, yet by no means unimpassioned, view of Kippenberger's artistic approach, contains monographic and thematic texts. As well as two essays on the main works presented in the exhibition, there are another three very different contributions which fill out our picture of Kippenberger. While the art historian Gregory Williams has written an analytical text, looking in from the outside, Susanne Kippenberger, a younger sister of the artist, explores a very personal connection. Lastly, to incorporate the original voice, the catalogue also includes a reprint of an interview with Martin Kippenberger just a year before his death. In it Kippenberger talks at length of *The Happy End of Franz Kafka's 'Amerika'* in a manner that explains why this large-scale installation, at the heart of the present exhibition, can rightly be regarded as the artist's legacy to posterity.

Saint Martin

Jessica Morgan

In retrospect, the title of Martin Kippenberger's 1991 debut exhibition in London, *The Beginning was a Retrospective*, has an ironic twist that even Kippenberger, the master of layered innuendo, could not have predicted. Until recently, it seemed that this 'retrospective' at Karsten Schubert's gallery would be both beginning and end, as no other appearance of Kippenberger's work took place in the city for well over a decade despite the artist's prolific production until his death in 1997. Although the brevity of his London appearance probably says more about the now well-documented events of a navel-gazing London art world in the 1990s than about the late artist's work, the decision to devote a survey to his work in 2006 raises the question 'why Kippenberger now?' After all, along with an absence of Kippenberger exhibitions in the UK, we could add a long list of others from his generation in Germany who have gone similarly unnoticed – Albert Oehlen, Georg Herold, Michael Krebber and Werner Büttner for example, to name just a few.

Kippenberger's loudly performative self, prolific production and early death, as well as the endless anecdotes that surround any mention of him, guarantee an art-world notoriety, and his attraction as a father figure for countless artists from the last generation is no doubt partly a result of this cult of personality. The intense interest in his work from younger artists is perhaps argument enough for the current exhibition, but the dominating persona that appeals to many now is probably what deterred institutions from embracing his work during his lifetime. The museum was anyway too slow for Kippenberger's work – its stylistic pace, and running commentary on the present environment, be it artistic, social or cultural – and his output was arguably too large to be satisfied by intermittent museum displays (despite his desire for institutional acknowledgement). Kippenberger, like Jeff Koons and Andy Warhol, was, in any case, a consummate commercial gallery artist: his work exposes the process of art production, the market and the art world in its broadest sense as a network of interrelated structures, and it was best suited to the environment on which it commented. As with all Kippenberger's activities, a dialectic was established in his relationship to the commercial realm, and his immodest participation implied a critical mimicry of the self-celebratory operations of the market.

By the 1990s Kippenberger averaged a show a month, and in addition to the work he made for exhibitions there were the catalogues, posters and announcement cards that were an integral part of every presentation, the artist's books, multiples, and other projects or ephemera that emerged from one idea or another, including such conceptually, if not literally, massive projects as his own Museum of Modern Art, Syros, in Greece (see fig.4), and the world-wide subway system METRO-Net. Kippenberger was prolific in almost every sense; this extended also to the work's content, which is characterised by an endless abundance of mutating references and cross-references.

The scale of Kippenberger's output, its referential topicality and, above all, the role of the artist's personality in the making and presenting of the work are, ironically, reasons both for and against its showing now. The work's stylistic, linguistic and cultural allusions can be written off as fashionable one-liners, relevant as a humorous reaction to the moment but

failing to retain lasting significance. These endless citations, seen in the context of a group of works, however, reveal a system of complex inter-textual puns that establish the artist's ongoing preoccupation with the world around him viewed through and alongside his personal perspective. His massive output can be read as slapdash work, 'bad' painting that is just that (rather than a commentary on the state of the media), and a flirtation with many styles and approaches that results in the mastering of none. Alternately, this prolific production is an acknowledgement of the bankruptcy of aspirations to originality, which Kippenberger mercilessly critiqued even if they were his own, while struggling with the conflicting desire to continue to create. Kippenberger's bohemian life, the anecdotal reading of his work (fostered by the writing of his personal friends and associates) and the abundant presence of self portraits or symbolic stand-ins for the artist (from frogs and lampposts to eggs and finally Spiderman), can be dismissed as a belated, albeit humorous, revival of the tragic/heroic artist figure whose biographic stunts and excesses serve only to bolster the mythical act of creation. In defence, a strategic significance can be argued for Kippenberger's forefronting of personality in his art, a strategy to which the German writer and critic Diedrich Diederichsen has applied the term *Selbstdarsteller* – which he translates as 'self performer' – to identify the particular type of self-promotion that the artist adopts. This hovers deliberately between role-play and expressivity, appropriation and authenticity, complicating what might otherwise be dismissed as an anachronistic display of artistic bravura.

Common to all the strengths of Kippenbegrer's work listed above is that they only become evident in expanded presentations of the artist's work. In fact, it is arguable that his work remains only partially legible when seen as individually isolated objects, an observation that is supported by the significance that Kippenberger himself placed on his own exhibition presentation and display. This aspect of his work is probably the best argument for a survey exhibition, the only form in which the artist's multi-faceted work can be fully appreciated and through which his 'other' careers – as would-be film star, gallery owner, nightclub impresario and, not least of all, curator – become apparent. Kippenberger's systematically subversive approach emerges through references between the works that develop over many years, if not decades, such that one piece calls for the presence of another and yet another in order to fully represent this ongoing process.

For a UK audience that lacks the history of the recent artistic context of Kippenberger's work, as well as the cultural and linguistic access to many of his citations, this informational aspect of the work can prove challenging. Indeed even with this cultural advantage, it is easy to become lost in the arcane nature of Kippenberger's language which never touches on the obvious or primary object of reference, utilising instead that which has been handed down as second- or third-rate material. Kippenberger's complex constellation of citations consists of quotations not only from his own work and that of other artists, but also gestures to the issues of the day, be they artistic or political, local or international, as well as referencing B-list celebrities, kitsch (of the unfashionable sort), bourgeois protocol, and his own personal habits or preferences. Indeed, the sometimes obscure nature of these allusions, and Kippenberger's anecdotal manner of presenting them, is such that art audiences may increasingly lose the ability to unpack Kippenberger's system of reference as the familiarity of his subjects gradually cedes from public consciousness.

In part, perhaps to preserve this history, an industry staffed by a coterie of friends, writers, assistants and fans has developed, whose job it is to decode and identify the artist's signifiers. Examining both recent and contemporaneous texts on the artist, one sees the same list of authors offering often-personal accounts again and again. Among the better known, Diederichsen, Jutta Koether, Merlin Carpenter, Roberto Ohrt, and most recently Alison Gingeras, have been called upon, or taken it upon themselves to divulge the possible meanings of Kippenberger's endless allusions to his life, art, peers, politics and so on. The task involved requires a first-hand experience or, at the very least, primary research into the micro-events that took place at the time and appear, obfuscated by the artist's deliberately skewed perspective, in visual or verbal form. An unpacking of Kippenberger's work in this manner, the identification of the source of reference for his iconography or style, undoubt-edly provides the reassuring ability to at least begin to 'get the joke', to be able to start to recognise the sometimes oppressively esoteric mountain of anachronisms and formal quotations, offering in return an appealing sense of insider access.

Kippenberger's running commentary on the state of art and the art world undoubtedly positions him as an extreme example of an artist who makes art about art – albeit in this case alongside very many other topics – but it is questionable if the real significance of his work actually lies in decoding the minutiae of his allusions. While the information it supplies gives insight into individual works, it is ultimately what is revealed between works, or even between exhibitions or bodies of work operating in a larger context, that is of greater interest.

As Diederichsen, Kippenberger's most astute apologist, suggests, the type or level of information selected for reference in his work, its 'secondarity', is a strategic gesture and one comparable to Kippenberger's role as a *Selbstdarsteller*. 'Secondarity' for Kippenberger, Diederichsen writes, 'was in the first instance not a postmodern position, enlightened about its own status, which had to take into account the real impossibility of primary expression – be it critical or cynical – but … a new form of authentic handle on the world that befitted that time – not unconnected to the often cited paradox of authentic/non-authentic'. Commenting on one of his typically 'secondary' sources, in this case the egg, Kippenberger reflects, 'When you are painting you have to look for the windfall of fruit left for you to paint. The egg hasn't had its fair share, the fried egg hasn't had its fair share, the banana already had Warhol. You take a shape; it's always a question of something angular, square, in this or that format, the Golden section. The egg is white and colourless; how can you make a colourful picture of it?' The second-class nature of Kippenberger's references was, in part, a means to avoid accusations of misplaced sincerity, yet he still aspired to be taken seriously (even if this aspiration was itself carefully masked by the appearance of ironic performance). By admitting outright the impossibility of contributing to the dominant project of the avant-garde, Kippenberger could energetically pursue his desire to be the 'first of the second best'.

How then to approach Kippenberger's work for exhibition? To single out 'signature' works for special analysis does not make sense given the systemic nature of his practice. Whatever interest individual works may hold it will inevitably be magnified by the presence of other corresponding production. To isolate his practice as a painter flies in the face of

his own acknowledgement of the possible redundancy of the medium, while to view him only as a postmodern practitioner of 'inauthentic' appropriation obscures the artist's performative creativity. The cliché that often proves true of so many artists, that their career peaks with one successful period of production that is never again attained, may hold true for Kippenberger as well (though he died too young for this to be entirely explicit). Yet working against this standard career curve in Kippenberger's case are the strategic manoeuvres that only become entirely clear when looking back over a number of decades of his production. The provocative gesture of the *Lieber Maler, male mir* [Dear Painter, Paint for Me] 1981 series, for which Kippenberger hired the Berlin sign painter known as Mr Werner to paint images selected by the artist, a gesture clearly intended as a deflating riposte to the then current reigning stars of the German art world – the *Mühlheimer Freiheit* and the *Junge Wilde* and their painterly expressionism – would be less significant if he had not continued, in unpredictable stylistic fashion, to consistently question the prevailing artistic trends with equally acute but complex verve. Indeed this early series of paintings contained many of Kippenberger's concepts and preoccupations that reappear in his work for the next twenty-five years. Kippenberger the *Selbstdarsteller*, for example, is already established in this exhibition – unassumingly entitled *Kippenberger: Through Puberty to Success* – and he appears in four of the twelve paintings in the roles that were repeated throughout the subsequent years: as drinking partner off on a bar crawl seen from behind outside a Düsseldorf hangout; as the sophisticated tourist seated ironically on a thrown out couch on a New York street corner; as would-be film star (like 'Helmut Berger on a good day' as he once said) posed in front of a Berlin tourist stand that sports posters referring to the then-fashionable kitsch of Eastern European culture (and a hammer and circular motif that strikingly resembles what was later to become the logo for Kippenberger's loose association of friends titled the 'Lord Jim Loge' [Lord Jim Lodge]); and finally the artist appears most mysteriously clutching a sausage-like rubber ring as the sad clown, already physically in demise with hunched back at just twenty-eight, but nevertheless wearing the Picasso-inspired outfit of white underpants that accentuated his manhood. But the *Lieber Maler, male mir* series also introduces Kippenberger's many other favourite topics (aside from himself), with thinly veiled references to Germany's uneasy attempts at appraising its recent past, a critique of the petit bourgeoisie and their hypocritical gestures, the equal treatment of commodities, kitsch and culture, the ridiculing of minor celebrities, the presence of his own and other artist's work, and of course, not least of all, the act of hiring someone else to produce the work in the first place.

The Exhibitionist

The exhibition as such is a running gag for the artist. No more. But the expression 'running gag' should be understood literally here, please! Moving, continuing on, keeping up the pace ...

Kippenberger's own self-penned curriculum vitae, *Martin Kippenberger: Life and Work* (see pp.167–9), in which certain events and exhibitions as well as personal details are selectively highlighted (a twist on Joseph Beuys's affectedly portentous version marking the artist's mythical development), helps to establish a sense of this structural development in his work and offers an appropriate frame of reference for exhibition and discussion of his oeuvre. The biography is a retrospective view, a verbal exhibition even, written or curated by the artist, and reveals, among other things, to what extent Kippenberger produced work entirely for exhibitions, and with the determination to make each event a new manifestation of the Kippenberger enterprise.

In *Martin Kippenberger: Life and Work*, the 1981 events of *Through Puberty to Success*, which included not only the series of *Lieber Maler* paintings but concerts, publications and postcards, are soon followed by mention of Kippenberger's various collaborations with Albert Oehlen, including the works for the exhibition *Capri by Night* in 1982 for which they covered a Ford Capri with paint mixed with rolled oats – a reference it seems to the encrusted surfaces favoured by such self-serious painters of the time as Anselm Kiefer or Julian Schnabel. Kippenberger's paintings meanwhile, now produced en-masse by himself,

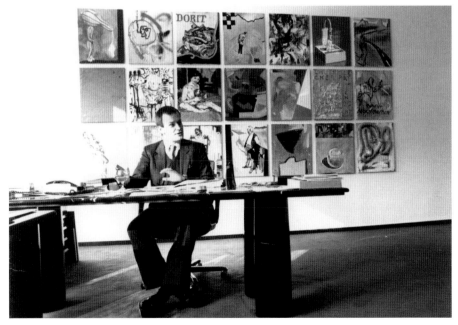

fig.1 Martin Kippenberger, Bureau Uli Knecht, Stuttgart 1981

Overleaf: fig.2 Martin Kippenberger, *The Exhibitionist*, installation, Hamburg 1976/7

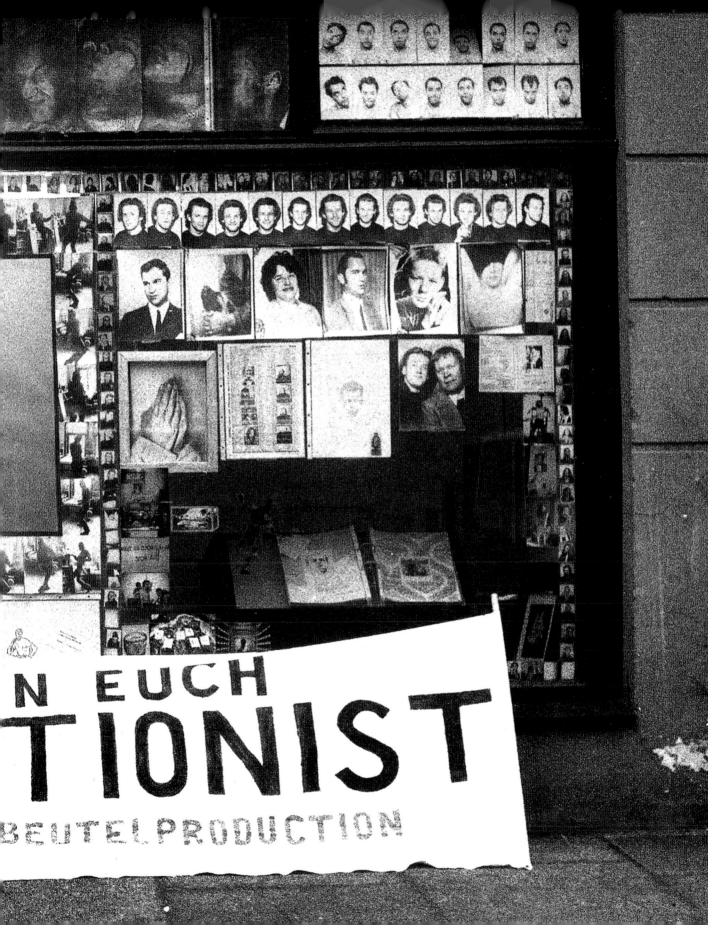

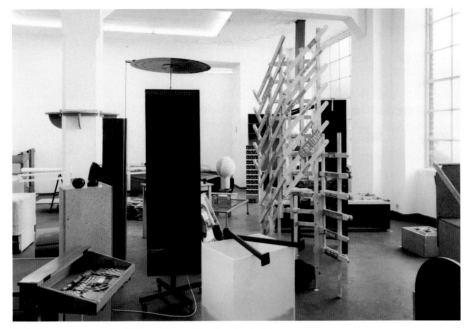

fig.3 *Peter – die russische Stellung* / Peter – The Russian Position,
installation, Galerie Max Hetzler, Cologne 1987

were exhibitions in themselves consisting, in the case of *Blass vor Neid steht er vor deiner
Tür* [Pale with Envy, He Stands Outside Your Door] 1981 (no.5), for example, of twenty-one
individual canvases, each titled separately. These panels range in style from pastiche of
early twentieth-century abstraction and expressionist impasto, while incorporating imagery
as diverse as a Helmut Newton / Duchamp-inspired figure descending a staircase, still-life
studies, a half-naked man in a crucifixion-pose leaning over an easel (entitled *Jeder
Künstler ist ein Mensch* [Every Artist is a Human Being], a humorous twist on Beuys's
dictum 'everyone is an artist') and various playful combinations of abstract and
representational imagery. All of these references, as well as many of the others included in
this multi-panel work, typically appear again and again in subsequent paintings, drawings,
sculpture and ephemera, their repeated outings building on the variable significance they
contain.

 Singled out for comment in the entry for 1984 are the *Die I.N.P. Bilder* (I.N.P. = Ist Nicht
Peinlich Bilder = Is Not Embarrassing Pictures), individual works this time, that explore
further Kippenberger's deliberately provocative interest in socialist realism. *Sympathische
Kommunistin* [Likeable Communist Woman] 1983 (no.10), for example, seems designed
to infuriate the petit bourgeois and leftist sympathisers alike, while humorous one-liners
like *For a Life without a Dentist* 1984 (no.8), revel in Kippenberger's signature combination
of unrelated image and text. Again, the exhibition, or rather in this case the catalogue,
served as a rejoinder to recent artistic events, specifically the glorified exoticism of Walter

Dahn and Jiri Dokoupil's *Die Afrika-Bilder*, a catalogue published earlier that year for a show of African-themed paintings at the Groninger Museum in Holland. On the cover of Kippenberger's volume, otherwise a direct copy of the duo's effort, instead of an African mask is a head configured out of butt cheeks and oversize ears. In this same year Kippenberger mentions that he makes his 'first attempts at sculpture, including the *Peter* series', but rather than showing these (presumably unfinished) works, his first exhibition of sculpture is listed in the entry for 1985. *Familie Hunger* took place at the Grässlin gallery in Frankfurt and Kippenberger's choice of title for this exhibition appears to have been in part a critical reference to the city's status as the heart of Germany's finance industry. The Henry Moore-like sculptures are also equipped with the British artist's signature empty interior, however, and so the title may also be a pun on the apparently stomach-less state of the figures.

Kippenberger's first major museum show, mentioned in the notes for the year 1986, at the Hessiche Landesmuseum, Darmstadt, illustrates his cost-effective concept of paintings based on economic graphs. These financial plans merge with Kippenbegrer's interest in architecture in painting and sculptural form in works such as *Ertragsgebirge* [Profit Peaks] 1985 (nos.17, 23, 24) and the *Entwürfe für Müttergenesungswerk* [Design for Rest Centre for Mothers] 1985, a series of sculptures constructed out of palettes, that has been interpreted as both a commentary on the use of this material by other artists at the time, and as a reference to his mother's death which was caused by palettes falling from the back of a passing truck. The *Peter* sculptures mentioned already in 1984, which were largely conceived by Kippenberger's assistant at that time, Michael Krebber (one of many who played a Werner-like role in Kippenberger's inclusive practice), are then presented in 1987 in the exhibition *Peter – die russische Stellung* [Peter – The Russian Position] (fig.3). The timing of this exhibition at Max Hetzler gallery in the summer of 1987 seems to have been chosen to coincide with the opening of Documenta 8 and an exhibition at Paul Maenz gallery of the US sculptors Jeff Koons and Heim Steinbach. Reviews from the time conclude that this departure for Kippenberger – the room was packed with objects made variously out of slightly altered readymades, combinations of furniture/sculpture, and most famously a Gerhard Richter painting transformed into the top of a table – was a not-so-subtle riposte to both exhibitions: the craftsmanship and perfect proportions espoused by Documenta's sculptors and the readymade assimilation techniques of the new object makers. Clearly the sculptures in *Peter*, their formal qualities and relationship to the architectural motif that runs throughout Kipenberger's work, was of some importance to the artist, as not only did the works travel in various combinations for exhibitions in Vienna, Graz and New York, but the objects themselves appear repeatedly in paintings and drawings (such as the series of self portraits from 1988), and ultimately as elements of the masterwork *The Happy End of Franz Kafka's 'Amerika'* 1994 (no.50).

The exhibitions of *Peter* sculptures and related works (that were variously titled *Peter 2, Sorry III, Reise nach Jerusalem* [Journey to Jerusalem], *Petra* and *Nochmal Petra* [Petra Again] 1987/8) may have in part inspired the tripartite exhibition that Kippenberger made in Cologne, Los Angeles and New York in 1990–1 that is mentioned already in the entry for 1989. Like the reference for the *Peter* sculptures that appears three years before they are

presented, this early mention again enforces Kippenberger's strategic production for exhibition statement. The three-in-one event that finally took place (and was documented in the catalogue for his show at Villa Arson, Nice) was almost certainly a challenge to Jeff Koons's earlier example of simultaneous, multiple, international openings. Like Koons, Kippenberger presented near-identical works for these shows including three gondola sculptures entitled *Sozialkistentransporter* [Transporter for Social Boxes] 1989 (nos.35, 38) – a continuation of his kitsch romance with the past glory of the tourist destinations Venice and Capri as well a reference to that summer's Venice Biennial – and different versions of the now notorious work *Martin, ab in die Ecke und schäm Dich* [Martin, Into the Corner, You Should Be Ashamed of Yourself] 1989 (nos.30, 33, 37) – a response to a negative article by a German critic who accused Kippenberger of drunken cynicism and a flirtation with neo-Nazi behaviour.

For 1991 Kippenberger writes of an 'exhibition at the Kunstverein, Cologne, of photographs of works painted and later destroyed'. With this work, *Heavy Burschi*, Kippenberger returned to the idea of handing over the responsibility of painting to someone else, in order, as he once said, to 'keep oneself well protected from any idea that you have to make everything yourself'. This time his assistant Merlin Carpenter was instructed to make a series of paintings based on reproductions of the artist's work that, once finished, Kippenberger was unsatisfied with, and, after photographing them all, placed the destroyed canvases in a large dumpster, displaying the paintings in their new photographic form and turning them, as he said, 'into a kind of double kitsch'. Carpenter's appropriations were themselves appropriated and the 'original copies' destroyed in order to become another original work. When presenting the same installation in San Francisco for his exhibition at the Museum of Modern Art that same year, Kippenberger accompanied it with a series of watercolours, also produced by Carpenter, which depicted the covers of his numerous books. In front of each book cover lies a magnifying glass, suggesting perhaps a search for evidence of the artist's hand or indicating the importance of this major part of his production.

fig.4 The METRO-Net subway entrance in Syros, Greece

The entry for 1993 is one of Kippenberger's longest and begins, 'Revises his address book, parting from several friends. Becomes increasingly convinced that the world of music is defunct and the theater is insular. From now on, concentrates on recommendations from people previously unknown to him.' Among the various major events that he highlights is the announcement card for 'a candidature for a retrospective' at the Centre Georges Pompidou in Paris, issued by his Paris gallery. The actual exhibition for the candidature also took place that year and photographs of this exhibition reveal Kippenberger's experimental form of curation – works are double-hung in tightly packed rows, a large vitrine containing books, multiples and ephemera is obscured by the artist's 'Business class curtain' and straddled by the work *Tankstelle Martin Bormann* [Martin Bormann Gas Station] 1986 (fig.5). No single piece is allowed to dominate in the installation and the inter-dependence of the works is made apparent through this equal treatment. In addition to this dry-run for a retrospective, Kippenberger mentions in the same year the opening of the first subway station for METRO-Net in Syros, Greece (linked in 1995 to the Dawson City entrance, in Yukon Territory, Canada; in 1997 to an entrance in Leipzig; and in the same year to a transportable entrance that first appeared at Documenta X with a transportable ventilation shaft shown at the same time as part of Sculpture Projects, Münster). This worldwide subway brings together Kippenberger's sculptural/architectural fascination for 'Psycho-buildings' (as he called them in his 1988 book), the role of the artist as consummate traveller and mind-expander, and of course incorporates a commentary on other ambitious outdoor projects including those of Robert Smithson, and in particular plays with this artist's notion of site/non-site in the transportable nature of the last two elements of METRO-Net.

In the same year that Kippenberger became general manager of this transport system, he also took on the role of museum director, opening MOMAS, the Museum of Modern Art Syros, by declaring the ruined structure of a slaughterhouse to be the museum building. An extension of Kippenberger's long activity as curator of both his own and others' work,

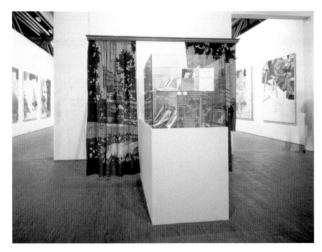

fig.5 *Candidature à une Retrospective*, installation,
Centre Georges Pompidou, Paris 1993

MOMAS was also a new twist for Kippenberger's own brand of institutional critique. Continuing his preoccupation with display and exhibition-making, Kippenberger notes that in 1994 he presented his masterwork, *The Happy End of Franz Kafka's 'Amerika'*, a show that was accompanied by no less than nine books and consisted of a vast accumulation of tables and chairs incorporating the work of numerous other artists as well as remnants from his own production, all arranged to suggest the mass-interview scenario described in Franz Kafka's posthumously published volume, *Amerika*. The final entry Kippenberger includes in his biography is for the year of his death, 1997, and records the opening of his exhibition *Respektive 1997–1976* at the Musée d'art moderne et contemporain (MAMCO) in Geneva. This retrospective, again a conceptually conceived installation, featured a large selection of paintings brought together under the rubric of size (all 180 × 150 cm), a mini-reconstruction of the *Peter* sculptures as well as selections from many of the series mentioned above.

Reviewing just these few highlights of the already edited selection of exhibitions and works that Kippenberger mentions in his biography, it is remarkable perhaps that London managed to remain so unaware of this artist's work. In conversation, Karsten Schubert explained that even this brief appearance at his gallery in 1991 almost did not take place, as the artist had to be called repeatedly and reminded close to the opening date that he was having a London debut in a few weeks. Quite probably Kippenberger sensed the disinterest of London in his work and this feeling was mutual – for an artist so involved in contextual commentary, London's artistic provincialism would have offered little attraction. An installation shot from the Pompidou exhibition, however, reveals a memento he kept from his experience with the tabloid culture of the UK: a newspaper clipping in the vitrine bears the headline, 'Have an Art, Helen! Well, would you want one of these as a wedding present?' The clipping is a *Daily Mail* article about Karsten Schubert's then Director, Lady Helen Windsor, on the eve of her wedding to dealer Timothy Taylor. Below the headline are images of Kippenbeger's work from the Schubert show with price tags attached, one of which is 'tied' to the image of some taped-up shoe boxes Kippenberger had placed on the staircase of the gallery, and instead of the numerical price has the words PRICELESS printed on it (fig.6). Looking at this reaction to Kippenberger's work, perhaps it is not so hard after all to understand why it has taken until now for the UK to recognise the complex commentary of Kippenberger's production, a presentation of which now serves not only to alert people to the brilliance of his work, but goes some way to account for many of the developments in contemporary art that were sadly overlooked here for so long and which feature so consistently in Kippenberger's work.

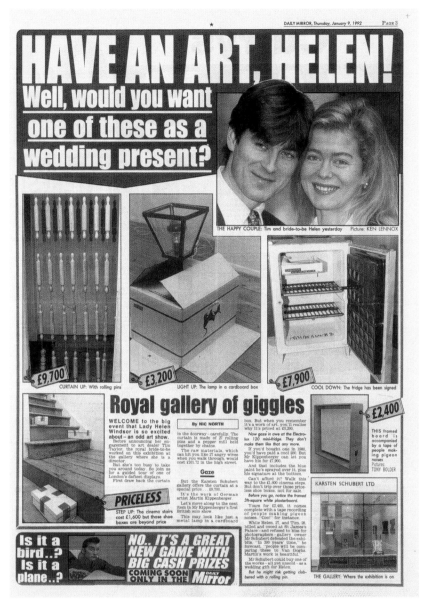

fig.6 *Daily Mirror*, 9 January 1992

Overleaf: fig.7 *The Happy End of Franz Kafka's 'Amerika'* 1994, installation, Museum Boymans-Van Beuningen, Rotterdam

23

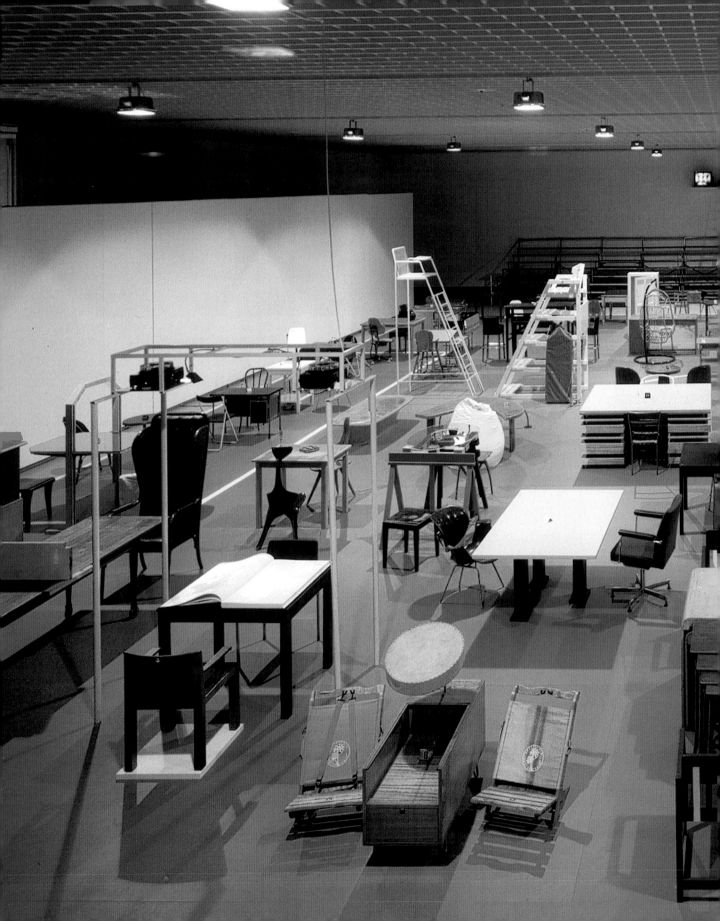

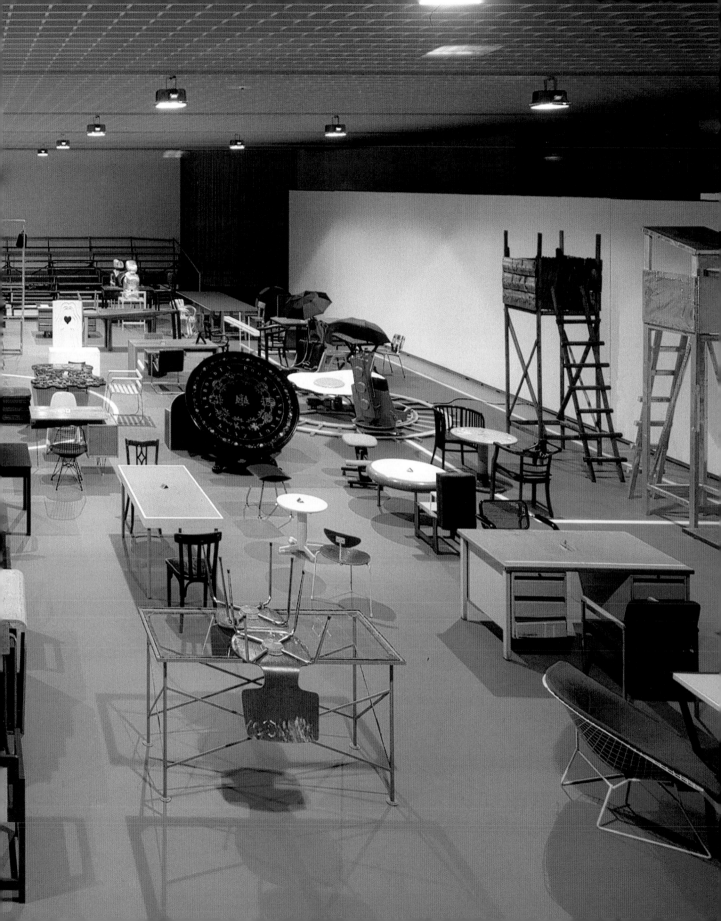

The Biggest Theatre in the World
Complexity and Vacuity in *The Happy End of Franz Kafka's 'Amerika'* 1994
Doris Krystof

Dear Readers, Dear Visitors!

Each of the various books for this exhibition and the exhibition containing these books
has its own small part to play. In all honesty, one didn't finish reading the book Franz
Kafka's 'Amerika', but there was in our circle of acquaintances one who did read it and
informed me of the fact that for the first time, in a work by Franz Kafka, albeit unfinished,
there was a Happy End in sight.

The situation is as follows: There's a circus in town, looking to employ reliable hands,
helpers, doers, self-confident handlers and the like. Outside the circus tent, in my
imagination, there would be tables and chairs set up for job interviews.

These conversations should be seen as my application for a job interviewing the
candidates for these jobs.

<div align="right">

Kippenberger, St. Georgen/Black Forest, 1993
– Foreword to B – Gespräche mit Martin Kippenberger [1]

</div>

The Language of the Stranger and Thieving by the Wayside

When the French philosopher Jacques Derrida received the Adorno Prize awarded by the
City of Frankfurt am Main in late September 2001, he offered his thanks in a speech
entitled 'The Language of the Stranger and Thieving by the Wayside'. In it he cited two
important sources of inspiration for his own thinking: dreams, and texts by other writers.
Bearing in mind that the prize was named after that renowned exponent of critical theory,
Theodor W. Adorno, whose writings had been such a spur to Derrida, as he himself said, it
was natural that the speaker soon turned his attention to the work of Franz Kafka. Derrida
made particular mention of the novel *Amerika*, which had been so crucial to Adorno's
thinking. Written between 1912 and 1914 and then put aside, it was only published in 1927,
three years after Kafka's untimely death, in a version prepared by Max Brod. As Derrida
pointed out, Adorno's reading of Kafka very noticeably left its mark on his sociological
examination of the United States.[2] Known since the publication of the critical Kafka edition
in 1983 as *Der Verschollene* ('The Lost One', Kafka's original title), Kafka's *Amerika*
stands as the first socio-critical manifestation in modernist literature of the burgeoning
mass-society under the capitalist system. The dream-like scenario of the Theatre of
Oklahoma (at which point the novel breaks off) serves as a veil, albeit a surreal veil, for
Kafka's social and cultural critique. Following a series of failed attempts to find his feet in
America, the protagonist Karl Rossmann, a European immigrant, stumbles upon a fantastic
scene. In an open field, women standing on tall pedestals and dressed as angels are
sounding trumpet fanfares to recruit new members for the 'biggest theatre in the world'.
Elsewhere a poster declares, 'If you think of your future you are one of us! Everyone is
welcome!' A staff manager takes the astonished youth to the racecourse at Clayton. There,

in two hundred differently styled bookmakers' booths, interviews are being conducted with all the eager applicants. But in the years leading up to the Great War, the promise of full employment may already have been nothing more than the spawn of a beautiful dream. Whatever the case, in October 1914 Kafka finally stopped work on the text, already at an advanced stage; the implied Happy End is left open, the novel a fragment.

Eighty years later, with his large-scale installation *The Happy End of Franz Kafka's 'Amerika'*, Martin Kippenberger took up the idea of a novelesque utopia of employment for everyone. For his exhibition in the Museum Boymans-Van Beuningen in Rotterdam (27 February – 24 April 1994) the '*enfant terrible* of the German art scene', also the 'most significant German artist since Joseph Beuys', as the Dutch press called him at the time, created a theatrical scenario of fifty different sets of tables and chairs. Originally intended to be installed in an area measuring 23 × 20 metres, this piece has since come to be regarded as Kippenberger's most important work, his 'magnum opus' (Zdenek Felix), although it is only rarely shown.[3] To put together this motley assortment, Kippenberger resorted to a tactic, well known to him and so aptly described by Derrida as 'thieving by the wayside', and collected together furniture, sculptures and objects of the most diverse provenance. He thereby translated the literary notion of massed job interviews into an exhibition display. The seating is placed in the usual arrangement for a person-to-person negotiation: two chairs face each other with a table separating them. The richly varied constellations of chairs and tables suggest a huge range of psychologically loaded dialogue situations. The placing of the furniture on a green floor, with white lines as if it were a football pitch and stands for the spectators at the ends, underlines the competitive situation that the individual in the modern job market has to contend with. At the same time, as Kippenberger archly suggested in the Dutch daily newspaper *Het Parool*, on 26 February 1994, the parallel between art and sports might appeal to – and lure into the museum – the tennis stars Steffi Graf, John McEnroe and Boris Becker who would be in Rotterdam at the end of February for a tennis tournament.

In Rotterdam in 1994, Kafka's literary fiction was transposed into the material reality of a sculptural installation. The work itself plays with the conditions surrounding the presentation and communication of art in museums, and subjects the very notion of art production and reception to a test. The sheer amount of sculptural objects arranged within an irregularly meandering ground plan calls to mind a stage set, a well-stocked repository, an archive ordered in its own particular way. At the same time, with its different types of tables and chairs, the arrangement also in effect constitutes an overview of the multiply intertwined histories of design and art in the twentieth century, from Josef Hoffmann to Donald Judd. This impression was reinforced in Rotterdam by the inclusion of items from the repository of the museum's applied arts department. Kippenberger's 'aesthetic of excess' (Manfred Hermes) is perfectly demonstrated here, where the – admittedly precisely calculated – superabundance of exhibits is a strategy specifically designed to hasten the breakdown of rigid classifications and standardised notions of art. As though to signal that it is still possible, despite everything, to achieve an overview, four different kinds of 'high chairs' rise up above the rest of the field – two look-out towers, an umpire's chair and a lifeguard's perch. The exhibition-visitor's eye is also caught by two chairs with opened

fig.8 Double page from the catalogue *Martin Kippenberger, The Happy End of Franz Kafka's 'Amerika'*, Museum Boymans-Van Beuningen, Rotterdam 1994

umbrellas circling around a fried egg, by a cupboard, and a tall stand with two slide projectors, these last alluding to the underlying theme and its connection to books and literature.[4] Colour accents are set by a chest of drawers painted blue and yellow reminiscent of pieces by Donald Judd, by the glowingly yellow painted top of a school desk brought back from Tenerife, and by a variety of red chairs that crop up intermittently. Here and there figures – a life-sized jointed doll, two wooden African figures and two perforated sculptures from the *Familie Hunger* [Hunger Family] group (1985) – 'stand in' for different interlocutors. Seen as a whole, the *Kafka* ensemble is also reminiscent, and not just by chance, of a restaurant, and as such of those places of human interaction and semi-public negotiation that have left their mark on so many of Kippenberger's works. The notion of dialogue underpins both the chair-table-chair constellations and the overall layout of the piece, with the spectators' stands facing each other from either end. Even the most noticeable items on the 'playing field' – the four 'high chairs', arranged as two pairs – continue the notion of duplication by demarcating two sides of the game they are looking down on from above.

Peter – die russische Stellung

As far as the configuration of the objects is concerned, the *Kafka* installation recalls an important precursor in Kippenberger's oeuvre, the exhibition *Peter – die russische Stellung*

28

[Peter – The Russian Position], presented in 1987 at the Galerie Hetzler in Cologne. With a nod to the cheek-by-jowl presentation of paintings of all shapes and sizes cultivated at the court of the Russian Tsar – known to German-speakers as a 'Petersburg hanging' – in 1987 Kippenberger set out his own position with sculptures largely made by his friend and assistant, the artist Michael Krebber. These poor-looking objects with their blatant Do-It-Yourself aesthetic were remarkable for their wealth of conceptual detail. They raised a whole range of questions concerning the nature of artistic existence right down to the net product and, during that Documenta summer, offered a provocatively trashy riposte to the ever-so smooth sculptural aesthetic of the so-called model-makers from the neighbouring city of Düsseldorf. But the *Kafka* installation in Rotterdam could be said to follow in the footsteps of the *Peter* exhibition not only because it takes the idea of a cumulative sculptural presentation a stage further and realises it on a much larger scale, but also because numerous *Peter* objects also found their way into the Rotterdam installation. Presented under the rubric 'job interview', these more or less minimalist objects take on a functional air. And, in so doing, the sculptures prove to be open forms, signs whose meaning can change depending on the circumstances. While the over-sized Barbie bathtub, with a silver cover, looked like a non-representational, post-Minimal sculpture in the context of the *Peter* exhibition, this same voluminous object clearly turns into a table as soon as it is placed between two chairs, as in the *Kafka* arena.

Many of the furniture sculptures and objects shown in Rotterdam came from earlier Kippenberger shows and bear out the immense benefit of extensive recycling. The four 'high chairs', for instance, stood like lost observation points in a Paris exhibition (1992) presenting an overview of contemporary art in the newly reunited Germany.[5] The year before that, they had a dual function as fixed points and openers for the multi-media show *Tiefes Kehlchen* [Little Deep Throat] which Kippenberger realised in the context of the Wiener Festwochen. The show itself took the form of a ghost-train-like performance-installation in an abandoned service tunnel in the Viennese underground rail system, and included – among other mobile structures – the 'egg carousel' with its circling seats, each with its own umbrella. With his multiple re-use of works, which, in the context of an installation form an indispensable component of a larger whole, Kippenberger is deliberately chipping away at the criteria that define an already contextually extended concept of 'the work'. This strategic neutralisation of the distinction between original and copy, edition, multiple and variant, along with the subversive deployment of the possibilities of changed meanings and the introduction-into-circulation of certain objects, is perfectly illustrated by the red padded chair placed, in the *Kafka* installation, on a low white plinth beneath the stand with the slide projectors. This in itself is a variant of the sculpture *Not to be the second winner* shown in the *Peter* exhibition, and made from an original Aldo Rossi chair.[6] Since this piece was not available at the time of the *Kafka* installation and the chairs themselves were no longer being produced, Kippenberger had a copy of the chair made. When it came to the *Kafka* installation, the tall plinth used for the 1987 version was replaced by a very much lower one, and the original green was abandoned in favour of red upholstery. Only the drilled 'bullet holes' on one of the front legs form the same pattern in both versions.

As soon as one subjects the individual items in the *Kafka* piece to closer scrutiny, as soon as one starts to draw comparisons with other sculptures in Kippenberger's oeuvre or tries to reconstruct the development of particular forms, a strange discrepancy emerges between the initially harmless-looking simplicity of the individual pieces and the at times convoluted complexity of the narratives that go with them. The almost centrally placed writing desk, made from stacked horizontal wooden boards, for instance, has a specially remarkable provenance, as though its unadorned exterior was decorated with a bizarre anecdote. Made from sheets of raw chipboard, this desk owes its existence to a Papal visit to Cologne in 1986. After Mass had been celebrated in a sports stadium, the chipboard components used to construct the necessary stage were offered to anyone willing to take them away, with the result that many artists' studios and households in Cologne found themselves blessed with rich pickings of 'sanctified Pope-board'. With contextualisation manoeuvres such as this, Kippenberger's treatment of things and objects is not unlike that of the collectors and fans who enjoy an obsessive relationship with the objects of their desire, and love to store up huge amounts of highly specialised, detailed information.

Many of the items of furniture exhibited in Rotterdam came from Kippenberger's own household, which was more than well-stocked with exclusive designer furniture but which he was also in the process of dissolving, having moved twice – from Cologne to Los Angeles in 1989–90 and back again to Frankfurt, where he was appointed Guest Professor in autumn 1990. The private possessions that made their way into the installation include a number of Colani pieces, the Castiglioni chair with the tractor seat, Gehry's 'wiggle side' chair, Jacobsen's 'ant' and one of the then very popular ergonomic balance chairs. In addition to this, there were also souvenirs from the American West Coast, Eames's rocking chair, the so-called Air France poly shell chairs in red, white and blue, a pair of bar stools with leather seats, historic collectors' pieces from Thonet and the Wiener Werkstätten, an original matching table and chair form the Café Fleur in Paris, and even genuine rarities like the solid wood, African chair for a child-prince and the black-upholstered chair with a particularly high back, a relic from the early days of psychiatry, and once used to restrain patients.

Besides the ready-mades from Kippenberger's own household, another category in the *Kafka* installation consists of furniture and sculptures made by the artist. Many of these were produced in 1992–3 in St. Georgen in the Black Forest, where Kippenberger had the use of an apartment and studio. Together with Andreas Höhne and Sven O. Ahrens, one-time art students in Frankfurt and Kassel, he pieced together intentionally unique items of furniture – a table in the shape of a foot, a mushroom-cloud chair, a glass writing desk. The construction of more complicated items, such as the silver writing desk with pullout paintings, fell to the joinery run by Georg Moosmann in nearby Pennenbronnen. It was also in St. Georgen that the strikingly plain table with a pale green top was made, a replica of the table where Robert Musil supposedly sat to write *Mann ohne Eigenschaften* [The Man Without Qualities], which in itself adds a second classic of literary modernism to the associations inspired by the Rotterdam exhibition.

In addition to these pieces, the *Kafka* installation also contains a number of genuine works of art, mostly from Kippenberger's own considerable art collection. A foot-stool by

Reinhard Mucha from 1985, marked underneath with a dedication and the words 'Kampf der Wohnungsnot!' [Fight the Housing Shortage!], was combined with the remains of a *Peter* sculpture to create a hybrid sculptural table structure. Directly related to the job-interview scenario are several chairs by Franz West, Cosima von Bonin's table lamp on the Musil table, a wardrobe with a chair standing sideways in it by Ulrich Strothjohann, a chair made as a present for Kippenberger by Krebber and von Bonin with a clothes hanger attached to its back (dreamt up by Dieter Roth), and, still in its original packaging, Jason Rhoades' *Sheetrockchair*. As far as the interviews themselves were concerned, Kippenberger had recruited the strangest candidates from an exhibition in the New York gallery Metro Pictures in the shape of Tony Oursler's *Organ Play No.2*, which consists of projections of typically-babbling Oursler heads on organs preserved in glass jars. Slightly left of centre in the installation, as if it were detached from the functional scenario of the setting, there is a beguilingly simple piece – again by Cosima von Bonin – consisting of four freestanding, cream-painted chair legs. Their position, at the four corners of a square, corresponds to their original function supporting the rest of a chair. The absence of a chair seat and back prevents the object from being used as such; its possible use is only hinted at. So the four pieces of wood, turned on a lathe, which had been shown in 1993 in Peter Weibel's legendary exhibition *Kontext-Kunst*, created a welcome vacancy in the midst of the massed materials and narratives of the *Kafka* installation.

Seating Arrangements[7]

The relationship between the individual and society, the efficacy of inclusion and exclusion, the consolidation of hierarchies, and the strategies people use to find, occupy and hold on to their own space, form what might be described as the core of Kippenberger's artistic approach. With statements such as 'Al vostro servizio' [At your service], 'Einer von Euch, unter Euch, mit Euch' [One of you, among you, with you], with his 'Preisbildern' [prize paintings] and his claim to be 'Chef der zweiten Liga' [Boss of the Second League], Kippenberger had already explored consumption, the service industries, competition and league tables as some of the most significant factors driving the creative artists of the day. Now, in the shape of the *Kafka* installation, he presented easily his most complex attempt so far to review the situation of art as a whole, to define his own position and take his place in (art-)historical tradition. Kippenberger was in no doubt that every form of art is socially conditioned and hence an integral component of the prevailing competition-based economic system. Relentlessly, and with a sure sense of aim, Kippenberger evolved his own particular critique of the art mythology that operated in Germany at the time with the same idealism and edifying intentions as it had ever had, exemplified in the towering figure of Joseph Beuys, Kippenberger's most stimulating antagonist. Against this background, the *Kafka* installation should be read as a presentation with multiple intentions, reflecting Kippenberger's quest for a very differently extended – life-affirming, even materialistic – concept of art and understanding of artists, in the tradition of Dada, Francis Picabia, Andy Warhol, Marcel Broodthaers and the young Sigmar Polke.

fig.9 Invitation card for the exhibition *The Happy End of Franz Kafka's 'Amerika'*, Rotterdam 1994

Kippenberger never allowed himself to be reduced to 'visual artist'; on the contrary, from the outset he not only engaged with art in a total, all-embracing sense, but he also literally embodied art. He threw himself into the most diverse of roles, thereby fostering the difficulty people still have in distinguishing the man from his work. Statements like 'I am rather like a travelling salesman. I deal in ideas. I am far more to people than just someone who paints pictures',[8] concealed the unstinting demands he made of himself, underpinned by his immense productivity. It seemed that he could turn his hand to any branch of art, apparently effortlessly, eloquently, with a sure light touch and entertainingly, in the best sense of the word. Therefore, in any critique of his work, every attempt should be made to view the many and varied results of Kippenberger's productivity as equally valid artistic statements rather than regarding the texts as no more than a commentary on his artistic objects. In that sense, the pieces made specifically for the Rotterdam exhibition are on a par artistically with the furniture sculptures, which generally take centre stage. And it is only when the full range of material included in the show is taken into consideration that the viewer stands a chance of grasping the meaning of Kippenberger's *Kafka* project.

For a start there is the official exhibition catalogue, an artist's book with no text. Entitled *Afb. [Abb.], [Ill.], Martin Kippenberger, Sollicitatiegesprekken, [Einstellungsgespräche], [Job interviews]*, it is a collection of 330 black-and-white images presented in the form of a picture atlas with echoes of Aby Warburg or Broodthaers. In it, a reproduction of Goya's famous engraving *Ya tienen asiento* [They've Already Got a Seat] from *Los Caprichos* (1797–8) rubs shoulders with shots from advertisements for office furniture and images from Kippenberger's private life. In keeping with the usual practice in catalogues, there are also shots in the classical manner of many of the items on show in the display. The next undertaking for the purposes of the Rotterdam exhibition was the planned Herculean production of more books picking up on the idea of job interviews; it proved impossible to realise the original idea of making a separate book for every table, in other words, a total of fifty different publications. Nevertheless, at the opening there were eight books on display submitted by fellow artists, critics and collectors as their 'applications' for the project.[9] And there was a ninth book, a sample of Kippenberger's own work in the shape of his *B – Gespräche mit Martin Kippenberger*.[10] Another component in *The Happy End of Franz Kafka's 'Amerika'* was of course the invitation card with a historic black-and-white photograph from 1917.[11] This faded photograph, a find that Kippenberger had long treasured, shows a large campaign tent, out in the open, belonging to a cavalry division of the United States Army. In the context of the *Kafka* installation, this image suggests as

it were that the real source of artistic creation lies in this intertwining of the military and circus life. And for the exhibition in Rotterdam Kippenberger did indeed recreate the feel of a circus by painting the walls of the area visitors passed through on the way into the exhibition-room proper with red and white stripes and putting up posters.[12] In two adjacent rooms there were paintings on display along with a number of drawings on hotel writing paper. Many of the pencil drawings of people with particular talents were stamped with the words 'The Happy End of Kafka's "Amerika"', officially 'accrediting' the project. The crowning glory of the exhibition comes with the video clips shown on the monitors on the stands with American cheerleaders chanting aloud 'Kippenberger is my man! If he can't do it nobody can.'

Artist, Reader, Author – Kippenberger Can

In *B – Gespräche mit Martin Kippenberger*, the artist confounds his conversation partner, Jutta Koether, when he declares (in 1991) that he will shortly be writing a Happy End for Kafka's unfinished novel, *Amerika*.[13] Kippenberger, who 'admits' in the foreword to this same publication that he had not actually read the whole of the novel, had always had trouble reading and writing and had cultivated, instead, the image of the articulate performer and cultured non-reader. Nevertheless, books, the life of the writer and literary creation were important constants in Kippenberger's life and work. The first step in this direction came in 1980 when he went to Paris in order to become a writer. This led to numerous poems, mostly collaborations with Albert Oehlen, the book *1984. Wie es wirklich war am Beispiel Knokke* [How it Really Was, by Way of Knokke's Example] written by a ghost writer in Kippenberger's name (published in 1985) and *Café Central. Skizze zum Entwurf einer Romanfigur* [Café Central, Sketch for a Study of a Figure in a Novel] (1987), with diary-like entries. Kippenberger's literary ambitions, reflected in his anecdotal self-stylisation as a bookworm ('reading rat' in German)[14] scale new heights with his huge *Kafka* project. However, his opening declaration in an almost Kafkaesquely contrived style: 'In all honesty, one didn't finish reading the book Franz Kafka's 'Amerika', but there was in our circle of acquaintances one who did read it and informed me of the fact that … ', is a clear indication of the camouflage tactics he used in his *Kafka* project, set in motion long in advance and strewn with numerous clues and red herrings. When, in the foreword to *B*, he mysteriously refers to an acquaintance who has read Kafka, Kippenberger is in fact citing an existing conceit of his own in *Café Central* from which we can deduce that the 'acquaintance' is Michael Krebber. In the entry for 21.5.1987, Kippenberger notes that he has decided not to read any 'uncanny' books, which means that in matters literary he has to rely on help from 'good acquaintances'. Whenever the need arises Michael Krebber and Diedrich Diederichsen are ready to step in, and, by way of confirmation, Kippenberger includes in *Café Central* a list of works of fiction, which has Kafka's *Amerika* in fifth place.[15]

 Another indication of the deliberate engagement with books in the run up to the *Kafka* project is the mock-invoice from Bittner, a bookshop in Cologne, which reads '981,80 DM

für einen Meter Unterhaltungs- und ernsthafte Literatur' [981,80 DM for a metre of entertaining and serious literature] which was made in 1989 as an edition for the Swiss art journal *Parkett* (19/1989). In 1992 there was an increase in the signs pointing to a large-scale exhibition project associated with Kafka. The Graz literary journal *Manuskripte* published a number of photographs showing an inward-looking Kippenberger absorbed in a book on the Greek island of Syros at his friend Michel Würthle's holiday home. The accompanying text tells us that 'He [Kippenberger] is avidly reading a book instead of representing himself as in previous photographs. Here, it is possible to see him as a hermit, as a monk in search of purification … The sense of timelessness and calm in these photographs … contrasts starkly with Kippenberger's constant air of distraction and his capacity to respond. On the other hand, there are repeated allusions to the fact that he reads a lot, and that he is writing a book based on or aimed at providing a happy ending to Kafka's *Amerika* … There is also a suggestion that he is building a metro station on the island.'[16]

There are various reasons to assume that at some point Kippenberger did of course read the whole of Kafka's *Amerika.* The buildings and objects described in Kafka's meandering compound sentences – such as the two-page long account of a monstrous writing desk in the second chapter – Kafka's love of absurd comedy and slapstick sequences, and above all the wealth of imagery in *Amerika,* are perfectly in tune with Kippenberger's own complexly complicated extravagances. A certain affinity between the two emerges from their shared leaning towards vivid exaggeration, towards thought processes riddled with associations and correspondences and from the scarcely disentanglable mixture of artistic and biographical influences on their work, which each wilfully manipulated. Nevertheless, it could also be that Kippenberger's interest in Kafka was not kindled by his reading of the novel but had much more to do with the appeal of the three words or ideas which he elaborated to form the title of the exhibition in Rotterdam: Kafka, Amerika and Happy End.

By citing Kafka, Kippenberger brought into play one of the most important modernist writers, whose work is associated with so many things – the masterly portrayal of the abstrusely administered life of the individual in Modernity, Eastern-European traditions, the royal and imperial monarchy, multi-cultural Jewry, Prague as one of the oldest cities in Europe, and murky, surreal atmospheres reminiscent of *film noir*. As such, Kafka embodies the polar opposite to the New World, which is cast in a distinctly critical light in *Amerika* and portrayed in a manner which, in some respects, may well have tallied with Kippenberger's own experience of the United States. When Kippenberger uses Kafka's incongruous account of his hero's attempt to find redemption as the basis for a multi-faceted artistic manifestation in a museum, he not only transposes the material into another medium, into another language, but he also articulates his own dream of redemption in the form of a Happy End, in keeping with the age we live in – although when he was over there, so close to the promise of Hollywood, there was no Happy End in store for him. When he lived for a time in Venice, Los Angeles, he could find neither the social structures he needed nor the right places, restaurants and bars where he could have sat himself down at a table and communicated with those around him. During his time on the West Coast he only had one exhibition there. The motif for the invitation cards to that exhibition at Luhring Augustine Hetzler in March 1990 was a shot taken by the Düsseldorf photographer

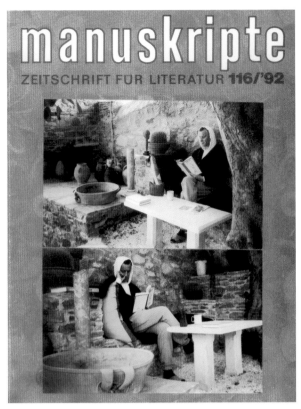

fig.10 Cover of *Manuskripte* magazine 1992

Nic Tenwiggenhorn in southern Spain in summer 1988. It shows an unmistakably European-looking Kippenberger in a white vest in the midst of an archaeological dig, regarding the remains of an ancient temple, his thoughts possibly already turning to the construction of the entrance to a metro stop on Syros (fig.11).

Taking into account all the divergent components of *The Happy End of Franz Kafka's 'Amerika'*, it is clear that this is a rhizomatically ramified piece, a multi-media spectacle with an overtly socio-political dimension to it. It also epitomises Kippenberger's virtuosic ability to blend form with content, which, together with the constant circulation and the perpetual motion of signs and meanings, is fundamental to a dynamic, transformatory concept of artistic work. As the Austrian critic Martin Prinzhorn has said, 'Kippenberger thought of exhibitions less and less as a lining up of single pieces, but understood them rather as platforms where he could sum up his art into bigger narrative units. The stories that were hereby developed increasingly substituted the actual representation of the work of art.'[17] The multi-part exhibition in Rotterdam was just such a dense web of narrative strands creeping across the individual objects and connecting one with the next. Each single artefact, displayed in the green arena, is filled with narratives of its own – tales of its

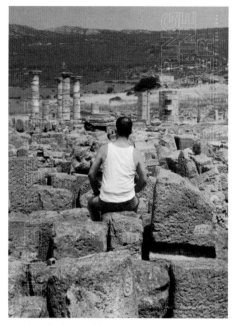

fig.11 Invitation card for the exhibition at
Luhring Augustine Hetzler, Los Angeles 1990

provenance, production or utilisation – making connections to earlier works and actions,
always leading back to Kippenberger and his many associates, as the originator(s) of the
whole. The narratives attached to these objects, skilfully striking the balance between
complexity and vacuity, ultimately establish a notion of the work of art that does not point –
as a metaphysically transcendental phenomenon – beyond itself to something else, but
which – entirely real – derives its own logic from the artist's living praxis and its circum-
stances. With its axial reflections, constantly broken and re-established, *The Happy
End of Franz Kafka's 'Amerika'* stands as a highly complex self-portrait, informed
by the fundamental notion of face-to-face communication between two positions. In
Kippenberger's view, it is only in dialogue with another party that the Self can articulate
its self; by the same token, almost any conversation between two people can turn into a
job interview.

This essay draws liberally on conversations (in 2005) between myself and Sven O. Ahrens, Cosima von Bonin, Gisela Capitain, Karola Grässlin, Michael Krebber, Karel Schampers, Wilhelm Schürmann, Ulrich Strothjohann, Nic Tenwiggenhorn and Johannes Wohnseifer, all of whom I should like to thank most sincerely.

1 Cited from *B – Gespräche mit Martin Kippenberger*, Ostfildern-Ruit 1994, p.14.
2 Jacques Derrida, *Le Monde diplomatique*, no. 6647, 11.1.2002, pp.12–15; Kafka's novel *Amerika* has notably made an impact in very different fields. Federico Fellini failed in his attempt to make a film based on the novel; more recently, the film *Class Relations* 1984, by Jean-Marie Straub and Danielle Huillet; Lars von Trier's *Europe Trilogy*, made in the 1990s; and Bojana Srbljanovic's stage play *God Save America* 2002, are all inspired by this same unfinished novel, to name but a few of the most recent and best known examples.
3 During Kippenberger's lifetime the installation was shown in 1995–6 in the context of the exhibition *Memento Metropolis* in Copenhagen, Antwerp and Stockholm; in each case the piece was adapted to suit the space. In 1999 it was the focal point of the first major posthumous exhibition of Kippenberger's work, in the Deichtorhallen in Hamburg, see *Martin Kippenberger, The Happy End of Franz Kafka's 'Amerika'*, exh. cat., Deichtorhallen Hamburg, Cologne 1999, with contributions by Zdenek Felix, Rudolf Schmitz and Veit Loers. In 2000 a marginally different version of the installation was shown in the Renaissance Society in Chicago. For its presentation in London and Düsseldorf in 2006 the floor area was reduced by around 20%; with the objects being closer together than before, it was no longer possible to walk in and through the installation, which had previously been possible, at least with plastic overshoes.
4 The special construction for the presentation of single pages of the book by means of a slide projector was made for the exhibition *Künstler Bücher* in autumn 1993 in the Museen Haus Lange und Haus Esters in Krefeld, in which Kippenberger, an obsessive producer of books and catalogues, participated.
5 In the exhibition *Qui, Quoi, Où?* realised by Hans Ulrich Obrist at the Musée d'Art Moderne de la Ville, Paris, Kippenberger also showed his *White Paintings*.
6 This sculpture is today in the Friedrich Christian Flick Collection, Zürich/Berlin. See Manfred Hermes, 'Martin Kippenberger', Artists' Monographs, Friedrich Christian Flick Collection, Cologne 2005, p.93.
7 See Babette Richter on this subject in *Sitzordnung. Methoden der Platzzuweisung*, Cologne, 2002, a study of the sculptures of Ulrich Strothjohann.
8 *Martin Kippenberger. Ten Years After*, Cologne 1991, p.29.
9 Uwe Koch, *Annotated Catalogue Raisonné of the Books by Martin Kippenberger 1977–1997/Kommentiertes Werkverzeichnis der Bücher von Martin Kippenberger 1977–1997* (Cologne 2002), pp.283–99: Jörg Schlick, *Ein Einstellungsgespräch*; Sammlung Grässlin, *The Happy End of Franz Kafka's 'Amerika', Tisch 3. Zwecks Einstellungsgespräch. Vorschläge zur Diskussion*; Rüdiger Carl, *Einstellungsgespräch Tisch Nr. 54. Dialog für zwei Akkordeon zum Thema: Das glückliche Ende von Franz Kafka's 'Amerika'*; Walter Grondt, *Der Schoppenhauer. Ein Schauspiel. Tisch 32*; ~~Werner Büttner~~ & Daniel Richter, *Toll*; Diedrich Diederichsen & Roberto Ohrt, *Mehr Rauchen! Der Zigarettentester im Test*; Michel Würthle, *Embauche au Balkan. 24 elastische Seiten zum Thema Einstellungsgespräche oder 'The Happy End of Franz Kafka's Amerika'*; Heliod Spiekermann, *frech und ungewöhnlich am Beispiel Kippenberger*.
[English translations of the above book titles, as in Uwe Koch (see above): Jörg Schlick, *A Job Interview*; Collection Grässlin, *The Happy End of Franz Kafka's 'Amerika'. Tisch 3. Zwecks Einstellungsgespräch. Vorschläge zur Diskussion / Table 3. Interview. Proposals for discussion*; Rüdiger Carl, *Job Interview Table No. 54. Dialogue for Two Accordions on the Subject of the Happy End in Franz Kafka's 'Amerika'*; Walter Grondt, *The Schoppenhauer. A Play. Table 32*; ~~Werner Büttner~~ & Daniel Richter, *Amazing*; Diedrich Diederichsen & Roberto Ohrt, *More Smoking! The Cigarette Tester Tested*; Michel Würthle, *Employment in the Balkans. 24 elastic pages on the theme of the job interview or 'The Happy End of Franz Kafka's "Amerika"'*; Heliod Spiekerman, *frech und ungewöhnlich am Beispiel Kippenberger/ fresh and unusual Kippenberger in mind.*]
10 This volume, published under the imprint Reihe Cantz, contains interviews that Jutta Koether and Diedrich Diederichsen conducted with Kippenberger in 1990–1, some of which had already been published in the art journal *Texte zur Kunst*.
11 *Martin Kippenberger. Bei Nichtgefallen Gefühle zurück, die gesamten Karten 1989–1997*, no.112, Cologne 2000.
12 As an instance of Kippenberger's supreme ability to overcontextualise, the stripes painted on the walls are also a reflection of a permanent piece in the foyer on the ground floor of the museum by the French concept artist Daniel Buren, which was under construction at that time in spring 1994.
13 *B* (as note 1), p.150.
14 See Diedrich Diederichsen, 'The Bookworm', in Koch, 2002 (as note 9), pp.5–10.
15 Martin Kippenberger, *Café Central. Skizze zum Entwurf einer Romanfigur, Hamburg* 1987, p.49; according to Krebber, the works of fiction were his suggestions and had already been chosen for a holiday with Kippenberger in Tenerife in 1986, whereas another list compiled by Diederichsen, with exclusively political texts, has since been lost.
16 As cited in Koch, 2002 (as note 9), p.256.
17 Martin Prinzhorn, 'Signposts', in *Nach Kippenberger*, exh. cat., Wien/Eindhoven, 2003, p.249.

fig.12 *Respektive 1997–1976,* Musée d'art moderne et contemporain (MAMCO), Geneva, 1997

Jokes Interrupted: Martin Kippenberger's Receding Punch Line
Gregory Williams

There is one point on which most interpreters of Martin Kippenberger's legacy seem to agree: it is only through recourse to the anecdote that are we capable of gaining any significant purchase on his work. From the earliest days of his career, his critical reception has, for good reason, relied heavily on the background story. Few contemporary artists have pursued as persistently as Kippenberger the idea that social context and group conversation form the crux of the art-making process. There is no question that in order to understand the paintings and sculptures one must explore the self-constructed subjectivity for which he is known. Yet nine years after his death, the objects themselves have settled into the art market as singular commodities with individually assigned value, making it difficult to keep them attached to their narrative of origin – whether it took place in the bars of Cologne, the piazzas of florence, or the punk clubs of Berlin. The innumerable tales that have proliferated and morphed into legend have had the effect of erecting a screen behind which the pictures can appear to remain inaccessible. His works become more free-floating every year, even in the context of a large-scale exhibition that seeks to renew, as far as possible, appreciation for their original site of inspiration and production.

Kippenberger was well aware of the anecdote's draw for both artist and audience; it gives the impression of dialogue and shared ideas, appearing to produce a bond, however tenuous, between producer and recipient. His vehicle of choice for weaving an ever-expanding web of anecdotes was the joke, or *Witz*. Many of his works possess an aesthetic residue left behind by the verbal jokes that were partially recorded within the space of the image and in the appended title. Run-of-the-mill jokes tend either to be up to date, preying on current political or social ills and mocking those responsible, or they fit into classic categories, such as ethnic or profession-based themes. Regardless of the format, the telling of traditional jokes has long been a relatively tired narrative form, despite its resurgence during the age of the Internet and email message forwarding. According to one joke theorist, the form has suffered from a loss of the ability to edify, one of the key virtues associated with the *Witz* of the Enlightenment. Carl Hill writes that from the eighteenth century onwards the 'punch of tendentious jokes often contained a far-reaching yet immediate critique of repressive social structures'.[1] Hill blames the jargon of post-structuralism and theory in general for trapping the joke within a 'protective theoretical hypostatization'.[2] While not wanting to claim that Kippenberger knowingly sought to rescue comedy from repressive theory, he surely recognised a moribund narrative device that could be exploited to register the cultural pessimism felt in the late 1970s by members of his generation in West Germany.

Kippenberger belonged to a group of artists who turned to joking partly as a way of dealing with the postmodern predicament of occupying a position of secondarity, or late arrival. The joke's very blandness, its conservatism, held appeal for Kippenberger, Albert Oehlen, Georg Herold, Werner Büttner and others as they emerged in the art schools and gallery scenes of Berlin, Cologne and Hamburg in the wake of the so-called *Tendenzwende*, or change of socio-political tendency, of 1973–4. This term was used then, and would be used again in 1982 following the election of Helmut Kohl as Chancellor, to describe the

rightwards shift within West German politics that for many signalled the permanent demise of the idealistic projects of the 1960s. Artists who came of age after the onset of post-1960s pessimism often chose semantic obscurity and linguistic play over direct political messages that others like Joseph Beuys and Jörg Immendorff had still circulated throughout the 1970s. This is not the same as claiming that politics were excised entirely from this group's practice (as if such a thing were possible, or even desired). Rather, the political is referenced obliquely through the crab-like movements of visual and textual jokes spawned by well-known images from the media.

Oehlen once recalled how he, Büttner and Kippenberger had early on found their concepts and problems in the daily newspaper, with the goal that their subjects 'should be truly unpleasantly accessible to everyone'.[3] One such example by Kippenberger is his multiple from 1982, *The Night Is Alright*, a sign made of a thin sheet of wood that can be hung around the neck by a length of yarn. On the front of the panel, the words *Bitte nicht nach Hause schicken* [Please Don't Send Home] are written by hand in all-caps (no.6). More than a mere justification for long nights out drinking, it makes reference to the famous images of hostages taken by terrorist groups during the second half of the 1970s in West Germany. Perhaps the most notorious example is the photograph printed on the cover of *Stern* magazine in March of 1975 that shows Peter Lorenz, the head of the Christian Democrats in West Berlin, wearing a similar sign announcing his capture by the *Bewegung 2.Juni* ('Movement 2 June', a terrorist group loosely affiliated with the Red Army Faction). The hostage-takers had sent a Polaroid photograph to the media to publicise their cause, so Kippenberger similarly took Polaroids of friends sporting his sign in various locales. Sticking with his tendency to mine found visual material for all it was worth, the following year he painted an oil-on-canvas based on a photograph of himself wearing the multiple. Kippenberger reemployed the highly public, accessible nature of the original press reference for the purposes of a private laugh – politics is now located several removes from the source, but is not absent.

Kippenberger and his colleagues occupied the space between incisive criticality and what Diedrich Diederichsen has termed the 'Coming Of Cynicism', which he, perhaps ironically, considers to be a 'genre' in itself.[4] In the process, the artists have experienced both the advantages and pitfalls of humour and irony: they can function as highly valuable tools, affording a degree of conceptual flexibility that allows conflicting meanings to be communicated with great subtlety, but they can also quickly lead to complicity with the object of critique, or collapse into mere stylistic hybridity. The joke as I am considering it here is less a formula than a metaphor, a fallback solution that could take on a wide variety of forms. In the most straightforward cases, a gap emerges between the image and the work's title, many of which read like a punch line. More complicated on an aesthetic level are those pieces in which words find their way onto the terrain of the picture, with pictorial and textual components competing with the title for the viewer/reader's attention. A wide field thus opens up within which the works oscillate between excessive legibility (pictures lifted from porn magazines, for example) and the aesthetic of the in-joke, itself reliant on the power of the anecdote.

Like jokes, the anecdote has suffered in an age when oral history traditions are obsolete as primary transmitters of information. Walter Benjamin recognised this development

already in his 1936 essay on the figure of the storyteller, whose position was jeopardised in the aftermath of the first World War, a time when 'experience [had] fallen in value'.[5] Jokes and anecdotes are at their best in verbal form, which retains all the facial tics and bodily twitches lacking in the textual or pictorial version. It is thus not surprising that so many writers are drawn to the original scene of spoken exchange in the studio or pub, where the joke was first told. One of many former Kippenberger assistants, the English artist Merlin Carpenter has aptly described the crucial role of studio help in translating the in-joke to a wider audience. What he calls the 'secret explainer' is the intriguing idea that a great number of work titles and concepts derived from the assistants, implying that a public element was built into the artist's working method.[6] But despite any gestures towards comprehensibility that such a process suggests, Kippenberger is the member of the group who most thoroughly pursued the alienating effects of a work of art that provides an abundance of clues but no clear answers. The negativity at the heart of much of his work is partially mitigated by the initial sense of freedom granted by his open narratives. One can enjoy getting lost in the cross-references or coming up with possible thematic threads. Yet for many members of his general audience, especially those not privy to his particular sense of humour or fluent in German, the groups of paintings and drawings can represent an excess of options, a total lack of guidance that can finally seem overwhelming. The sense of freedom is short-lived; Kippenberger's observer is subsequently struck by the lack of a coherent conceptual framework, like a joke without a punch line.

With certain works, it is more accurate to say that they are all punch line and no joke. A representative example is the 1982/3 series *Schade, dass Wols das nicht mehr miterleben darf* [A pity that Wols isn't alive to see it], which features six individual works – each with its own longish title – that hang in a block. One can read the group in any direction, allowing for various narratives or points of connection to unfold. The two most consistent formal motifs are walls and orifices, opening up linkages among the images, but in general narrative transparency is denied. Looking to the titles for clarification does not necessarily provide any help. The upper-left painting, for instance, is called *Zurück vom Meer ist das Scheckbuch leer, am Samstag hat der Arbeitslose Ruh, da hat das Arbeitsamt zu* [Back from the sea and the checkbook's empty, on Saturday the unemployed have their repose, since the job centre's closed]. We do see two ship silhouettes in one painting, as if through a porthole, but otherwise the relationship between picture and title is tenuous. Similarly, the upper-right painting is titled *Zelle von Andreas Baader* [Andreas Baader's cell], making reference to charged political events of five years before. A brush sweeps dust from the rim of a hole in what looks like a concrete wall that may or may not be a prison cell, but no explanation of the orange and yellow monochrome fields making up the remainder of the picture is readily available. And finally, while the agitated surface treatment of the lower-middle painting (*11.11 elf Uhr* [11/11 eleven o'clock]) might vaguely bring Wols's painting style to mind, little else serves to link the single picture to the series, nor to the older German artist.

Kippenberger's preference for indirectness did not, of course, make his works any less humorous, but a certain element of surprise was usually kept intact. Within the visual space of his paintings and drawings he rarely announced that his intention was to make you laugh. An exception that proves the rule is found in his 1993/5 series of drawings on hotel

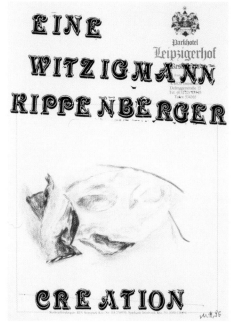

fig.13 *Ohne Titel* / Untitled, from the exhibition
Über das Über / About the About 1995

stationery, in the exhibition *Über das Über* [About the About]. Here Kippenberger included
a rendering of fried eggs and bacon bracketed by the words *eine Witzigmann Kippenberger
Creation* [a Funnyman Kippenberger creation]. Printed in a typeface with an old-fashioned
look, it is one of the few instances where Kippenberger deliberately spelled out his self-
appointed role as jokemeister. Instead of telegraphing his jokes, he usually had them enter
through the back door. We may recognise that we have encountered something amusing,
but often the exact source of the humour is tough to locate. This is partly a result of how
Kippenberger favoured a comedic mode that hid its provincial inspiration behind the
transparent banality of foodstuffs, celebrity, the media and popular culture in general, i.e.
the wide world of consumption. In this instance, he draws on the story of the Austrian
Eckart Witzigmann, star chef and founder of Aubergine, a Munich restaurant that in 1979
received the first 3-star designation given to a German establishment by the Michelin guide.
Witzigmann's well-publicised fall from grace in a 1993 cocaine scandal was too good for
Kippenberger to resist; the word '*witzig*' [funny] begged to be appropriated. Typical of
Kippenberger's approach, the *Witzigmann* drawing relies on 'unpleasantly accessible'
current events to imply that there is enough in the local press to laugh about without having
to come up with too many new ideas.

Just what ultimately defined the core of Kippenberger's comedic project is difficult to
pin down today, despite its having taken place in the recent past. It was plainly not his

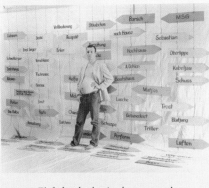

fig.14 Poster for the exhibition *Einfach geht der Applaus zugrunde* / The Applause Simply Dies, Galerie Grässlin-Erhardt, 1987

priority to develop methodological coherence; he was far more interested in exploring how a picture could convey a speedily hatched concept, how specific forms are required in order to enable, as Roland Schappert has put it, 'the rescue of the quick joke'.[7] The seductive manoeuvrability of the simulacrum was in the air in the 1980s, so the question becomes to what extent Kippenberger's coded allusions to lived experience were part of a conscious strategy or an accidental product of his working method. In a photograph printed on a poster advertisement for a 1987 exhibition at the Galerie Grässlin-Erhardt in Frankfurt, an out-of-shape and exhausted-looking Kippenberger stands trapped in a forest of signs. Words, mostly single, are written on pieces of cardboard cut into the shapes of arrows pointing to the right or left, all of which hang from lengths of string that dangle in front of a sheet-covered wall. We try vainly to discern a pattern or set of connections among the terms; several varieties of fish, people's names (Oehlen, Ernst Jünger), and other fairly random verbs and nouns compete for our attention. The title of the exhibition, printed below the photo, is *Einfach geht der Applaus zugrunde* [The Applause Simply Dies], a play-on-words since the arrows move from the wall onto the floor (*zugrunde gehen* literally means 'to go to ground'). Detached signifiers with no obvious correlation to each other, they recall Jean Baudrillard's labelling of simulation as a 'descriptive machine';[8] any potential contact with the 'real' is left to the viewer's imagination. Here Kippenberger takes on the role of poster boy for an aspect of the postmodern condition.

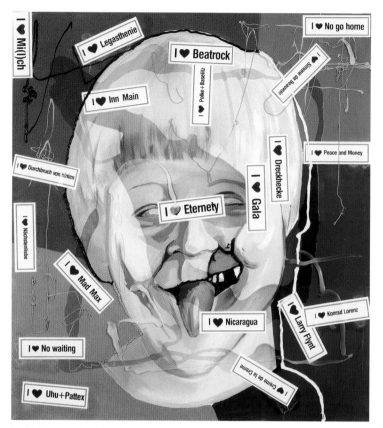

fig.15 *Kaputtes Kind* / Broken Child 1985

 With other works of this period, such as the painting *Kaputtes Kind* [Broken Child]
from 1985, language invades the image itself, plastering its surface with textual fragments.
An assortment of self-made bumper stickers in the then-ubiquitous 'I Love … ' format
(they appear in many works by Kippenberger from the mid-1980s, arising from an initial
collaboration with Oehlen) covers the face of a crudely grimacing child. Placed over the
eyes, the phrase 'I Love Eternety [sic]' threatens to blind this member of a younger
generation, her vision obscured by an explosion of empty catchphrases that invoke the
slogans of advertising. The broad spectrum of accessibility is on display here: From the
topicality of 'I Love Mad Max' to the crass suggestiveness of 'I Love Durchbruch von
hinten' (breakthrough from behind), from the self-referentiality of 'I Love No go home' to
the ironic fatherly glorification of 'I Love Polke + Baselitz', virtually any viewer can find
something to latch on to. Most of them are not laugh-out-loud funny, but all of them are at
least awkward and inane enough to be recognised as having been produced in a fit of
laughter on the part of the artist/s. That we might somehow still find our way back to the
original context of their amusement is a more doubtful prospect.

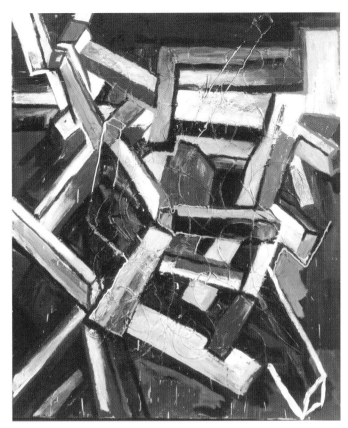

fig.16 *Ich kann beim besten Willen kein Hakenkreuz entdecken* /
With the Best Will in the World, I Can't See a Swastika 1984

Ultimately, the unstable output of the joke machine that churned relentlessly in
Kippenberger's studio did not prevent him from occasionally offering a picture composed
of a more traditional set-up/punch line structure. Perhaps the best example of such a work
is the legendary 1984 painting *Ich kann beim besten Willen kein Hakenkreuz entdecken*
[With the Best Will in the World, I Can't See a Swastika]. A medium-size canvas painted in
oil and silicone, it forms a clear separation between the picture itself, which stands in for
the narrative background, and the title that provides the punch line. Consisting of a jumble
of intersecting and overlapping cubic rectangles in grey, white, yellow and red against a
dark grey/black ground, it suggests Cubist spatial deconstruction as well as the outward-
directed motion of a Suprematist composition. The nods to modernist abstraction are
tempered by a slightly cartoonish linearity, with some of the forms more drawn than painted,
and the loose swirling lines of clear silicone gel that overlay the whole image seem to mock
the rigidity of the geometry. Without a title to provide context, this picture would likely
remain stranded in the realm of pastiche, one more example of Kippenberger's talent for

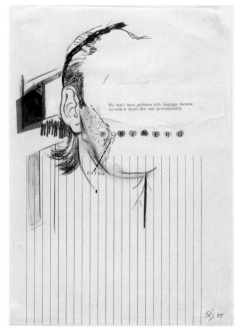

fig.17 *Untitled* 1985

stylistic quotation. Yet the text, with its reference to West Germany's attempts at *Vergangen-heitsbewältigung* (coming to terms with the past) in the 1980s, lends the picture a strong element of topicality and critical focus.[9] From an art-world perspective, he takes a dig at German artists like Markus Lüpertz and Georg Baselitz, who denied that their militaristic motifs (boots, helmets, guns, eagles) were meant to be read as anything other than empty formal supports for the practice of painting. Kippenberger responds indirectly to the dubious claim by Baselitz that he sought to 'create no anecdotal, descriptive pictures'.[10] In doing so, Kippenberger conveys an unmistakable sense of comedic timing, assuming one first examines the image before turning to read the wall label.

Not all of Kippenberger's series rely on an external textual component to get the idea across. Consider the 'Prize' paintings of 1987 (nos.19, 20): the prize number is emblazoned across the surface of the image, each amateurish abstract painting competing for the role of most pathetic. The audience can take pleasure in deciding whether the ranking of best to worst ought to have been reshuffled. There are certainly other examples of works by Kippenberger that so unambiguously declare their humour. Where Kippenberger leans heavily on the titles, one must be aware of the dangers of reading too much into the image/ title relationships that he constructed. Knowing how strong a role was played by friends, acquaintances and studio assistants in his generating of ideas, we have to proceed cautiously when looking to the title for answers to a puzzling image. An untitled collage from 1985 comes close to encapsulating Kippenberger's mode of incorporating language (fig.17).

A fragment of a man's head, possibly a self-portrait, is drawn roughly and placed in front of what looks like an architectural structure. The face is not articulated, its empty centre covered by a torn piece of paper with the following English-language aphorism typed or printed onto its surface: 'We don't have problems with language, because we write it down first and go immediately.' Below this line he spells out the word 'primero', or 'first', in children's stick-on letters and writes by hand 'ensaio' or 'essay'. One is tempted to construe the phrase above as a kind of first principle, an important methodological foundation upon which Kippenberger's work rests. Language is consumed, quickly digested and then left behind, not taken more seriously than is warranted by the demands of the moment. A fine summary of his approach, but again, one would be applying too much pressure to the words themselves by attempting to look there for fixed principles within Kippenberger's practice. Such a move would be to confuse the joke as metaphor with the joke as formula.

Still, the lure to do so is undeniably strong. The texts simply open up too many compelling interpretive routes into the images that beg to be considered. This is, of course, what makes Kippenberger's work so rich. Even without pictorial support, Kippenberger's titles/ aphorisms can function as independent pieces; think of his small book, *241 Bildtitel zum Ausleihen* [241 picture titles to be lent out].[11] This list of semantic blind alleys and playful non-sequiturs happily buries the *Witz* as an effective mode of edification. The book was published after Kippenberger's three-month stay in Brazil in 1985 and 1986, when he kept a record of T-shirt slogans he saw on the street or, one may presume, invented. Each slogan (two random examples: 'Beauty and the Beach' and 'Bad Boy Club '85'), the majority of which are in English, is accompanied by an 'explanatory' aphorism, the latter primarily in German. We would have to take a long detour to go through the linguistic gymnastics performed by his turns of phrase, which, like good aphorisms, toy with the suggestion of handed-down nuggets of wisdom. As with the titles of his paintings, they revel in their own absurdity, detached from pictorial support.

Writing in the late 1980s about the joke's lack of relevance in an era when most taboos had already been broken, the literary theorist Otto F. Best wrote: 'In a world without faces, the joke also has no face.'[12] Kippenberger understood this and, aside from a few moments of renewed faith in its powers of persuasion, took pleasure in reenacting the death of the joke as a fait accompli. At the same time, Kippenberger *needed* the joke in order to work through his issues of failure, compromised authenticity, second-order status, etc. Paradoxically, he relied on the joke's lifelessness to keep moving, to 'go immediately,' as he put it. Like a good comedian, he recognised the necessity of constantly offering new material. It was not his job to determine whether it held up under semantic scrutiny – that could be left for others to decide.

1 Carl Hill, *The Soul of Wit: Joke Theory from Grimm to Freud*, Lincoln and London 1993, p.227.
2 Ibid.
3 See Wilfried Dickhoff (ed.), *Albert Oehlen im Gespräch mit Wilfried Dickhoff und Martin Prinzhorn*, Cologne 1991, p.46.
4 Diedrich Diederichsen, *Sexbeat*, revised ed., Cologne 2002, p.x. [Originally published in 1985.]
5 Walter Benjamin, 'The Storyteller: Reflections on the Work of Nikolai Leskov', in *Illuminations*, ed. Hannah Arendt, trans. Harry Zohn, New York 1968, pp.83–4.

6 See Merlin Carpenter, 'Back Seat Driver', in *Gitarren, die nicht Gudrun heissen. Hommage à Martin Kippenberger*, ed. Thomas Groetz, exh. cat., Galerie Max Hetzler, Berlin 2002, p.27–30.
7 Roland Schappert, *Martin Kippenberger: Die Organisationen des Scheiterns*, Cologne 1998, p.33.
8 Jean Baudrillard, 'The Precession of Simulacra', trans. Paul Foss and Paul Patton, in *Art After Modernism: Rethinking Representation*, ed. Brian Wallis, New York 1984, p.254.
9 For a discussion of *Vergangenheitsbewältigung* in relation to the visual arts, see Andreas

Huyssen, 'Anselm Kiefer: The Terror of History, the Temptation of Myth', in *Twilight Memories: Marking Time in a Culture of Amnesia*, New York and London 1995, pp.209–47.
10 Georg Baselitz quoted in Wolfgang Max Faust and Gerd de Vries, *Hunger nach Bildern: Deutsche Malerei der Gegenwart*, Cologne 1982, p.37.
11 Martin Kippenberger, *241 Bildtitel zum Ausleihen*, Cologne 1986.
12 Otto F. Best, *Der Witz als Erkenntniskraft und Formenprinzip*, Darmstadt 1989, p.141.

Kippenberger!
25.2.53 - 25.2.83
ABSCHIED VOM JUGENDBONUS!
Vom Einfachsten nach Hause

fig.18 Catalogue cover for *Kippenberger! Abschied vom Jugendbonus! Vom Einfachsten nach Hause* /
Kippenberger! Farewell to the Youth Bonus! Start Simple Get Home, Cologne 1983

Heimweh Highway or: *Start Simple Get Home*

Susanne Kippenberger

> 'Every artist is a human being.'
> – Martin Kippenberger

He was still a child when he got a house of his own, a wooden hut, hidden away in our garden and named after him: Martinsklause. His very first house. It was to be his only house.

Why did he get it? Perhaps because he was special. The only boy in among four girls, squeezed in-between the 'big ones' and the 'little ones'. Sometimes he was put in with one lot, sometimes with the other, but he didn't really belong anywhere. A boy who wasn't a proper boy, a clown, who often wept and who preferred painting to playing with cars. 'Martin unser Künstler' [Martin our Artist] was written in big letters on the kitchen wall.

He rarely made use of Martinsklause. What could he do with a lonely hut in a wood? He never was a hermit. He always wanted to be with people.

The house in Essen in which we grew up was always full of people – and full of art. Martin was still a child the first time he left it. Sickly, not good at school, a difficult child (today's teachers would have called him hyperactive), so our parents sent him away. first to a family friend, a woman who illustrated picture books and lived in the Bavarian Forest, when he was just nine. After that, to boarding school, first in the Black Forest, then in Altenkirchen. That was how his life's odyssey began. As a teenager he came back to Essen. Later he went to Otterndorf, Hamburg, Berlin, florence, Stuttgart, St. Georgen, Cologne, Paris, Los Angeles, Madrid, Tokyo, Frankfurt, Vienna, Seville, Burgenland (Austria), Greece, Cologne again … St. Georgen … Burgenland. And every time with the intention of settling in that place. 'I never managed it, but the will is still there, as it ever was', as he remarked in an interview in 1993.

And then – he arrived. In 1996 he married the photographer Elfie Semotan, with whom he also worked. She was older than him and the mother to two sons. He felt at home with her in her house in Burgenland; for him it was a place where he could be at peace, where he could work and even be alone.

At that time, he did have a house, in a way, a house devoted to art. The museum on Syros, of which he was the self-styled Director, is of course an absurd skeleton of a house, a concrete ruin, with no walls, no windows, no doors. He had wanted to build a tower here, near his friends Michel and Katerina Würthle, a tower for painting and sleeping in. Now that he was with Elfie the tower was to become a proper house. The architect's plans were drawn up, but there was no time left for the construction work. A year after the wedding he was dead.

Heimweh Highway 90: that's what he called one of his catalogues, with a cover picture showing himself, as a boy, crushed into a photo booth with our father. But for Martin, this *Heimweh* – homesickness – went hand in hand with its opposite, *Fernweh*: longing for a home yet at the same time running away from the very idea in order to be free of obligations, duties and constraints; a desire to find a resting place that was at odds with the uninhibited curiosity with which he threw himself at anything new; torn between having to be alone, in order to paint, and not being able to be alone; the dilemma of being

fig.19 Map of the Frillendorf neighbourhood of Essen, drawn by Kippenberger's father in the 1960s:
their house, no.86, is marked near the bottom

recognised for what he had done yet not wanting to become public property. This was the ground bass of his life and his art, a lifelong struggle: *Vom Einfachsten nach Hause* [Start Simple Get Home] was the subtitle of the catalogue *Kippenberger! Abschied vom Jugendbonus!* [Kippenberger! Farewell to the Youth Bonus!], which he gave himself for his thirtieth birthday.

Bitte nicht nach Hause schicken [Please Don't Send Home] is the title of one of his most penetrating self-portraits. It shows him with the gaze of a refugee child that has lost its home and is begging to be taken in, a child that can never go back. Another painting, where he is seen from behind, in his underpants, going somewhere or other, bears the words 'Nicht zu Hause schlafen müssen' [Not to have to sleep at home].

'It was a form of escape', says Wiltrud Roser, the picture-book illustrator to whom he had been sent as a nine-year-old – and whom he couldn't wait to go and stay with. Now, this minute, or not at all. A few weeks later he returned home with the same impatient relish. Perhaps his whole life was a form of escape, but not from problems, if anything from stasis and boredom – it was always an escape to, never from. Being sent home would mean going backwards. But he wanted to make progress, to achieve something.

'To understand Kippenberger, you have to understand him as an artist who always chooses off-kilter, strange perspectives', writes Jutta Koether in her foreword to *Heimweh Highway 90*, 'an artist who stays in one place and lives out his vision of that place, for a

fig.20 Two drawings from *Input-Output* 1986

limited time, before he's off again'. Only rarely, unwillingly and in some embarrassment, did he ever return to a place once he had left it behind him, to Cologne, for instance, or St. Georgen. *Input-Output* was his own title for a series in which he drew, on hotel invoices, all the ground plans of all the homes he had lived in, going right back to his childhood. 'Boy, all you do is move from one place to the next!' our mother wrote to him when he was studying art in Hamburg in the mid-1970s and kept moving from one shared flat to the next. 'If a person is to find their own field', he wrote back, 'they have to collect all sorts of life experiences. Every flat – every person that I've shared with – is a stage on that journey. If you can see that there is no room for manoeuvre, that there's no longer any chance of developing further, you just have to move out. A change is a new beginning, every time.' And, as he assured her, ultimately he did want to develop: 'It's not just a financial investment.' No input, no output.

'Happily married, two children': in the interview with Jutta Koether this is his horrifying vision of cosy domesticity, the end to an existence as a creative artist. He was the kind who was forever exceeding limits: the limits of embarrassment and good taste, the limits normally associated with particular media and styles. And he was duly punished for that,

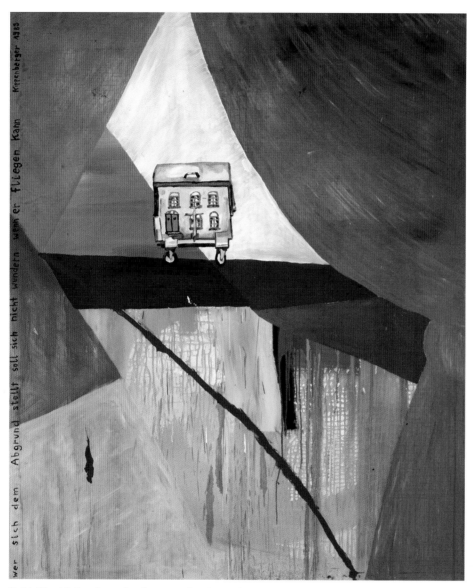

fig.21 *Wer sich dem Abgrund stellt, muss sich nicht wundern, wenn er fliegen kann /*
Anyone facing the abyss shouldn't be surprised if he can fly 1983

even calling a series of sculptures *Martin, ab in die Ecke und schäm Dich* [Martin, Into the Corner, You Should Be Ashamed of Yourself]. But a fixed abode would have been a prison to him.

There are no simple equations to apply to Martin Kippenberger, not even in terms of his biography, along the lines of life=art. People can understand his art without knowing him or his life, and it's important to avoid simplistically assuming that his art is a reflection of his life. The idea that the biographical stations of his life can be reconstructed from his drawings, for instance, is sadly misguided: Martin certainly never slept in all the hotels whose writing paper he used for drawing on.

The connection between his life and work is more complex than that, and interesting for that very reason. Art was not a reflection of his life, it was his life. 'Wer sich dem Abgrund stellt, muss sich nicht wundern, wenn er fliegen kann' [People who face the abyss shouldn't be surprised if they can fly] is written on one of his paintings; it shows a house on wheels, a rubbish bin as someone's home. That's how he worked, and how he lived: always on the move, always skirting along the edge of the abyss, in a mobile home of sorts. As artists go, he was a travelling salesman, he once said. A travelling salesman is constantly travelling around, knocking on strange doors, asking to be let in; someone in the business of persuasion, selling his wares – or not – and moving on again. An exhausting life, a lonely trade, a 'one man business', as he himself once described art. As an artist he was a solo entertainer, a rep and a dep, suffering for others in the name of art, like Fred the Frog whom he nailed to the cross. And he was also Spiderman, spinning his ubiquitous webs and forming families. Long before he got to know Kafka's *Amerika* and the Theatre of Oklahoma he had his own travelling circus – a more or less steady circle of friends who travelled around the world with him, going to exhibition openings, spending days and nights with him in bars. People, not places, were his home.

Exciting – that's how his life of artistic excess looked from a distance to his fans. But he himself found it 'desperately tiring' … 'a life constantly on the move, with no private life whatsoever'. And as he once said, he couldn't be cutting an ear off every day. Yet there were a lot of days when he did just that, leading a wild life, racing along at top speed, always looking out for places to have a break by the wayside. Staying for a few days or weeks with friends and acquaintances, where he felt accepted and taken care of. Where he didn't have to keep up some act, where he could afford to let any weaknesses show, and could hold his peace. 'Happily married, two children': when he needed to refuel he was only too glad to stay with people in steady relationships, a family, a home, never mind if it was all a bit petit-bourgeois.

Even as a student in Hamburg he used to go once a week to see his friends Ina Barfuss and Thomas Wachweger – a long-standing couple – for a meal of cabbage roulades. He liked it when people cooked for him, because he liked being mothered. Best of all he liked children's food, simple things, like black pudding, comfort food that reminded him of his own childhood home: pasta bake and spaghetti bolognaise, the only things our mother did well, were the mainstays of his diet, reliable constants in a restless existence. And food for art. As it says on a screenprint of a sieve: 'Nicht wegwerfen, kann man noch für Nudelauflauf verwenden' [Don't throw it away, it'll do for pasta bake].

Often, instead of looking for an apartment of his own, Martin would move in with other people, into a ready-made nest, where he could lay his eggs undisturbed, but which he could leave again whenever he liked. 'Housemate', as he described himself on a poster, or 'squatter', as granddaughter Grässlin once complained. For he would make every house his own, hanging pictures up, taking others down, always wanting to take charge, giving his occupation as 'Boss' on another poster. And it was just the same with towns and cities, leaving his mark on the places he went to, taking possession of them, shaping them, influencing them – 'the Kippenbergerisation of the world' as it was known. Every relocation was also a test: How much could a place take? Could he weave a web of connections there, could he find people who wanted the same things as him, 'something better'? How much could he take himself? Art was supposed to hurt. Life hurt, too.

So he was always on the move (although he never had a driving license), but never went on holiday. 'Martin was always on duty', says Gisela Capitain. *Wahrheit ist Arbeit* – Truth is Work – another of his catalogues. When he went to Brazil, he didn't lie around on the beach; he later turned everything into art that he had seen there, that he had experienced and photographed. And again he exceeded the usual limits, breaking through the pain barrier. 'I can always tell, now we're getting to the stupid minutes, now the fun will stop. You have to get through that too. That's when you have to have spent three months in Brazil!' he told Jutta Koether in an interview. 'And you've got to be in Brazil for three months! Not just tick off two weeks and then say: I've had the girl from Ipanema and her sister too, and then it all got too exhausting, then I left, and talk about "poor people", and "I've seen poor people!" That's all? It can't be! You've got to bear it! … that the most pleasurable sensation and fun change to just the opposite, right? And then stay!'

He often lived in hotels for days, weeks, months on end, sometimes paying for his accommodation with pieces of art, as he did at the Chelsea in Cologne, often exchanging art for food and drink. 'Kippy can't even butter a piece of bread', Rudolf Augstein was once heard to say. But that was only half the truth. It was also easier to have someone else butter your bread, make your bed, clean the bath; then all you had to worry about was women and art. And it's nice when someone else butters your bread and puts a piece of sausage on it, that feeling of being looked after.

Grosse Wohnung, nie zuhause [Big Apartment, Never In] is the telling title of one of the pictures that makes up the trilogy *Berlin bei Nacht* [Berlin by Night]: not at home in the living room, but out in the streets where life is in full swing. And even when he did for once have a large apartment of his own, as he did in Cologne, at Friesenplatz, or in Frankfurt-Sachsenhausen, most of the time he was out and about. Bars, cafés, restaurants, even a bookshop, these were his living room, his office, his studio, his museum, his dining room, his salon. He didn't want to be at home on his own; bars provided him with a stage where he could make an appearance, and he could always be certain of meeting friends there. There was no distinction between his public and his private life, between life and art: 'I very clearly just sort of generally exist as a living vehicle.' And his art always involved contact with other people. The periods spent with his friend and fellow-artist Albert Oehlen in Spain and Austria were amongst the happiest and most productive days of his life.

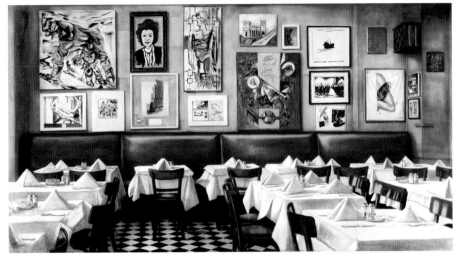

fig.22 *Paris Bar* 1991

And he had a talent for being-at-home anywhere. He would arrive somewhere and he'd be fully there, instantly and as though it was the most natural thing in the world. He could work anywhere, and in strange places he was never a stranger for long; he would already have identified his local and pub landlords and their families would take him in like a lost son. And he turned what he saw and experienced in bars into art. His home port was the Paris Bar in Berlin, owned by his friend Michel Würthle; a home where his word mattered and which he had designed himself. On two separate occasions, a long time apart, he hung the pictures in the Paris Bar. A home for art: as was also Kippenbergers Büro, located on one floor of a factory in Berlin where he lived in the late 1970s with Gisela Capitain, and organised exhibitions and concerts. He put on his first Happening in our childhood garden, with live music and 150 guests.

Any form of routine was abhorrent to him; every exhibition project involved trying out something new. But he needed rituals, like drunkards need lampposts – to hold on to. At twelve noon, 'on the absolute dot', lunch had to be on Mother Grässlin's table. In the afternoon he would have his nap, that was sacrosanct. At Christmas time he celebrated Christmas, with members of his own family or with elective relatives like the Grässlins in the Black Forest. And he would insist on the traditions we had known as children: turkey on Christmas Eve, a big fir tree, presents … He would even go to church. In fact he never left the Church. If there really was a Heaven, he wanted to get there, too. Not find himself standing outside a locked door when it came to it.

It wasn't the strange and unfamiliar, it was being alone that he was afraid of. He just couldn't stand it, someone always had to keep him company. And having a family meant you weren't alone. 'One Family – One Line' was his chosen inscription for our father's headstone, which he designed together with Hubert Kiecol. A few months after our father's death, in 1989, Martin's daughter was born, whom he named after our mother: Augusta

*Dieser Mann
sucht eine Frau*

Martin Kippenberger
Segitzdamm 2-4 · Berlin 61
☎ 614 79 28

fig.23 Sticker *Dieser Mann sucht eine Frau /
This man is looking for a woman* 1978

Eleonore Helena. 'I wanted life to go on.' He had what he had been longing for, a family
of his own. But he couldn't live the family life. So he moved on again.

He was an addict. Addicted to drugs and alcohol, to love, cigarettes and recognition. And
the German *süchtig* (addicted) could hardly be closer to *sehnsüchtig* (filled with longing).
He was both. And both come from *suchen*, 'to search', as he himself pointed out in his
interview with Jutta Koether. '*Sucht*', he declared, 'simply means searching'. Seek and ye
shall find. 'I'm rejecting everything and searching for something decent.'

'Dieser Mann sucht eine Frau' [This man is looking for a woman] was the legend on a
visiting-card-sized sticker with a photograph of Kippenberger and his address, which he put
about all over Berlin in the 1970s. It was more than just a good joke. Many people
underestimated this, not realising that there was always something deeply serious behind
his irony. He was looking for a wife and a home, and in the end he found them. Perhaps he
sensed that he was running out of time for looking. That now was the time for finding. For
arriving. During the last year of his life he was working on his last major piece, the *Medusa*
series. Elfie photographed him in the poses that a victim of a shipwreck might adopt. He
then painted himself in these attitudes. Poses between life and death, between despair and
the hope of rescue. Of reaching dry land.

It wasn't enough for him to just live with Elfie, he wanted to marry her, he had to marry her, straight away. He was a romantic, a film-goer, a big fan of Hollywood. He wanted a Happy End.

The Happy End of Franz Kafka's 'Amerika' was his own chosen name for his masterpiece. He never actually finished the novel, he was too impatient for reading; he got someone else to tell him the story. He must have felt an affinity with Kafka's Karl: a boy whose parents sent him away from home, all alone to a strange place. A child of sixteen who got the maid-servant pregnant and who never finished school. A humorous, optimistic boy, who believed in people, in their good side, and who – in the very first paragraph – discovers freedom, in the shape of the Statue of Liberty. And who soon realises how exhausting freedom is. Kafka's novel is also about going away, moving around, starting out anew time after time, and ultimately it's also about arriving. About being allowed in. 'Everyone is welcome!' is the cry at the Theatre of Oklahoma, 'If you want to be an artist, join our company!' Again and again Karl reads this sentence: Everyone is welcome. So, he's welcome, too. Even if he is a little disappointed that he doesn't get the position he wants. He continually reminds himself that 'it was not so much a matter of the kind of work as of establishing oneself permanently somewhere'. And considering all those who had come to this theatre, Karl is all the more moved by 'how well they had been received and cared for'.

In his foreword to the book, *B – Gespräche mit Martin Kippenberger*, which accompanied the *Kafka* installation and with which he proposed to apply for a post interviewing job-applicants, he notes that in this work by Franz Kafka there is a prospect of a Happy End. And at some point in his own book, he turns to Jutta Koether with the words, 'So let's get down to higher things now. Higher things will be very crucial. What we understand by love and affection and security. Is the collective term warmth?'

Translated from the German by Fiona Elliott

fig.24 Change-of-address card drawn by Martin Kippenberger for his mother
when they moved house in 1972: Martin is sitting in the arm chair.

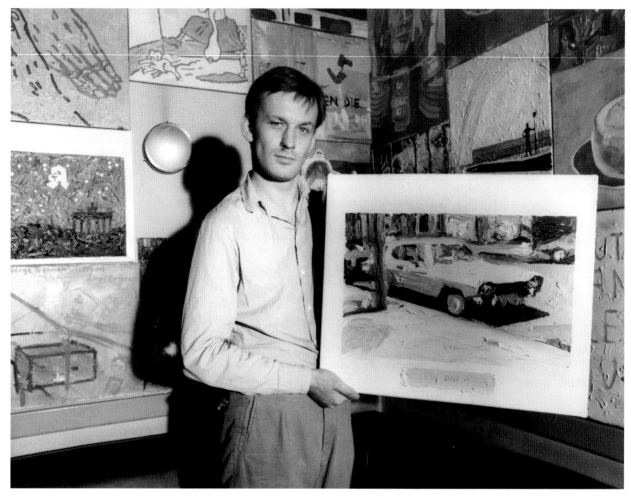

fig.25 Martin Kippenberger, with the painting *Capri bei Nacht* at the exhibition *Neukonservative Kneipenkunst* in the Paris Bar, Berlin 1981

Parachever Picasso/Completing Picasso
Interview between Martin Kippenberger and Daniel Baumann[1]

Daniel Baumann: *What was your home like? What was hanging on the walls?*

Martin Kippenberger: There were prints, covering the walls from floor to ceiling: works by Beckmann, Corinth, Heckel, the German Expressionists, Marino Marini, Picasso and lots of kitsch. I came into contact with all the different fronts of art, from the ultimate to the ultimate. Then, when I was ten, I started producing things in my own room. I worked my way through the whole of art history, as I found it on the walls in our house. First this way, then that, I imitated all the different styles, but not by copying them. I realised that it wasn't that great, what they'd been doing. So I was quickly finished with Chagall, and very quickly done with Klee. Kokoschka had more staying power, I was very struck by his portrait of Adenauer and his Rhine landscapes.

So what happened next, after you'd drawn your way through the family collection?

I drew my way through all the art books on the book shelves. That helped me to see things more clearly than if I just looked at the pictures. You find out how difficult it is to do certain things, that you're just not able. Then my father said that if I wanted to be an artist, I'd have to find my own style. That was the hardest thing of all for me. Finding my own style, I got very stuck until I suddenly realised that having no style is also a style, so that's what I did. That set me free. Don't worry about style but about what you want to say. How it looks is a different matter. Make an effort, work hard, remain more or less true to you, yourself. So I used certain things as a kind of a stamp, on the invitation cards for instance that I'm on; these then became my graphic output. Anyone who's collected all the invitation cards has a full set of Kippenberger's graphic works.

In 1976 you went to Florence. Was that where your artistic career began?

I always wanted to be an artist, even as a child. I saw what a pleasant life they lead. The only thing I could do was painting and drawing. But the people in the art world got on my nerves to such an extent that I just stopped for a while. Then in 1976 I decided to do art professionally. First I tried acting. I went to Florence, Italy, the land of film; I looked like Helmut Berger in his prime but no-one discovered me … Just the same as when I went to Paris in 1980 to become a writer. That didn't work at all. I produced four or five good little poems, but that was it. So that was the end of my career as a poet and man of letters, and I went back to Berlin. The poems later found their way into the catalogue *Die I.N.P. – Bilder.*[2]

I had no idea what Florence actually was, it just sounded so lovely. People told me about the Ponte Vecchio and how beautiful it is. So I thought to myself, 'At the beginning of next year, you'll go there.' I didn't speak a word of Italian, I didn't know the city, I just packed

my cases and set off. I stayed there for nine months. After three months I noticed that they didn't want me for my acting skills. And then I couldn't stand being in a guest house any longer, but there were no apartments to be had. One day I was standing in my local café, opposite the Palazzo Pitti, with greasy hair and unshaven. A woman comes in and immediately I knew that this was the woman who had an apartment for me. I spoke to her in English, asked about an apartment, and she said that I should come the next day at 12 noon but not to be late. When I sloped along the next day, I suddenly found myself in the part of town with all the old villas; the woman was the Principessa del Mare. For generations they'd always had artists in the house. Before there'd been that woman, Ornella? … Hackl? …

Ornella Muti?

No, unfortunately not, it was the reporter …

Oriana Fallaci?

Exactly. I read her book *Brief an ein nie geborenes Kind* [Letter to a Child that was Never Born] there, in bed. Everything happened in that room, live theatre. Then I ordered canvases; when you stacked them up they reached 1 metre 89 centimetres, my own height, a whole stack of canvases. Each morning and each afternoon I painted a picture, working from an original. In-between times I took photographs and cut up newspapers, so I always had plenty of originals. My paintings were always in the same format, always grey and white. In a way Richter was still a role model for me then. I'd fallen for his trick. When you're young, you're always impressed by gifts that you yourself don't have, you're bluffed by them. The pictures of sheep dogs – there was something appealing about the subject matter, I fell for them too. Added to which he was a good-looking man, well dressed …

And he had style?

I don't know if he does. I think that sort of people fall for themselves. He doesn't mix with other people, he just goes on creating his own world. Numb paintings, sad paintings.

Which isn't necessarily bad.

But to hark back to the Baader-Meinhof deaths, that seems like the ultimate in kitsch to me, I even think it's impudent. To liberally help yourself to what you want from something and then to come out with a statement that the series was never to be sold, to go all political as though he had some real political drive.

So then you turned to Polke instead?

No, I was already friends with Polke, had been since 1973/4. I visited him in Düsseldorf and

then stayed with him in the country. That was a fun time, lots of hippies, music, drugs and Düsseldorf beer. Then he cut himself off and didn't want anything more to do with all of that.

What about when you first started selling works, in the late 1970s and early 1980s, how was that?

At first there weren't any buyers, just gifts. Then in 1978 along came Michel Würthle and bought the sixty florence paintings. Well, he didn't exactly buy them, but I (and a companion) got free food and drink for the rest of my life in the Paris Bar.[3] Then, after Michael, the whole Austrian crew appeared: Oswald Wiener, Rainald Nohal, Ingrid Wiener and Katerina Würthle. So that's how I got to know the way the Austrians talked, their *Schmäh* – loving but deadly – I learnt a lot from them.

What was the first high point in your career?

In 1981, when the money I'd inherited was all gone, on the day when I sold my first big picture, in the exhibition *Lieber Maler, male mir* [Dear Painter, Paint Me] at the Neue Gesellschaft für Bildende Kunst in Berlin.

Your inheritance was all used up after four years. Where did the money go?

Into the *Büro Kippenberger*, then into the discotheque, S.O. 36, and I also had a leather workshop – Kombinat Leder Berlin West – with seven employees, doing Hopi embroidery and buying leather in bulk. But the girls just did yoga instead of working. And the dresses cost 2,800 marks each; no-one wanted them and they didn't even fit. Later on they were sold at a special price of 220 marks, not even the price of the leather, not to mention the production costs. That leather business just gobbled up money.

And who designed the collection? Was it out-and-out style-less?

Absolutely style-less apart from the Hopi embroidery.

1992, at Documenta 9, what was that all about? You didn't show anything but you were in the catalogue, and one of the official postcards showed a lamp of yours in front of the Fridericianum, the main Documenta building ...

I was in the Documenta office with my students from Kassel. I told them we'd do an interview with Jan Hoet without him realising. We'd get him to talk about Documenta. So he's busily talking away and we ask him some funny questions. Then I published the interview in Issue 4 of the *Das Zentralorgan der Lord Jim Loge,* Jörg Schlick's journal. So Hoet took revenge by putting me on the official list of participants, without asking me first. I was on the invitation card, in the catalogue, everywhere. So I made the poster and the

postcard with the lamp, which I'd placed on the Walter de Maria,[4] a kind of an extension. Then I photographed the lamp and took it away again. After all I hadn't actually been invited to participate.

When it came to Documenta 8 Schneckenburger invited me two or three months before the opening. I'd been at the same table as him on various occasions in the past but he'd never spoken to me. Now because other people whispered to him 'Do Kippenberger', he sent me an invitation. But I replied that since he didn't normally send me birthday cards or Christmas cards, we shouldn't go down that path. So he wrote back saying that I was in good company, along with Sigmar Polke and the others who'd also declined the invitation. Later on I printed his letter as a poster.

You once said that for a long time you wanted to edify.

Yes, but not any more. Perhaps it's automatically like that in art, that you – as an artist – shaped by your profession, because that's all you do and live from, have a hankering for edification or moral issues. That fades away again at some point, maybe because of the 'always-doing-the-same' thing, known as style, so that you can bore people. People want to be bored, they want to see the same picture again and again, never anything different, that very picture that's been published most. And at some point, looking at the people around you, you notice how they go about things, how they always fall for the same mechanisms.

In a conversation with Jutta Koether[5] you once said that you see yourself as a shepherd.

Yes, but that's a very wide-ranging occupation. If, for instance, someone does something better than I do it, or someone has already done something, which is part of my own labyrinth, then I don't have to do it any more. If it's a good solution, then that's enough for me, and if I've got the money I buy it, and show it along with my own pictures.

Preaching died out because it's absolutely senseless and boring, just like living in a city also becomes boring at some point. You've done it. You keep on going to the same pub, you're bored out of your mind time after time, you might just as well be living in the country. The occasional visit to the city, meeting close acquaintances, but beyond that you've not got a clue, no influence at all on the way that people react to your work, how they understand it. You can only work in a way that is morally right for you. Of course you add little jokes, which may bewilder people at first, but the piece is about self-recognition for them, not for me. You can't stand yourself next to every picture you paint and explain things. Pictures have to talk for themselves. Mostly the pictures you first set store by are not the interesting pictures. It's the imperfect pictures that go on creating some sort of tension. Of course it's nice to paint perfect pictures, it makes for a pleasant visit to a museum. And you can say Lüpertz is good, a good painter, but afterwards, what are you left with? So the only language I still preach about has a certain intensity to it.

For the installation The Happy End of Franz Kafka's 'Amerika'[6] *you recreated a series of job interview situations. How did you decide which furniture to choose for the installation?*

That's all about stylistics. Different styles have their own eroticism or asexuality, which you have to deal with. This is partly so in the case of found tables, and partly so in the case of tables you've created yourself. For instance, I had someone make the table at which Musil wrote the *Mann ohne Eigenschaften*, an endless narrative. Just like the *floss der 'Medusa'* cycle, *The Happy End of Franz Kafka's 'Amerika'* also implies movement, transferring from one thing to another, a transition. In *The Happy End of Franz Kafka's 'Amerika'* the movement is between different decades; everyone surely remembers a chair that stands for whatever, it instantly takes you right back to that time, like a visual lexicon that always tags along with you. So, when people see the tables and the eight books that came out in 1994 for the Rotterdam exhibition, they can make up their own conversations, job interviews. Suddenly you think differently and you can tell yourself a story. Like the *Psychobuildings* I saw in the street and photographed that were suddenly so appealing. You develop a gaze so that you can discover it for yourself.

That's got something to do with memory …

… and friends. You suddenly become friends with something you've never seen before. You don't have to go into a museum, it's out there in the street. All these things make you want to piece together your own world, but one that's fun. I'm in favour of good-mood worlds. Because I'm on the good-mood side, although that's not to say that tragic things aren't constantly happening to me.

How do you choose the themes of your works? How do you come up with the idea of painting cycles of pictures like the floss der 'Medusa', Jacqueline Picasso[7] *and the* Eierbilder[8] *you've just finished?*

In painting you have to be on the lookout: what windfall is still left for you to paint. Justice hasn't been done to the egg, justice hasn't been done to the fried egg, Warhol's already had the banana. So you take a form, it's always about sharp edges, a square, this and this format, the golden section. An egg is white and flat, how can that turn into a coloured picture? If you turn it around this way and that, you'll come up with something. Maybe even social politics, or jokes; whatever the case it's a beautiful form, just like a women's breasts have a beautiful form. Or like spaghetti, it never becomes boring always eating the same thing. The same thing is always on the menu, and then suddenly you get another version, a surprise item, and it doesn't taste the same. Like the lamps, you start seeing different lamps everywhere. Hence the question whether people are choosing them to throw light on things or because of their decorative form, and what they're thinking about as they do so, or what mistakes they're making. Or the boxes. In their case the form, a classical form, is again always prescribed. So it's about coming at them from a different side, that doesn't have this bad art-character, abstract, absolute, unapproachable. That you suddenly have to grin when you see a fridge. That you can find a way like that, that you take the ideas back to where they come from, by a roundabout route. That's also why I construct copies of some of the things I find in the street.

And why a portrait series of Jacqueline Picasso?

That's to do with painting itself, 'Things a painter can no longer paint.' Picasso died, she was sad. So I'm taking over his job. Working from the last photographs of Jacqueline Picasso – black and white, blurred – I'm trying to turn them into colour pictures and to paint Picassos. Completing his work, in a sense. After all she was one of his main subjects. He even claimed to have painted her by heart, which I of course *don't* believe.

And what's next for you, after the floss der 'Medusa', Jacqueline Picasso *and the* Eierbilder?

Photocollages on my four themes: the streets that I'm always photographing, *Psychobuildings*, lamps, and steps leading down into subways. The photographs are one-offs, I throw away the negatives.

Do you actually see yourself as a loner?

By now, yes.

Which artists do you feel close to?

Whenever I see good-looking artists, I feel drawn to them because I have the feeling the head perfectly matches the work. But of course that can also be boring. Giacometti was very good looking, his sculptures were very good looking, but I still feel there's something missing. As far as Léger goes, I like him, absolutely. And Zobernig, I like him a lot. Everyone feels drawn to the remarkable things in life.

Does friendship mean a lot to you?

I'll happily do without a friendship if I can have a close acquaintance instead. The word 'friendship' is so loaded with 'If ever I'm in a bad way, you'll help me.' If ever I'm in a bad way I'd prefer that no-one at all comes to help me. I've chosen just two people, both with the same first name, easy for me to remember: Michel and Michael. Michel Würthle: '*Wer nichts wird, wird Wirt* – He who becomes nothing, becomes a pub landlord'. Michael Krebber: He's become something, but he doesn't earn any money from it. These constant small injustices.

 Being able to obscure things, trivialising, exaggerating, these are all ruses for keeping humanity alive, as an individual and in confrontation with others. Anything you can do with language works just as well with pictures. Concealing, revealing, glossing over, leading people astray. You have to find a way through the game. Whenever I'm working on a picture I tell different people about the pictures and sculptures I'm making and take note of their reactions. Then I can see the mistakes they're making. They want to have such and such, misunderstand such and such, so then you can lay it on even thicker to compound some really lovely misunderstanding.

You go to Venice, where every stone has been endlessly photographed, every corner. So I told the others we'd use the most famous thing of all, St Mark's Square with the pigeons and the gondolas. Afterwards, the drawings I made of the stupidest things suddenly turned into something quite individual. It's such a comic process. Always get to the heart of the matter, to things that are so close that you wouldn't think of them. Like an egg, or that sort of thing, and mess about with that. That you can live from the simplest things. You don't have to painstakingly pull things apart, discover something somewhere or other. Some things are never used up because there's still so much in them.

In Geneva, at your Respektive, *there'll be a review of twenty years of your work. How do you feel about that?*

It's loathsome. It bores me. I just think I've had the recognition I need from a few people that I've understood.

No sentimental feelings at seeing old works again?

When I'm producing things I'm extremely sentimental. And if it works, I become positively slushy. In the past I used to hang all my pictures, putting even the best up for sale. But I never tell people which is my favourite picture and just wait until the exhibition is over. Then I put it into storage, and it's not for sale any more. Roughly two pictures per exhibition.

The lamps in this restaurant are extraordinary. Spotlights …

… discreetly shining to one side.

They've got the mix just right.[9]

Translated from the German by Fiona Elliott

1 Originally published in French and German in *Kippenberger sans peine avec des clichés de reconnaissance/Kippenberger leichtgemacht mit Erkennungsphotos*, on the occasion of the exhibition *Martin Kippenberger, Respektive 1997–1976*, Musée d'art moderne et contemporain (MAMCO) Geneva 1997, Cologne 1997.
2 *I.N.P. – Ist nicht peinlich* [Is Not Embarrassing], Galerie Max Hetzler, Cologne, 1984.

3 Restaurant owned by Michel Würthle in Berlin.
4 Reference to Walter de Maria's *Vertical Earth Kilometer*, a metal rod (5.08 cm in diameter, one mile long) which was sunk vertically into the ground outside the Museum Fridericianum in Kassel for *Documenta 6* (1977).
5 Cf. infra p. 46.
6 Museum Boymans-Van Beuningen, Rotterdam, 1994.

7 *Vis-a-View*, Galerie Samia Saouma, Paris, 1996.
8 Städtisches Museum Abteiberg, Monchengladbach, 1997.
9 This conversation took place on 16 July 1996 in the Club an der Grenze, Windisch-Minihof (Austria), and on 18 July 1996 in the Restaurant Burgenland, Vienna.

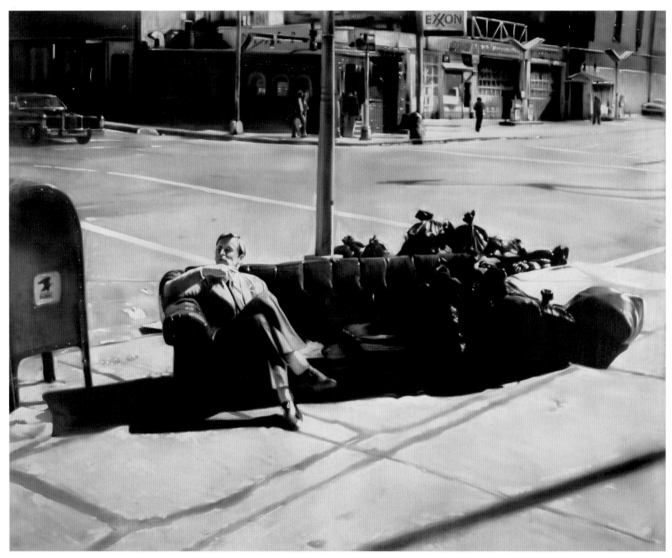

1 Untitled (from the series *Lieber Maler, male mir* / Dear Painter, Paint for Me) 1981

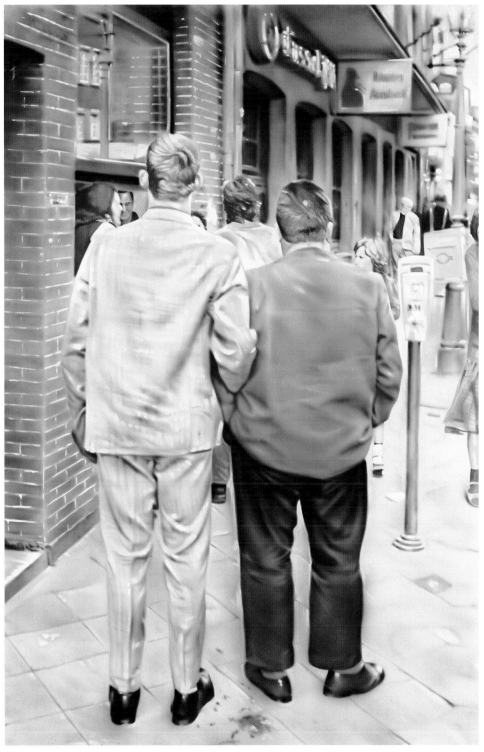

2 Untitled (from the series *Lieber Maler, male mir* / Dear Painter, Paint for Me) 1981

3 Untitled (from the series *Lieber Maler, male mir* / Dear Painter, Paint for Me) 1981

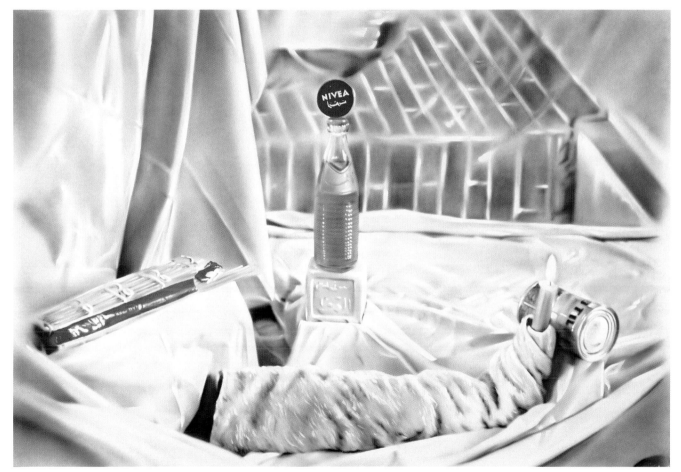

4 Untitled (from the series *Lieber Maler, male mir* / Dear Painter, Paint for Me) 1981

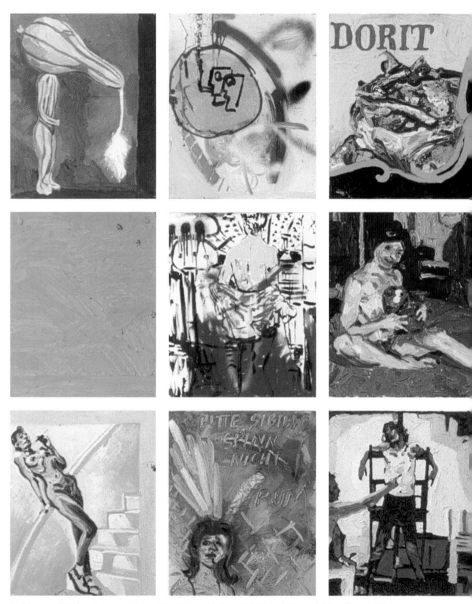

5 *Blass vor Neid steht er vor deiner Tür* / Pale with Envy, He Stands Outside Your Door 1981

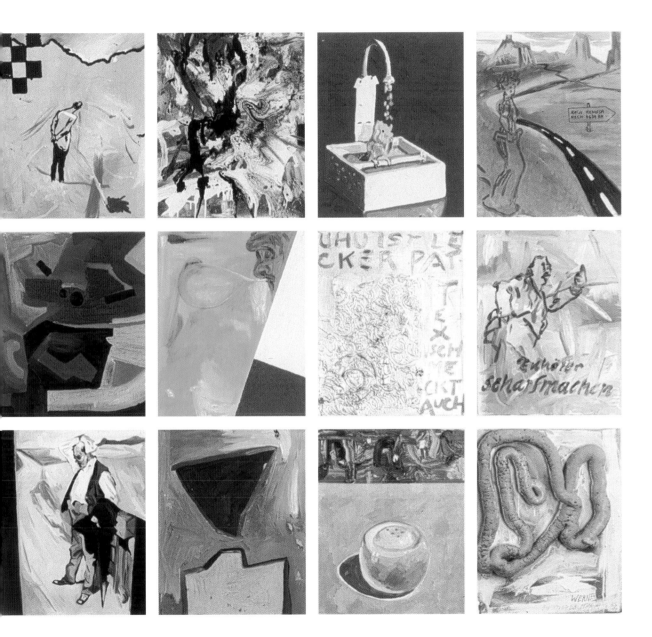

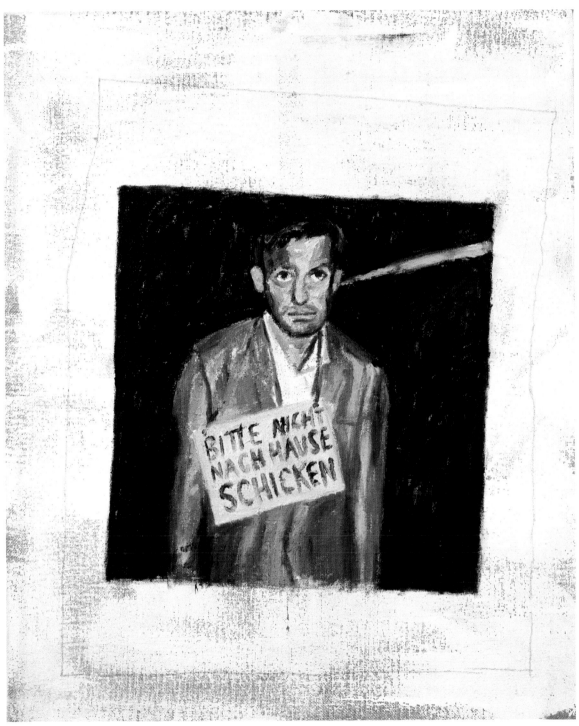

6 *Bitte nicht nach Hause schicken* / Please Don't Send Home 1983

7 *Nicht zu Hause schlafen müssen* / Not to Have to Sleep at Home 1984

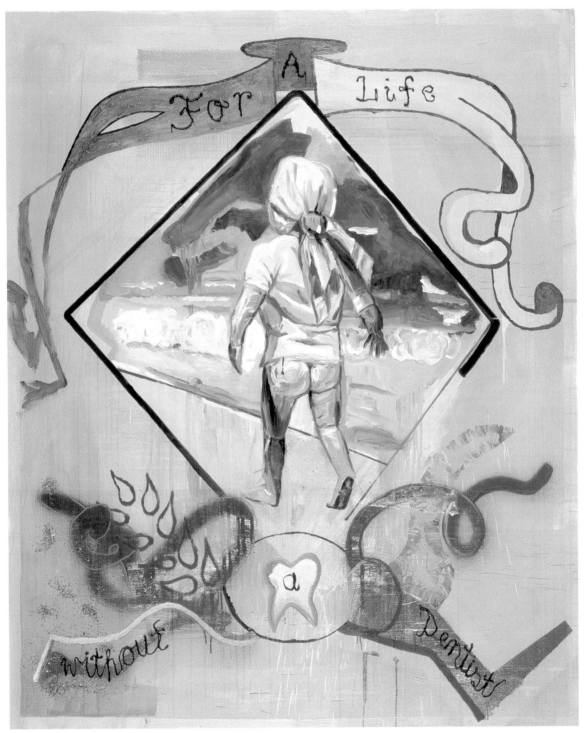

8 *For a Life Without a Dentist* 1984

9 *Kulturbäuerin bei der Reparatur ihres Traktors* / Cultural Revolutionary Peasant Woman Repairing her Tractor 1985

10 *Sympathische Kommunistin* / Likeable Communist Woman 1983

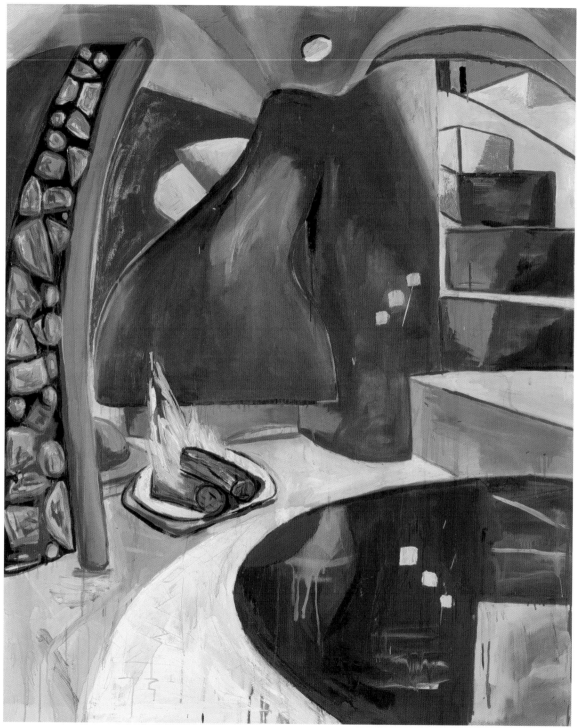

11 *Muttergedächtnisstube* / Shrine-to-Mother Room 1985

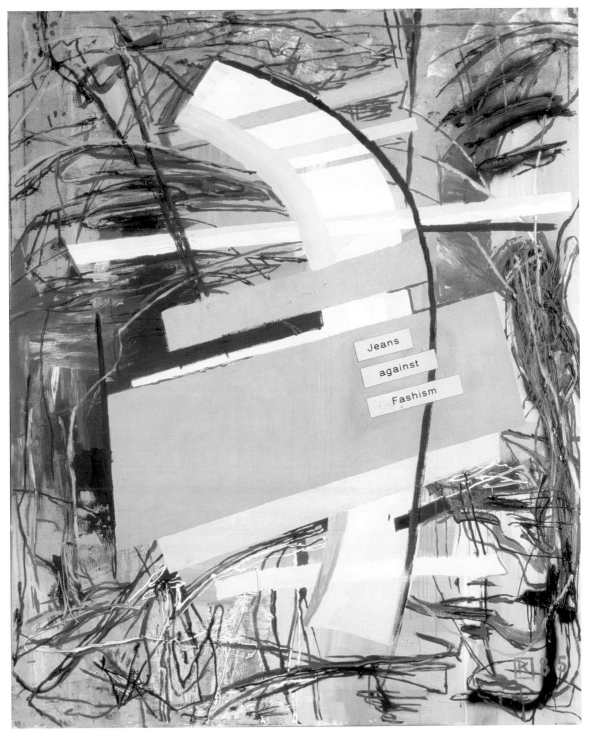

12 *J.A.F* 1985

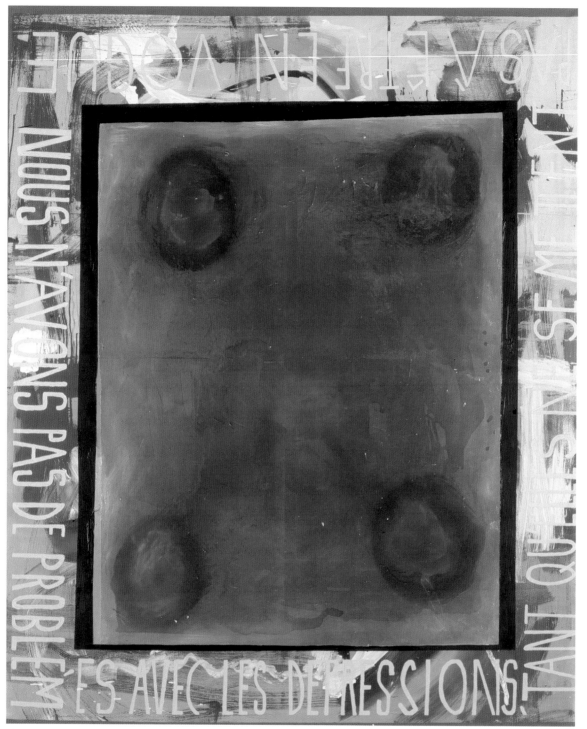

13 *Nous n'avons pas de problèmes avec les dépressions, tant qu'elles ne se mettent pas à être en vogue /*
We don't have problems with depressions, as long as they don't come into fashion 1986

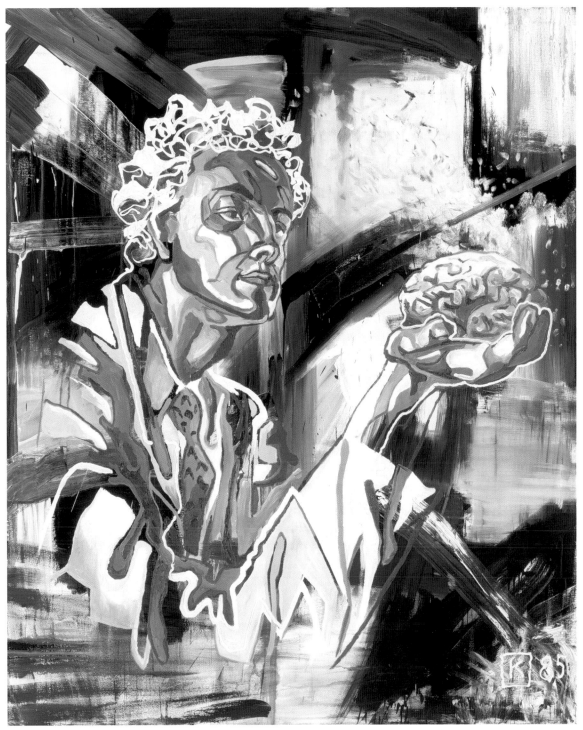

14 *Junger, progressiver Arzt bei der Betrachtung von Unrat* / Young Progressive Doctor Contemplating Yuk 1985

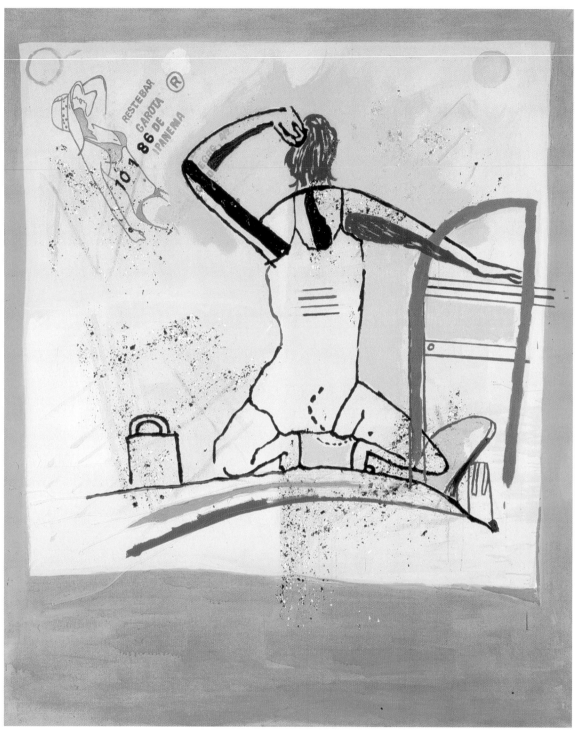

15 *Garota de Ipanema III* / Harlot from Ipanema III 1986

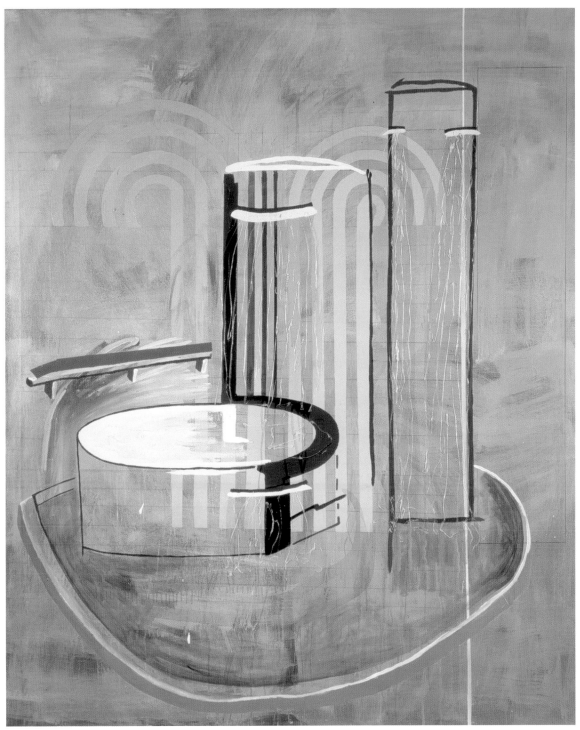

16 *Nachträglicher Entwurf zum Mahnmal gegen die falsche Sparsamkeit /*
Supplementary Proposal for a Monument Against False Economies 1986

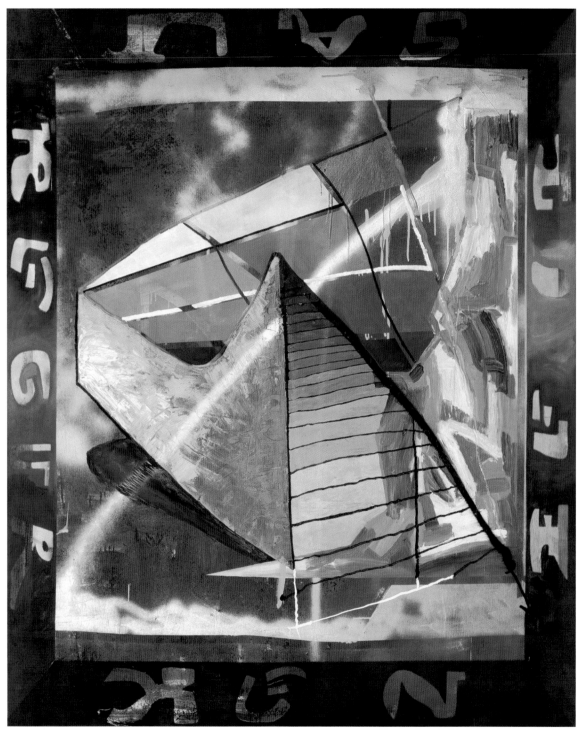

17 *Kostengebirge (Saure Gurken Zeit)* / Cost Peaks (The Silly Season) 1985

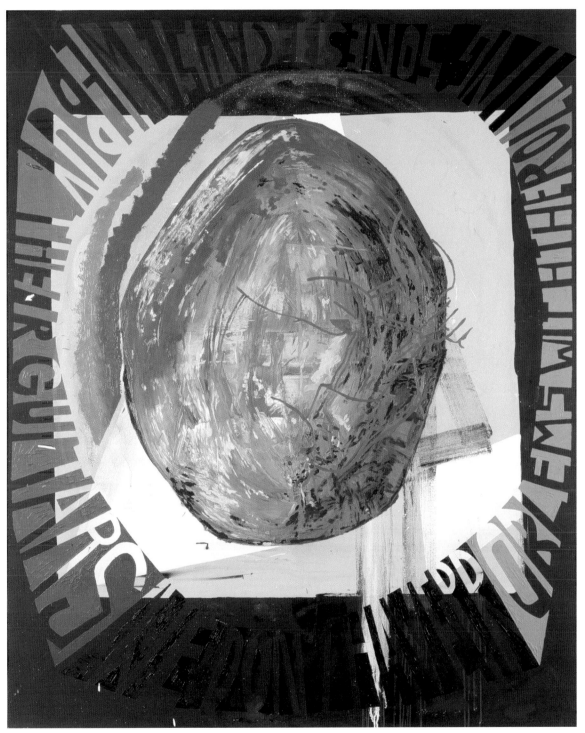

18 *We don't have problems with the Rolling Stones, because we buy their guitars* 1986

19 *2. Preis* / 2nd Prize 1987

20 *7. Preis* / 7th Prize 1987

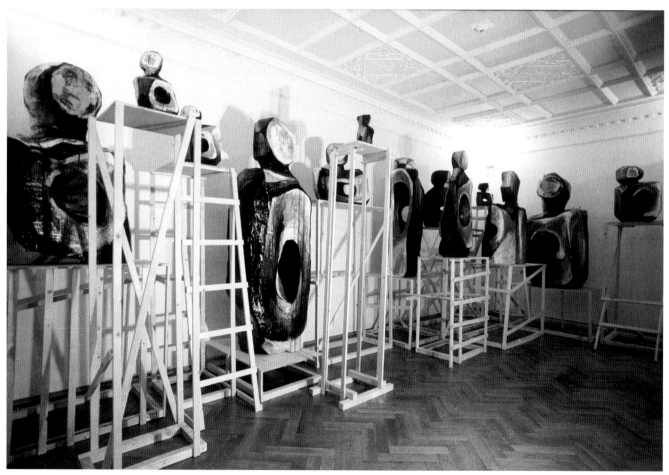

21 *Familie Hunger* / Hunger Family 1985

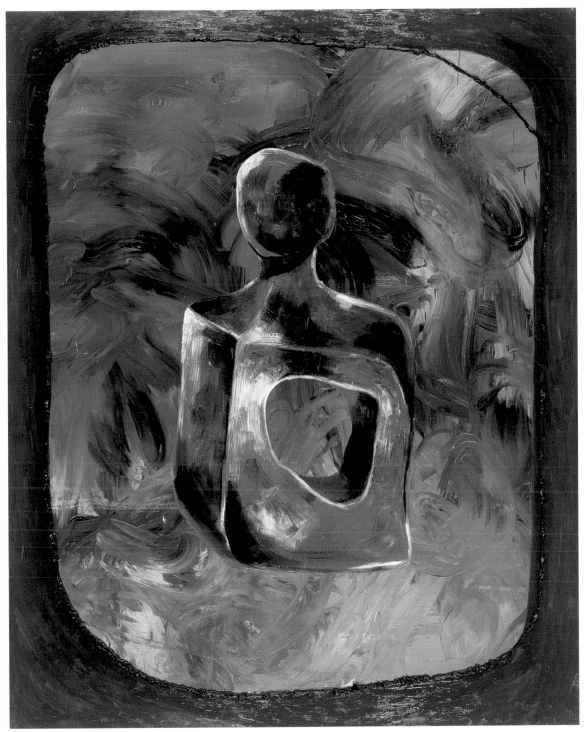

22 *Big Until Great Hunger* 1984

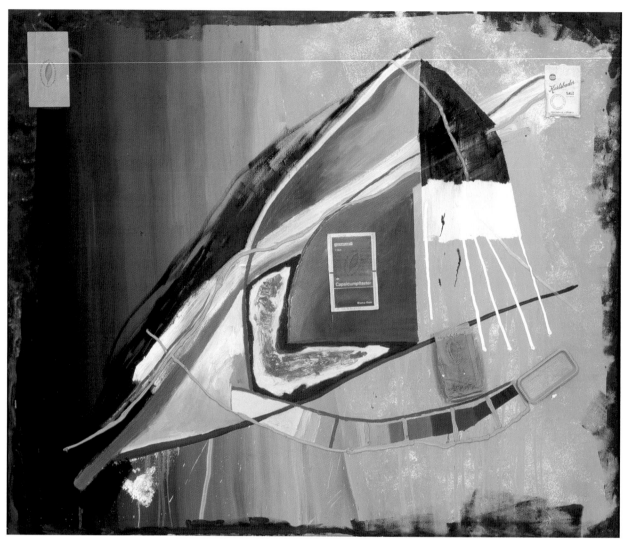

23 *Ertragsgebirge mit Wirtschaftswerten von Joseph Beuys I* / Profit Peaks with Economic Values by Joseph Beuys I 1985

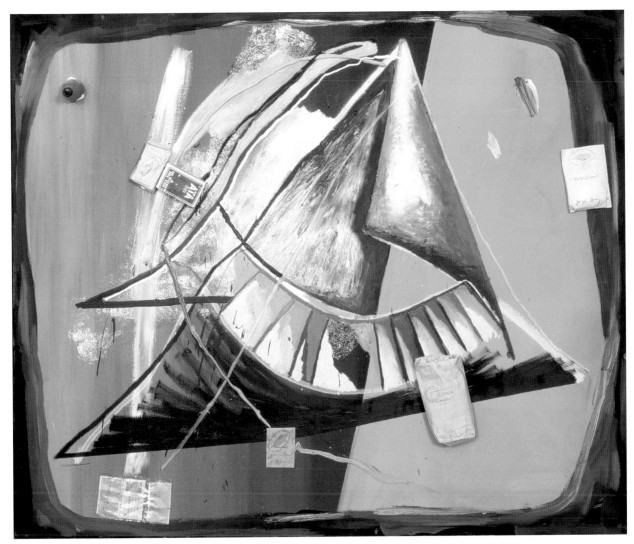

24 *Ertragsgebirge mit Wirtschaftswerten von Joseph Beuys II* / Profit Peaks with Economic Values by Joseph Beuys II 1985

25 *Die Mutter von Joseph Beuys* / Mother of Joseph Beuys 1984

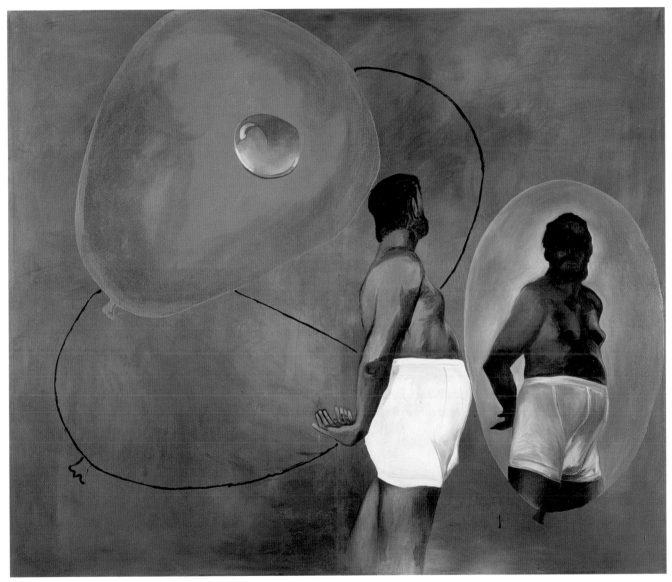

26 *Untitled* 1988

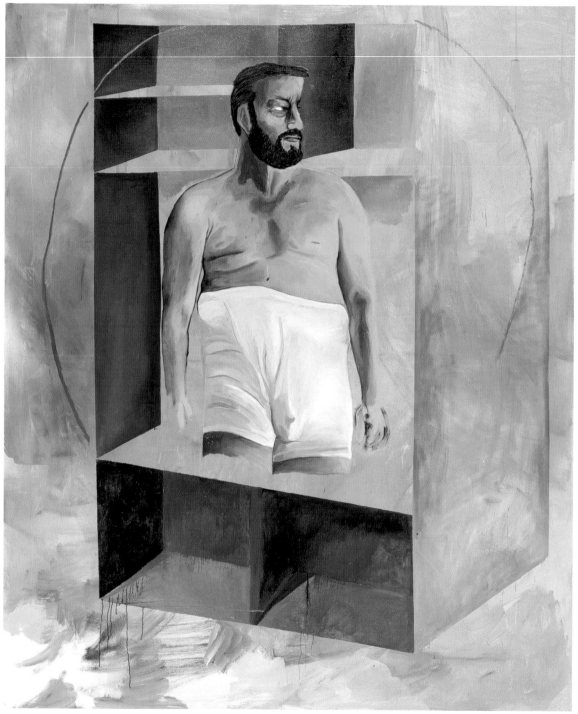

27 *Untitled* 1988

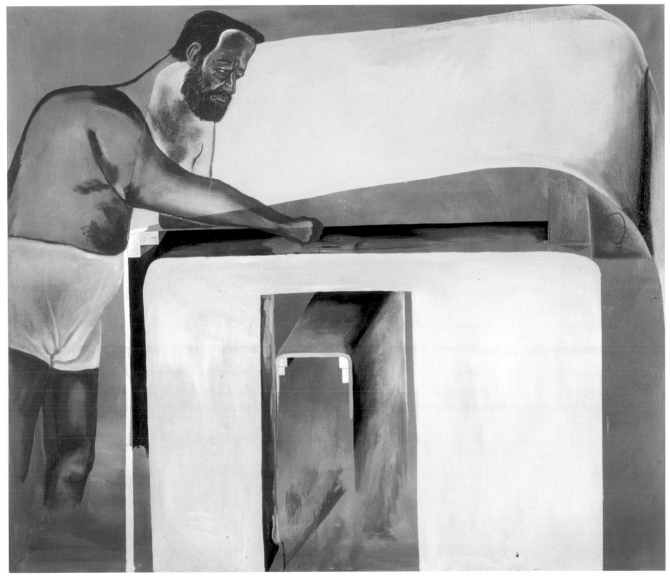

28 *Untitled* 1988

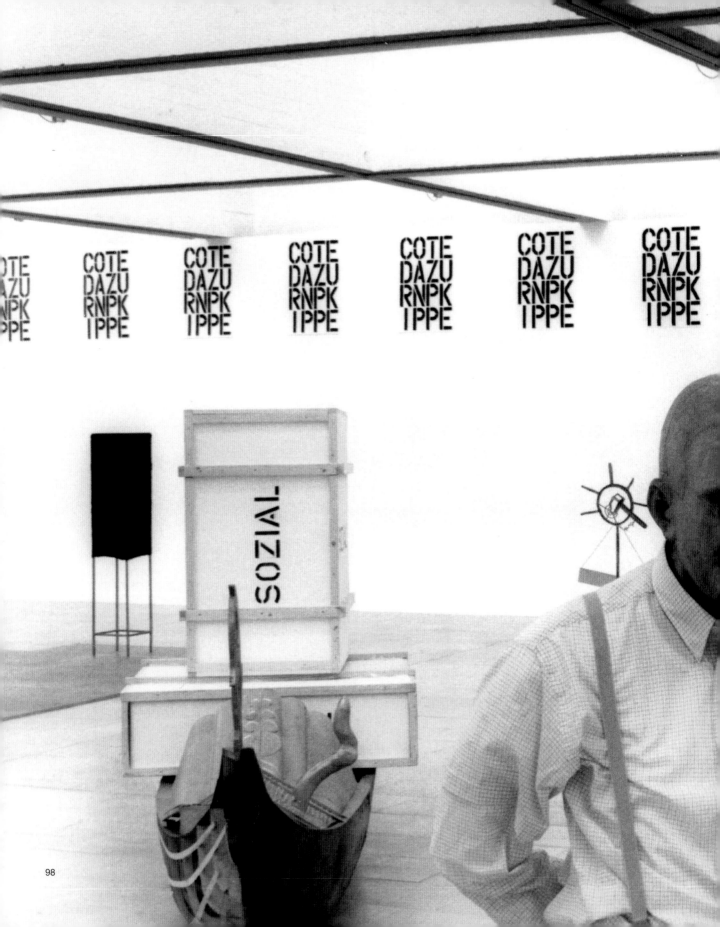

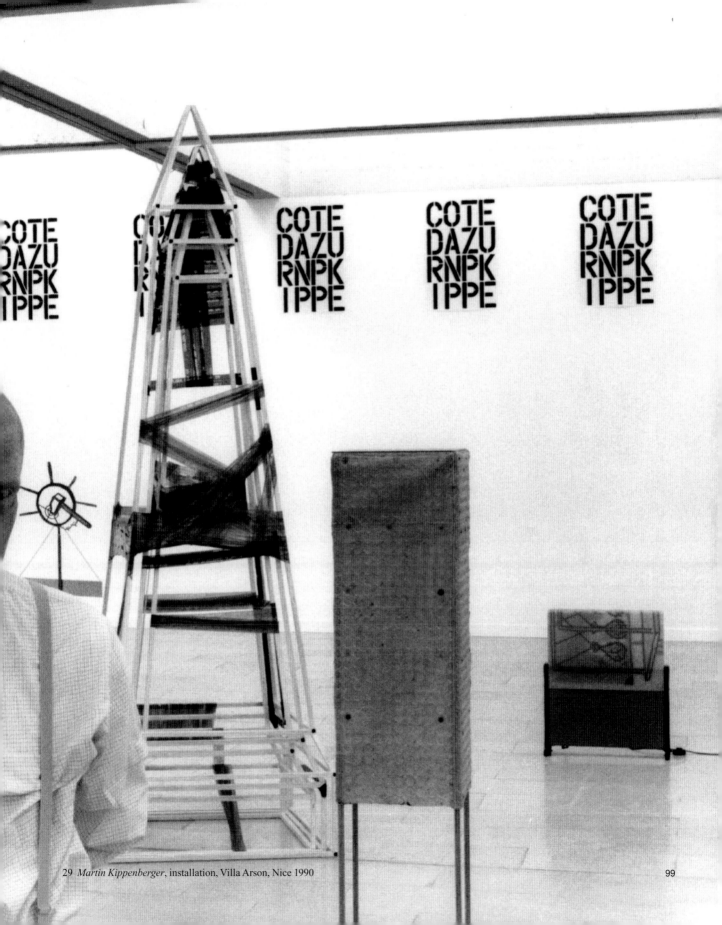

29 *Martin Kippenberger*, installation, Villa Arson, Nice 1990

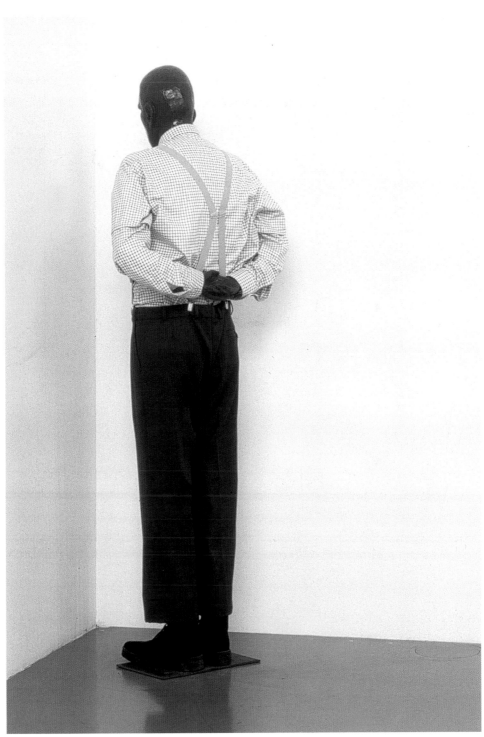

30 *Martin, ab in die Ecke und schäm Dich* / Martin, Into the Corner, You Should be Ashamed of Yourself 1989

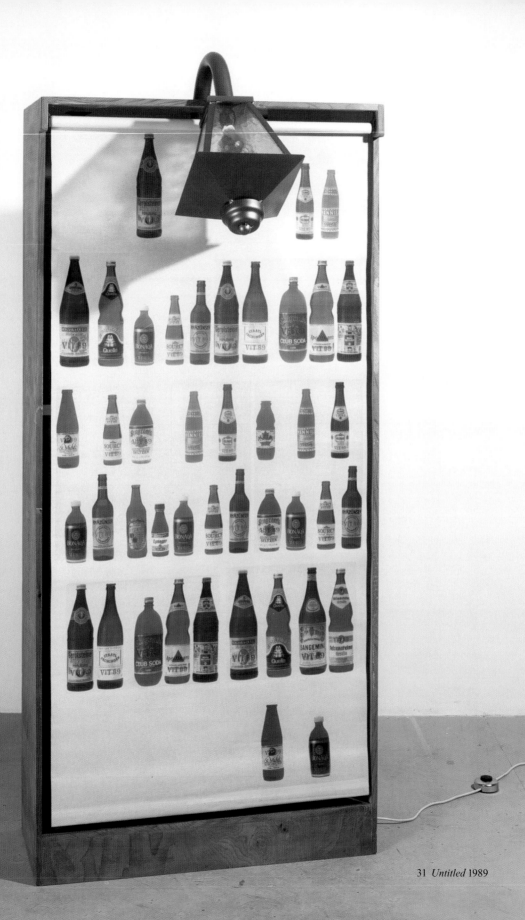

31 *Untitled* 1989

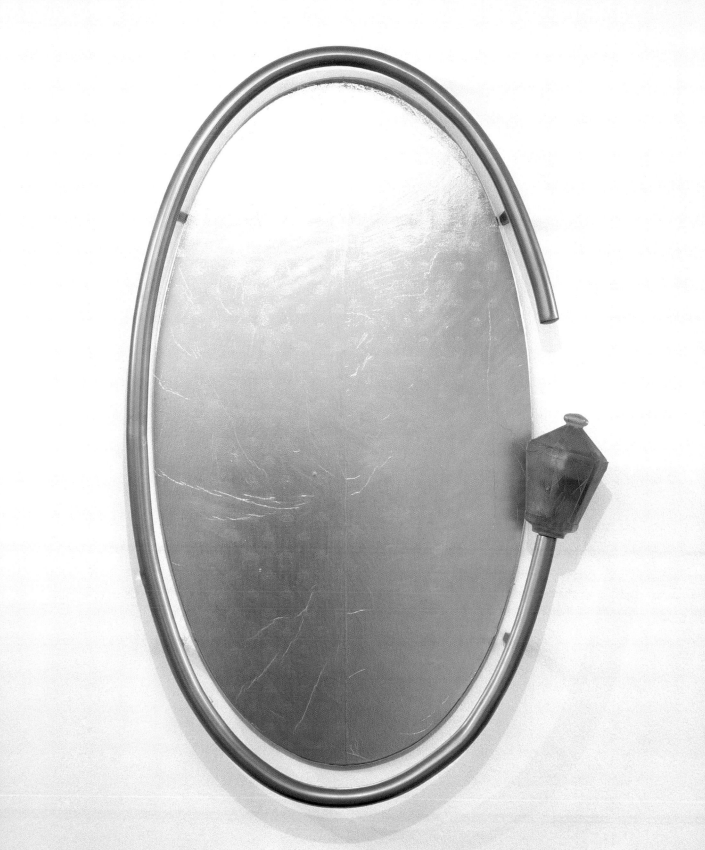

32 *Mirror for Hang-Over Bud* 1990

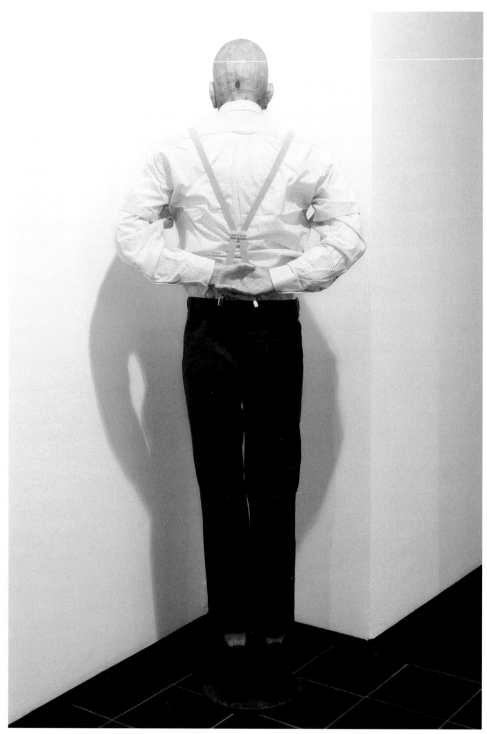

33 *Martin, ab in die Ecke und schäm Dich* / Martin, Into the Corner, You Should be Ashamed of Yourself 1989

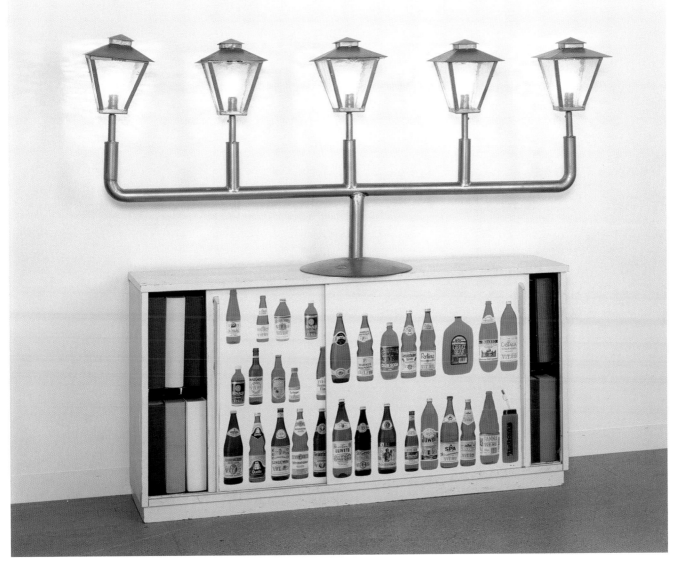

34 *Untitled* 1989

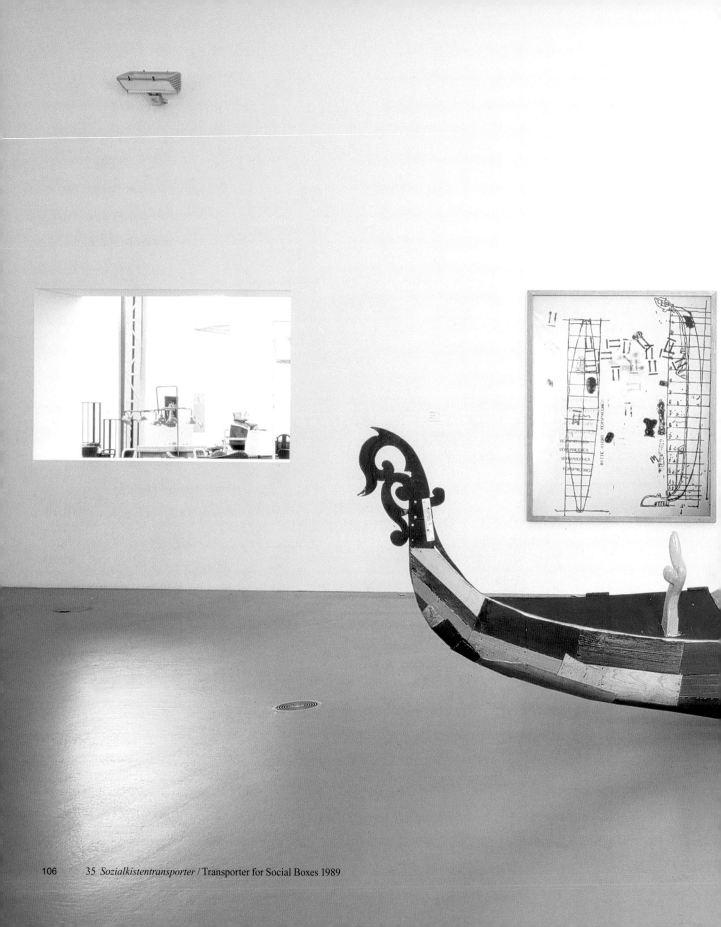

35 *Sozialkistentransporter* / Transporter for Social Boxes 1989

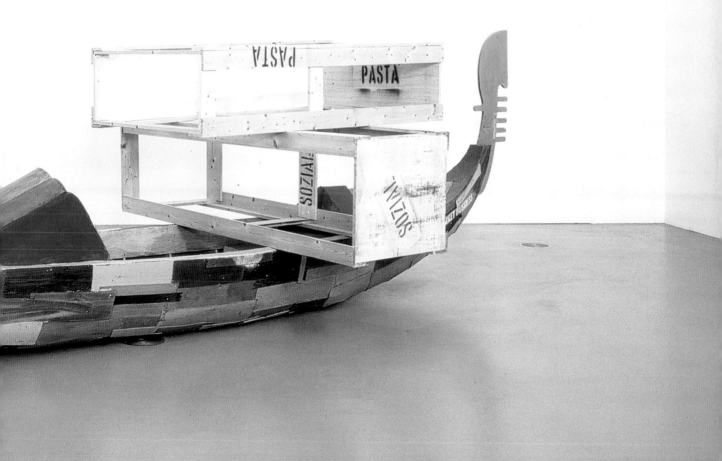

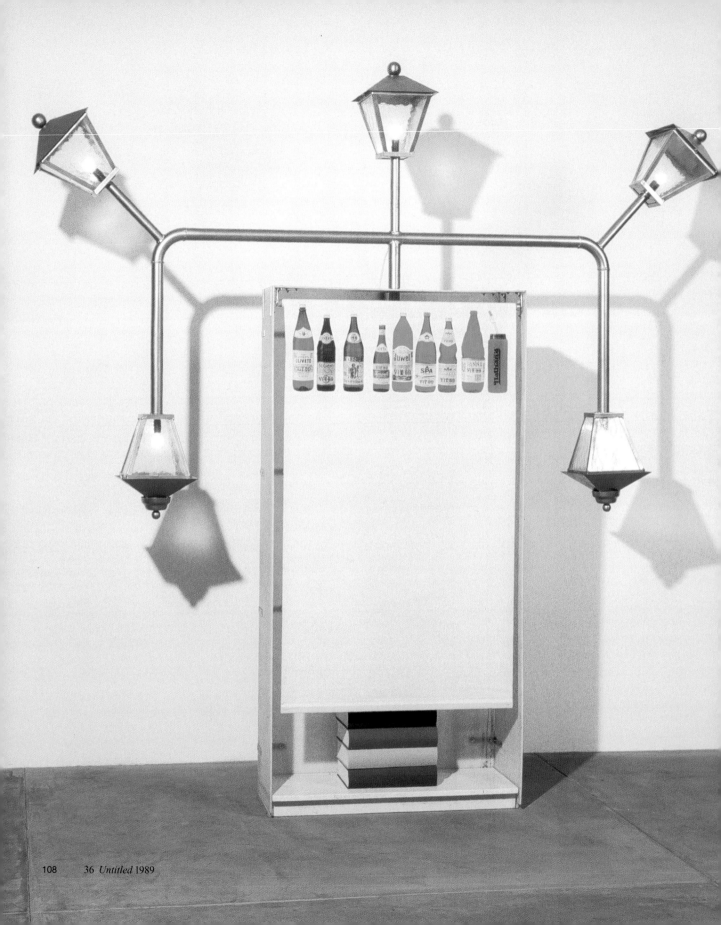

37 *Martin, ab in die Ecke und schäm Dich* / Martin, Into the Corner, You Should be Ashamed of Yourself 1989

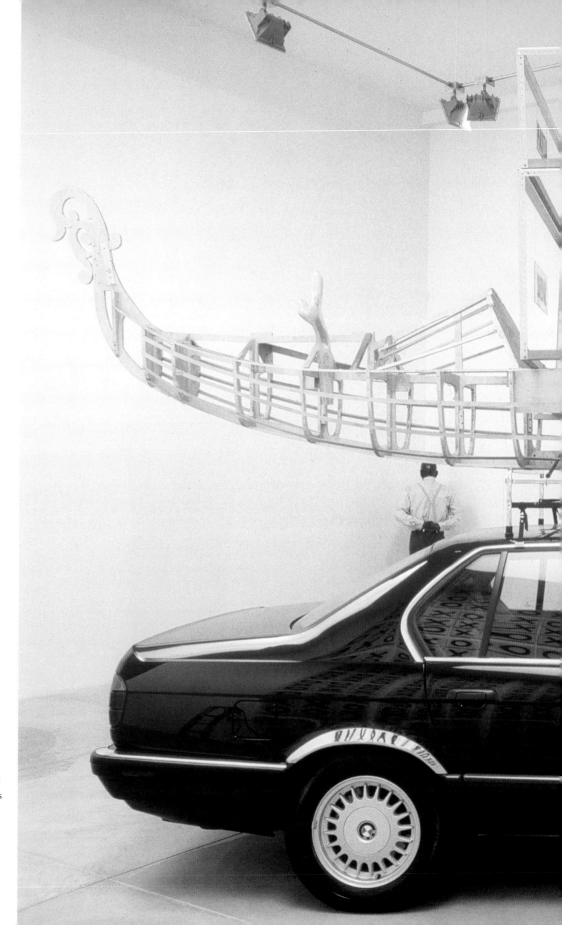

38 *Sozialkistentransporter* /
Transporter for Social Boxes
1989

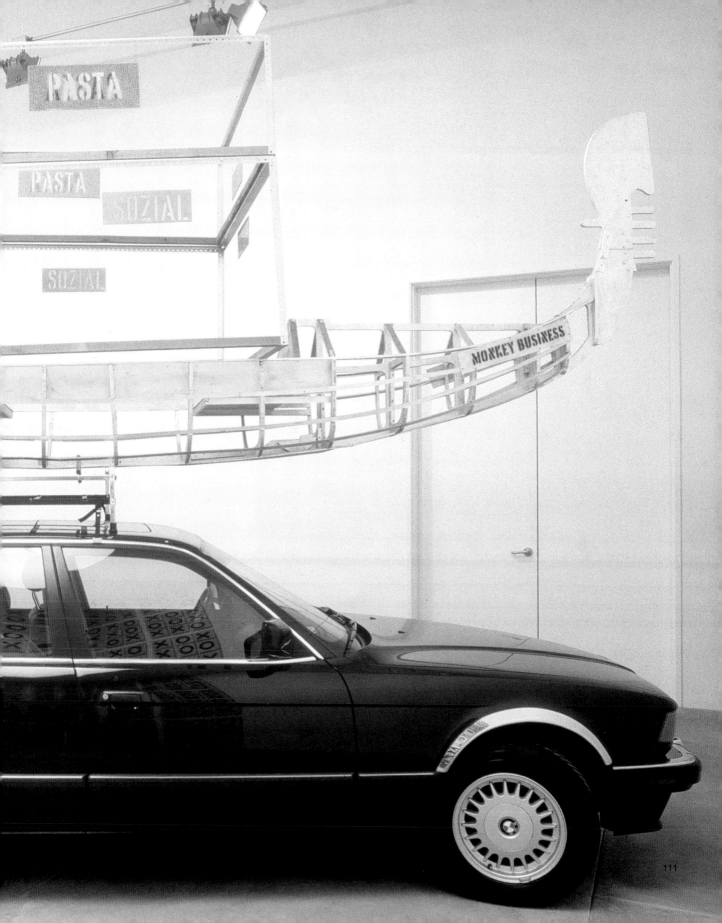

111

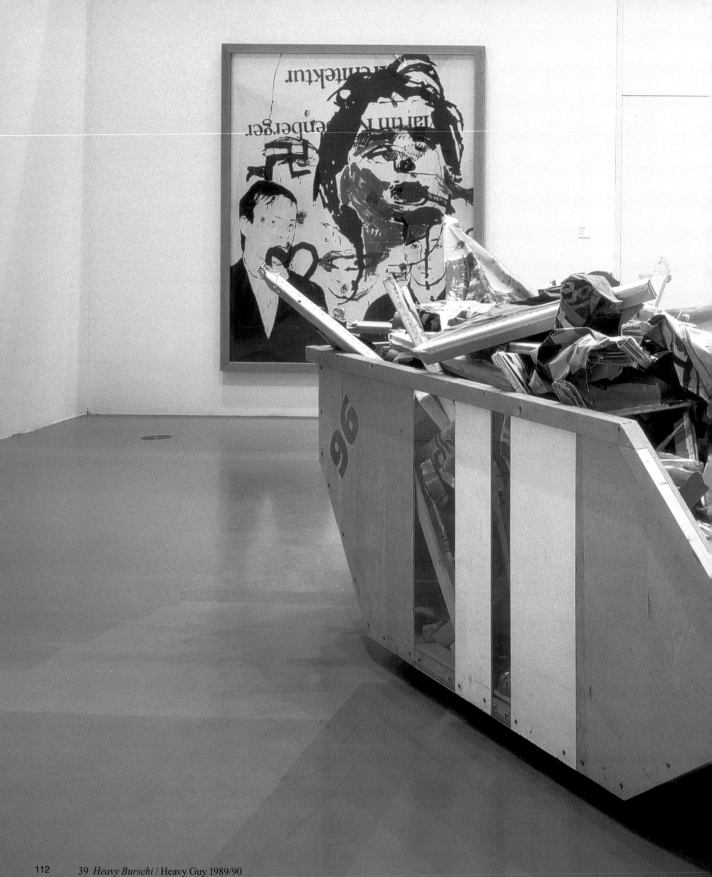

112 39 *Heavy Burschi* / Heavy Guy 1989/90

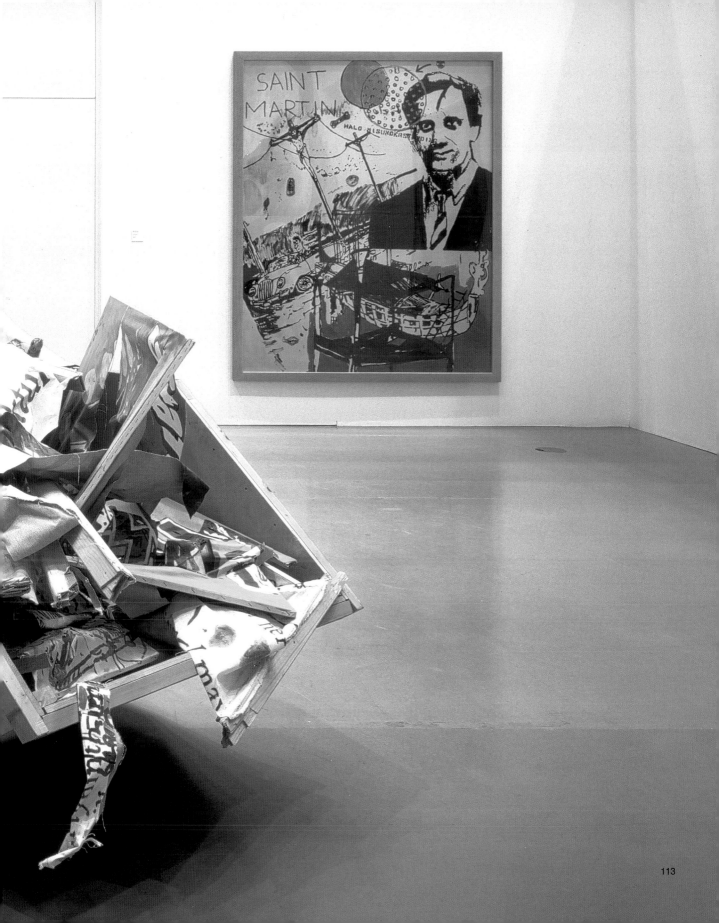

40 *Untitled* 1989/90 (from the series Heavy Burschi / Havy Guy)

41 *Untitled* 1989/90 (from the series Heavy Burschi / Havy Guy)

42 *Untitled* 1989/90 (from the series Heavy Burschi / Havy Guy)

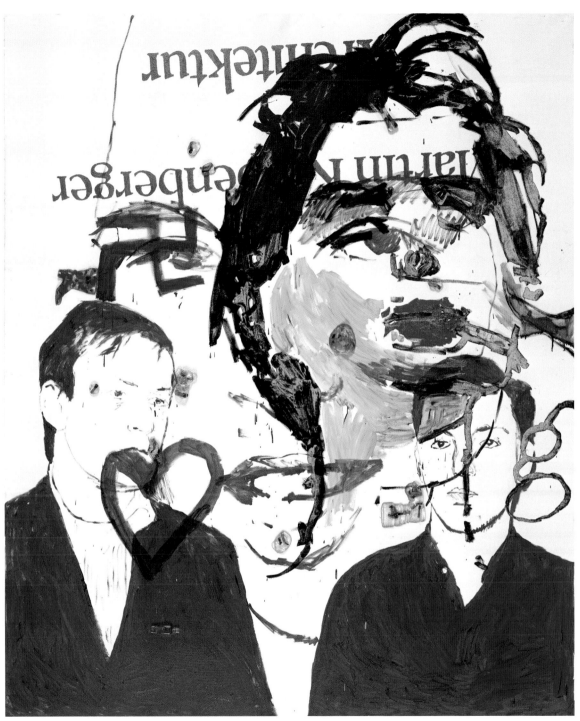

43 *Untitled* 1989/90 (from the series *Heavy Burschi* / Heavy Guy)

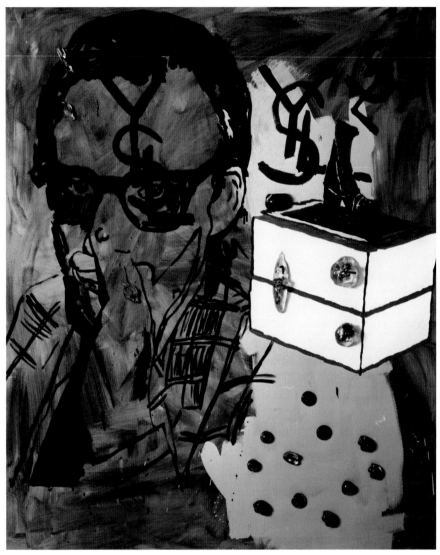

44 *Untitled* 1989/90 (from the series *Heavy Burschi* / Heavy Guy)

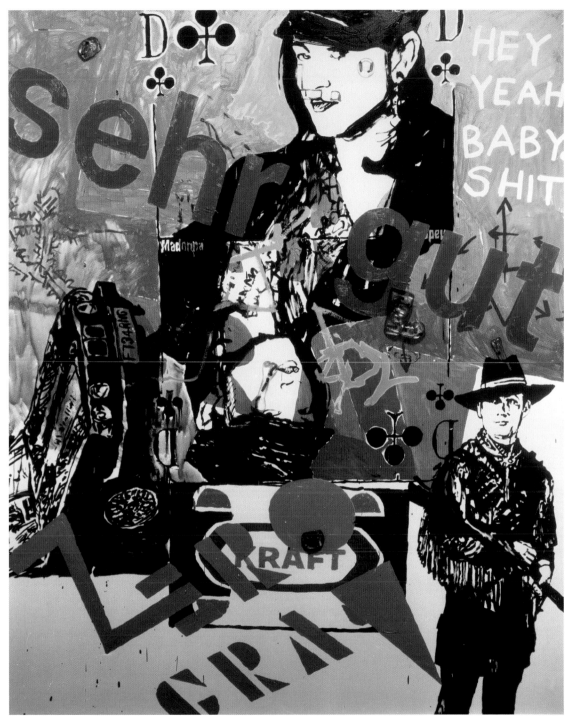

45 *Untitled* 1989/90 (from the series *Heavy Burschi* / Heavy Guy)

46 *Peter* 1990

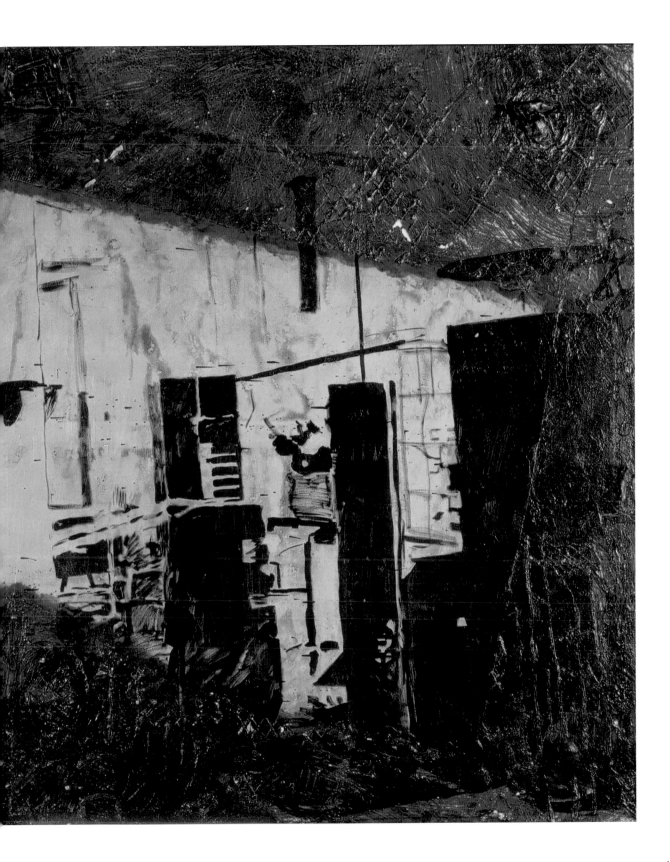

47 Installation of *Weisse Bilder* / White Paintings 1991

A house on leaders — very good
A pesh in glass — very good
The pevil and the angel — very good
Old lumber — very good
A house on the
fireplad — very good
Sailboats and people
in the water — very good
Martin Kippenberger
in front of an Absorbs
city — very good
An egg of old times — very good
A negro and a casetten-
payer — very good
A nice house at the
sea — very good
An old car with
some leaves — very good
A movieposter showing
a lion — very good
A shadore that grabs for
a goldnazget — very good
A golden sandglass — very good
The devil forgott his
spchr — very good

48 Original handwritten text by a 9-year-old boy describing
Kippenberger's paintings in one short sentence. These descriptions
were transferred in white paint to a white canvas to form the
White Paintings. [Not exhibited]

A house on leaders — very good
A nest in glass very good.
The pevil and the angel very good
Old lumber very good
A house on the
Fireplat very good
Sailboats and people
in the water very good
Martin Kippenberger
in front of his house
city
... very good
A ...
...
A red house on the
sea very good
An old car with
some leaves very good
A movieposter showing
a lion very good
A shadow that grabs for
a goldnugget very good
A golden sandglass very good
The devil forgot his
— socks very good

49 *Weisses Bild* / White Painting 1991

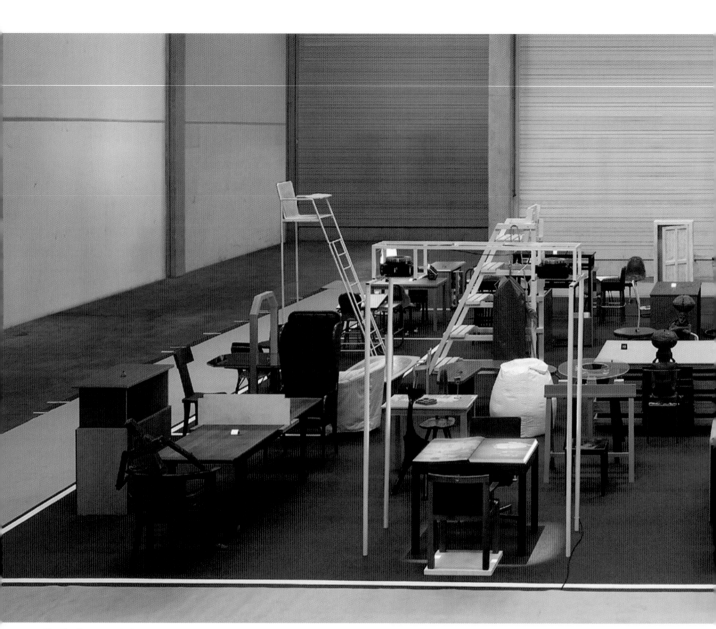

50 *The Happy End of Franz Kafka's 'Amerika'* 1994

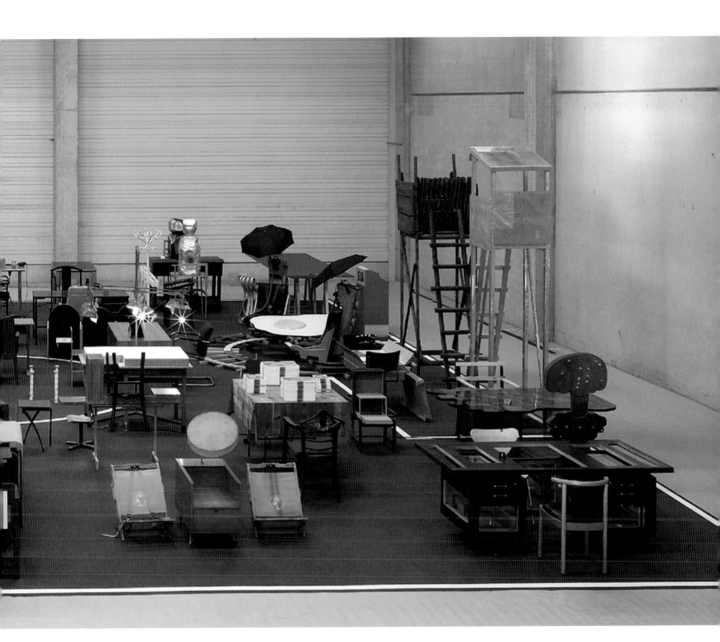

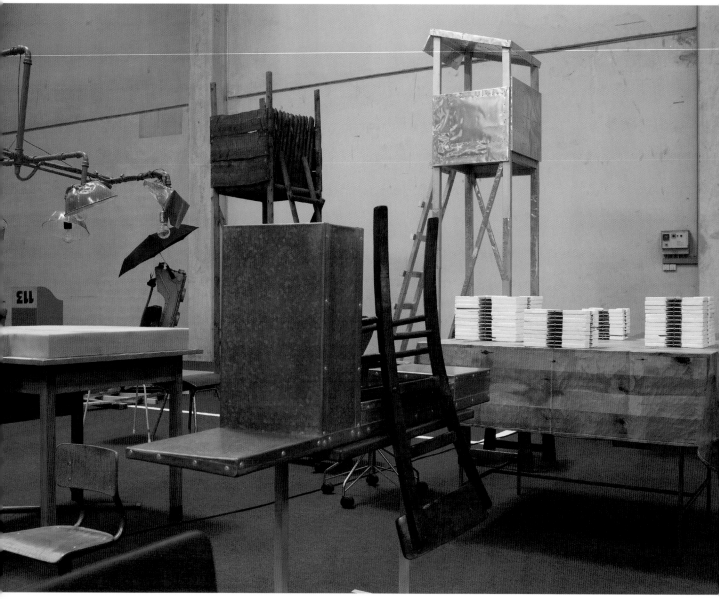

51 *The Happy End of Franz Kafka's 'Amerika'* 1994 (detail)

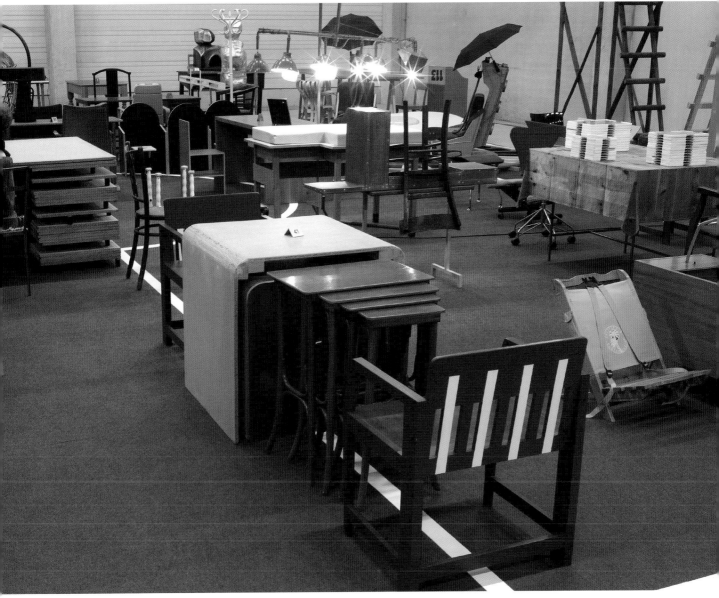

52 *The Happy End of Franz Kafka's 'Amerika'* 1994 (detail)

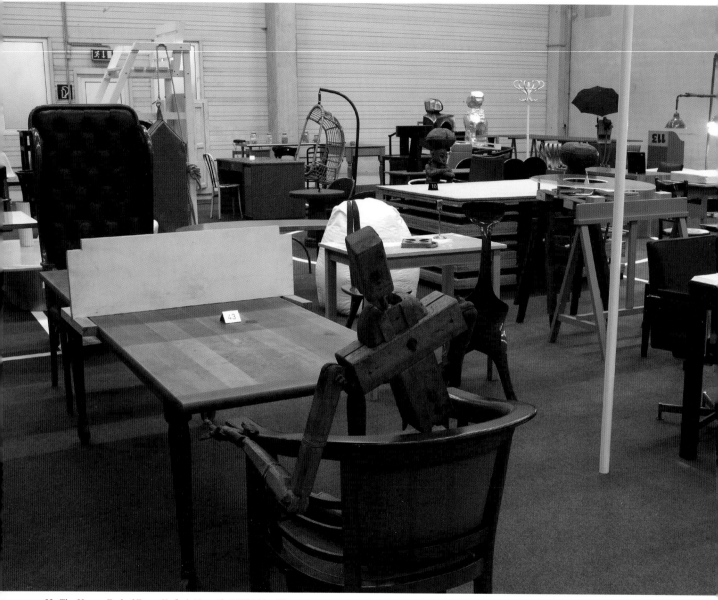

53 *The Happy End of Franz Kafka's 'Amerika'* 1994 (detail)

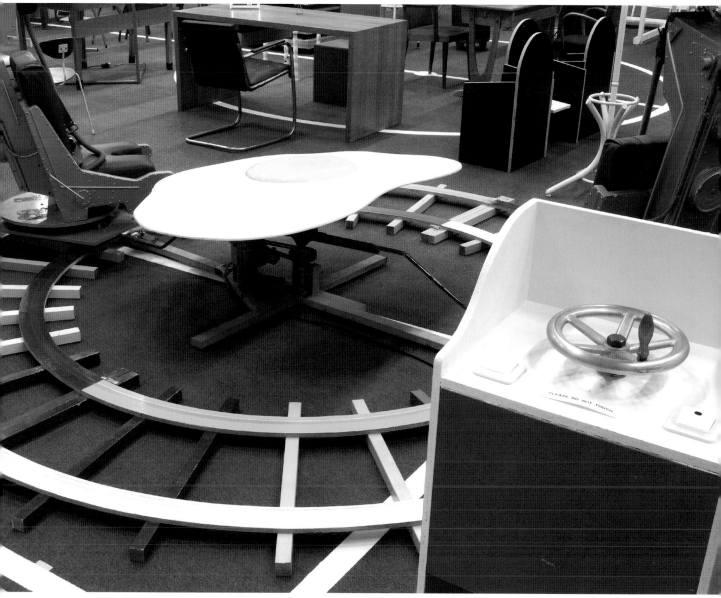

54 *The Happy End of Franz Kafka's 'Amerika'* 1994 (detail)

55 *Untitled* 1994

The Happy End of
Franz Kafka's 'Amerika'

Linus owned by Frank Bostich
Tail 16 feet
Double mane 10 feet long

56 *Untitled* 1995

57 *Untitled* 1993

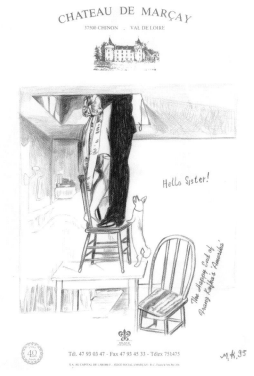

58 *Untitled* 1995

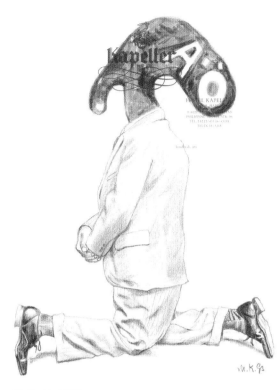

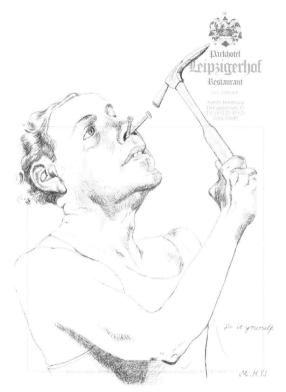

59 *Untitled* 1993

60 *Untitled* 1993

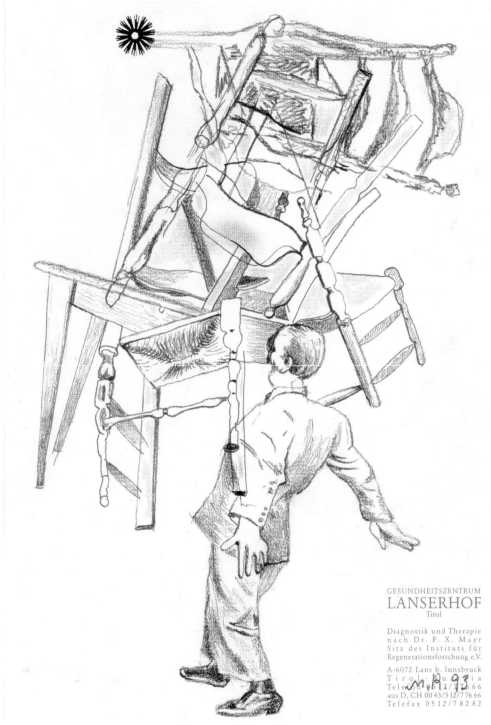

61 *Untitled* 1993

DOUBLETREE
MAYFAIR SUITES·ST. LOUIS
806 St. Charles Street
St. Louis, MO 63101-1507
(314) 421-2500
Fax # (314) 421-6254

John
Strocco

cracked hazelnutz, peanatz, and walnutz (May 4, 1938)
by smashing them with his finger

M.K.93

62 *Untitled* 1993

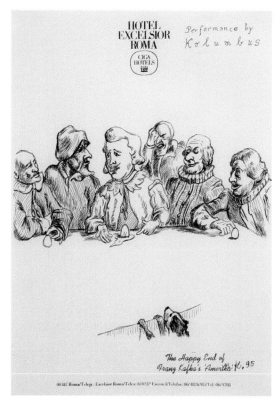

63 *Untitled* 1995

64 *Untitled* 1995

65 *Untitled* 1995

66 *Untitled* 1994

67 *Untitled* 1994

68 *Untitled* 1995

69 *Untitled* 1994

70 *Untitled* 1995

Ejakulation
Ekstase
Ellis, Albert
Ellis, Havelock
Empfängnis
Empfängnisverhütun
Enthaltsamkeit
Epilepsie
Erektion
Erektionsfähige
Erogene Zonen
Eros
Euphorie

FELLATIO
FELLATOR
FELLATRIX
FETISCH
FETISCHISMUS
FLAGELLOMANIE
FLAGELLATION
FRANCE, HECTOR
FREUD, SIGMUND
FRIGIDITÄT
FRIKTION
FRUCHTBARKEITSRITEN

DOLDER GRAND HOTEL ZURICH
Kurhausstrasse 65, CH-8032 Zürich, Tel. 01-251 62 31, Tx. 816

GAUTIER
GEBÄRMUTTER
GENITALIEN
GESCHLECHTSAKT
GESCHLECHTSBEGIE
GESCHLECHTSGENUS
GESCHLECHTSKÄLTE
GESCHLECHTSMORAL
GESCHLECHTSORGAN
GESCHLECHTSTRIEB
GESCHLECHTSVERKEH
GRUPPENSEX

The Leading Hotels of Switzerland The Leading Hotels of the World.
2589 - 25.1.95. M.K.

HASCHISCH 110
HERAKLEIDOS 198
HEROIN 107
HESSE, ERICH 106
HETÄREN 197
HEXENKULT 100
HIERONIMUS 237
HIPPOKRATES 232
HIRSCHFELD 214
HODEN 201
HOMOPHILIE 71
HSI-MEN 33
HUANG-ti 112
HUASMANS 280
HYMEN 59
HYPERSENSIBILITÄT 71
HYPNOSE 39
HYSTERIE 232

71 *Untitled* 1995

HYATT
HOTELS & RESORTS

M.H.95

72 *Untitled* 1995

Four
Seasons
Hotels · Resorts

FOUR SEASONS HOTEL · WASHINGTON
2800 PENNSYLVANIA AVENUE N.W., WASHINGTON, DC 20007, USA, TELEPHONE (202) 342-0444 TELEX 00-904008 FAX (202) 342-1673

Canada: Minaki (Minaki Lodge) · Montreal · Toronto · Toronto (Inn on the Park) · Vancouver · Caribbean: Nevis, West Indies · England: London · Indonesia: Bali · Italy: Milano · Japan: Tokyo
United States: Austin · Boston · Chicago · Chicago (The Ritz-Carlton) · Dallas at Las Colinas · Houston · Los Angeles · Maui at Wailea · New York · New York (The Pierre)
Newport Beach · Philadelphia · San Francisco (Clift) · Santa Barbara (Biltmore) · Seattle (The Olympic) · Washington DC
UNDER DEVELOPMENT: Carlsbad at Aviara · Hawaii at Kona · Mexico City · Singapore

73 *Untitled* 1994

74 *Untitled* 1994

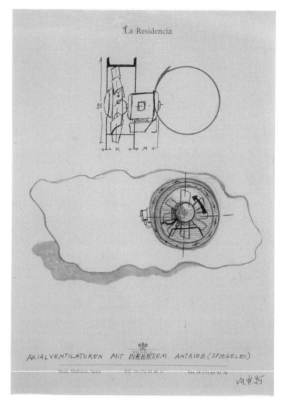

75 *Untitled* 1995

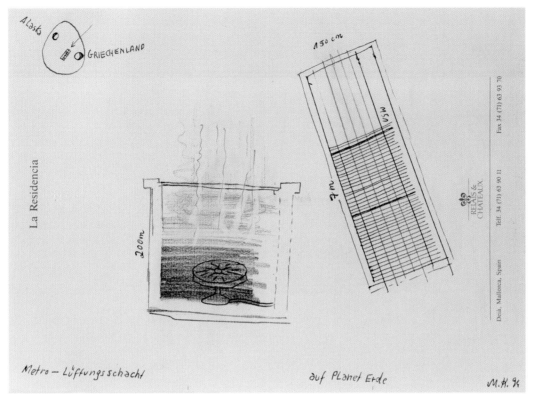

76 *Untitled* 1994

77 *Untitled* 1995

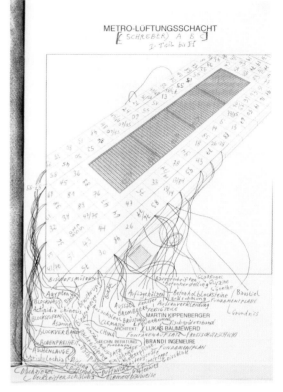

78 *Untitled* 1995

79 *Untitled* 1995

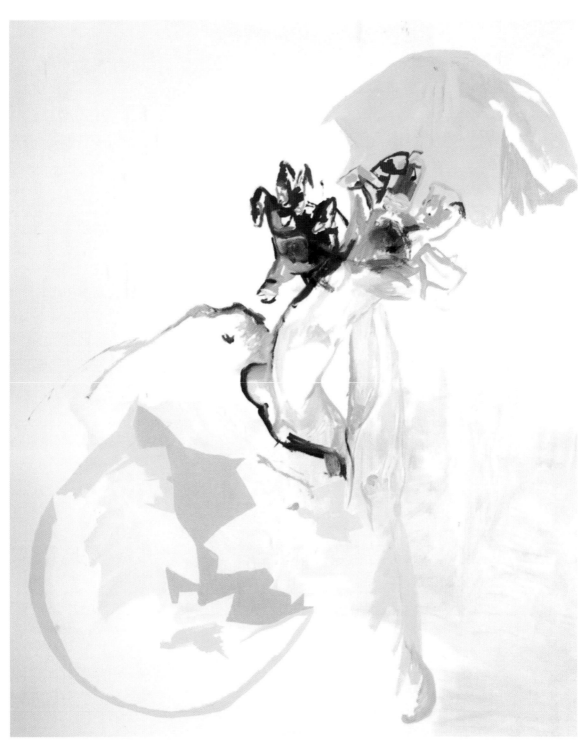

80 *Untitled* 1992

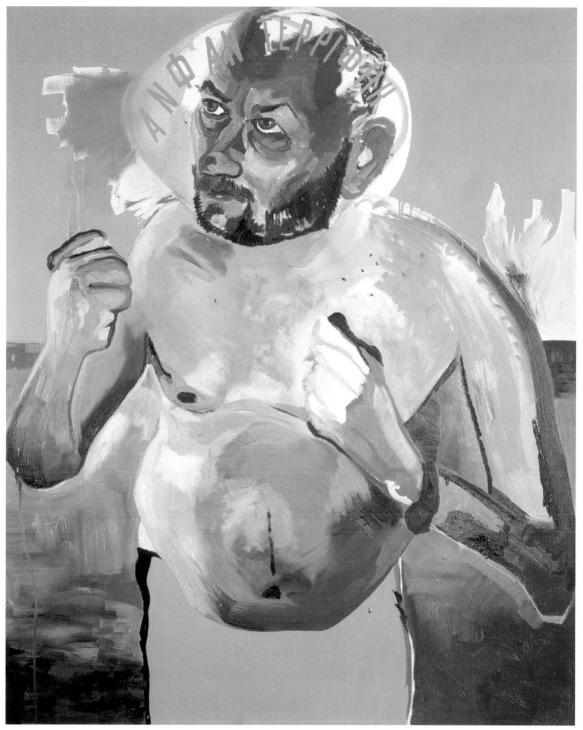

81 *Untitled* 1992

82 *Keine braune Schokolade* / No Brown Chocolate 1994

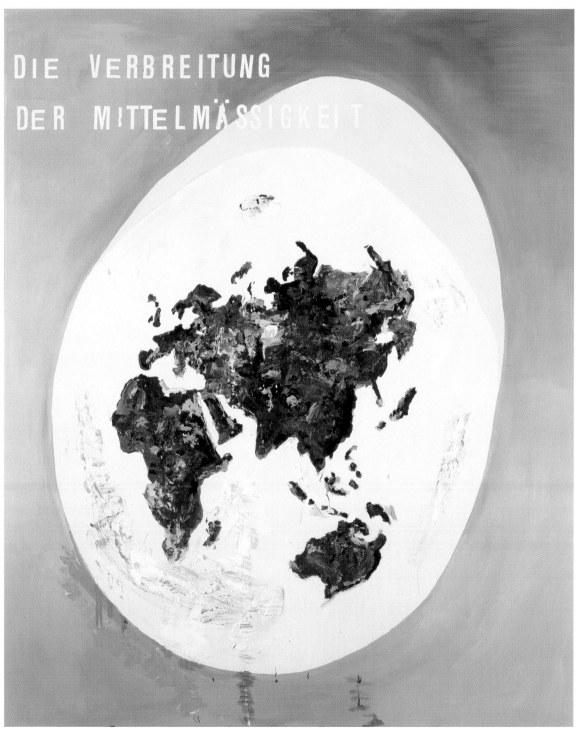

83 *Die Verbreitung der Mittelmässigkeit* / The Spread of Mediocrity 1994

84 *Untitled (Political Corect III)* 1994

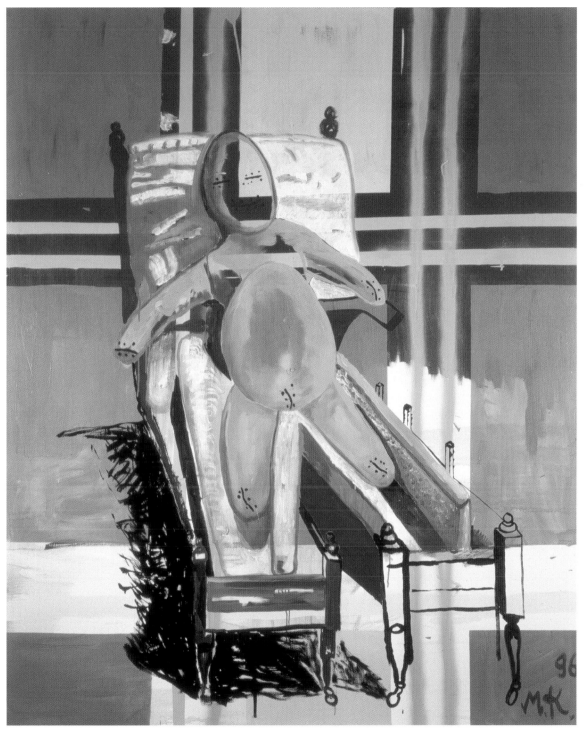

85 *Krankes Ei-Kind* / Sick Egg-Child 1996

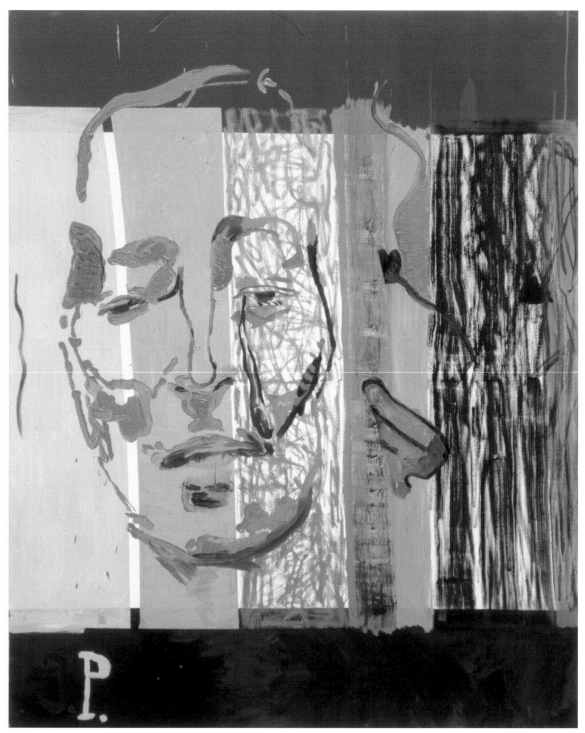

86 *Untitled* 1996 (from the series *Jacqueline: The Paintings Pablo Couldn't Paint Anymore*)

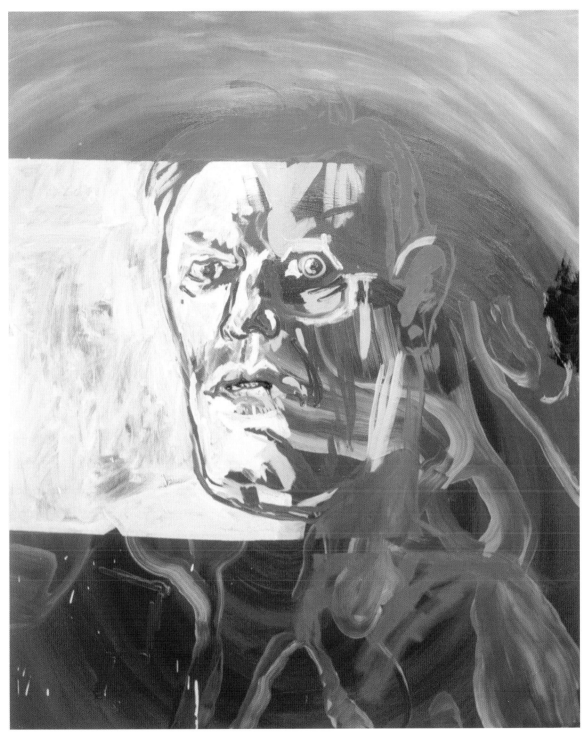

87 *Untitled* 1996

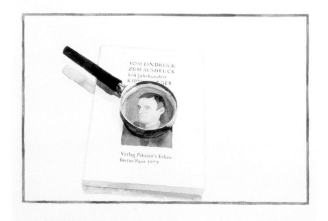

88 *Untitled* 1991

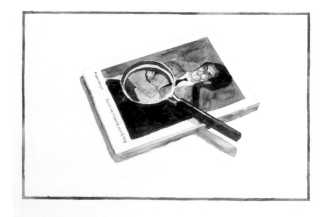

89 *Untitled* 1991

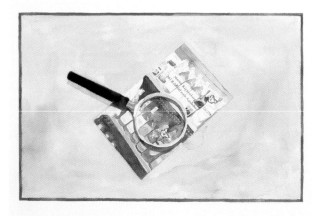

90 *Untitled* 1991

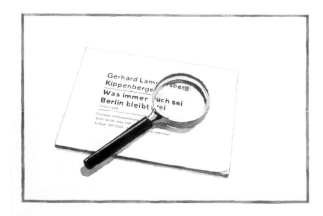

91 *Untitled* 1991

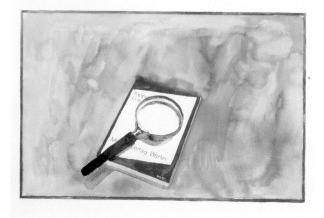

92 *Untitled* 1991

93 *Untitled* 1991

94 *Untitled* 1991

95 *Untitled* 1991

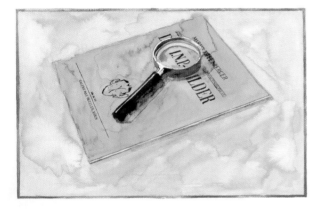

96 *Untitled* 1991

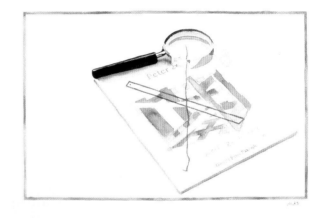

97 *Untitled* 1991

98 *Untitled* 1991

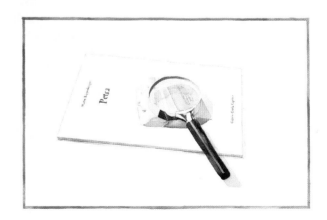

99 *Untitled* 1991

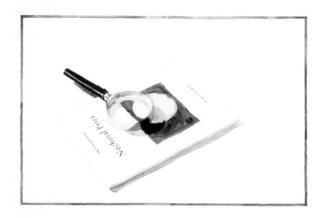

100 *Untitled* 1991

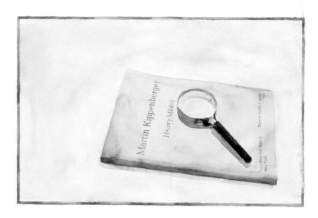

101 *Untitled* 1991

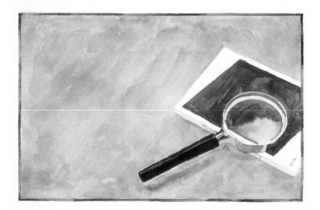

102 *Untitled* 1991

103 *Untitled* 1995

104 *Untitled* 1991

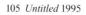

105 *Untitled* 1995

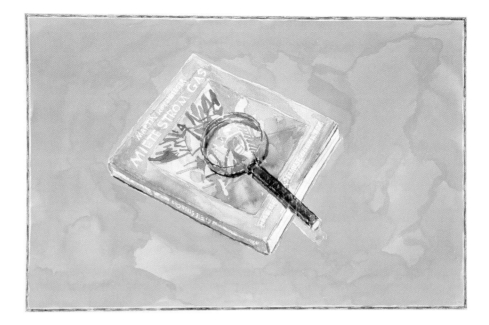

106 *Untitled* 1991

107 *Untitled* 1991

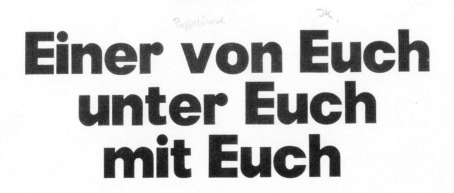

Einer von Euch unter Euch mit Euch

108 *Einer von Euch, unter Euch, mit Euch* / One of You, Among You, With You 1979

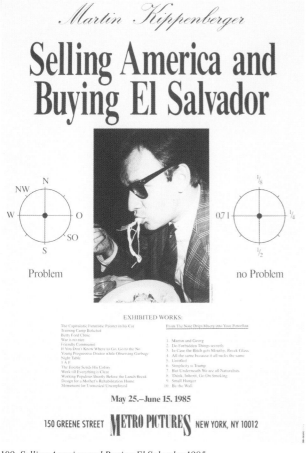

109 *Selling America and Buying El Salvador* 1985

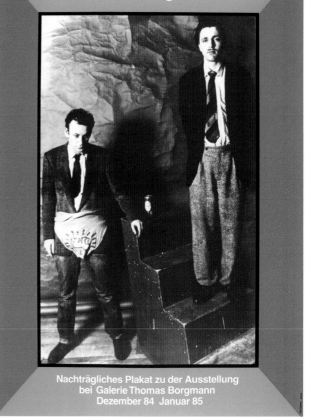

110 *Abschied vom Jugendbonus II* /
Farewell to the Youth Bonus II 1984/5

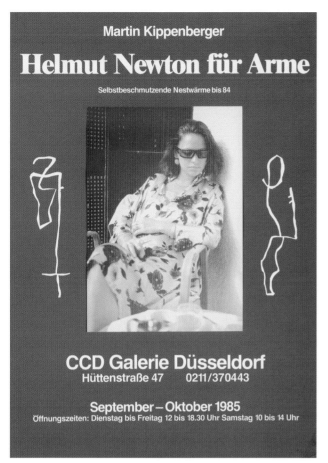

111 *Helmut Newton für Arme* / Helmut Newton for the Poor 1985

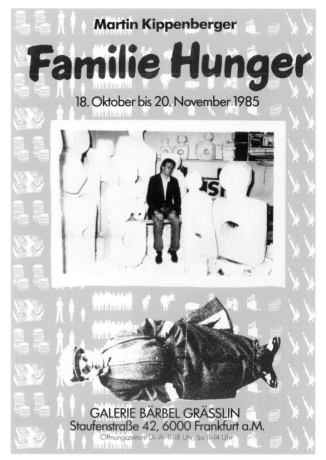

112 *Familie Hunger* / Hunger Family 1985

WAS IST IHRE LIEBLINGSMINDERHEIT
Wen beneiden Sie am meisten

113 *Was ist Ihre Lieblingsminderheit. Wen beneiden Sie am meisten* / Which is Your Favourite Minority. Who do you Envy the Most 1985/6

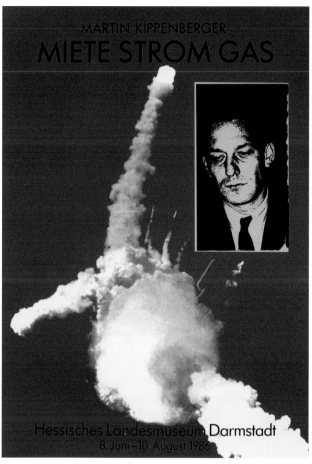

114 *Miete Strom Gas* / Rent Electricity Gas 1986

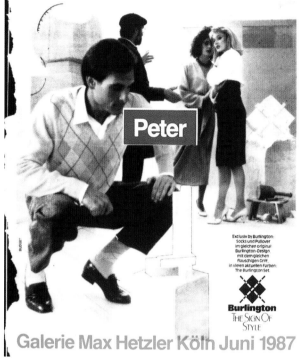

115 *Peter* 1987

116 *Martin Kippenberger* 1990

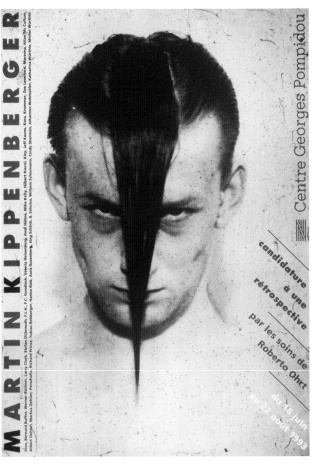

117 *Candidature à une Retrospective /*
Candidature for a Retrospective 1993

164

118 *L'atelier Matisse sous-loué à Spiderman* /
Matisse's Studio Sub-let to Spiderman 1996

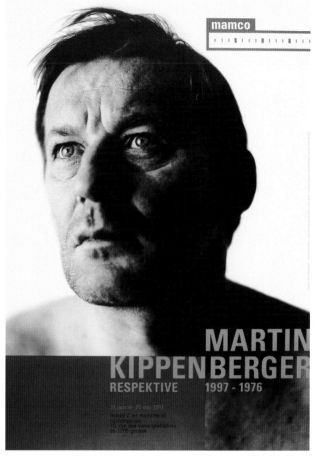

119 *Respektive 1997–1976* / Respective 1997–1976 1997

Martin Kippenberger: Life and Work

1953
Born in Dortmund, the only boy in a family of five, with two elder and two younger sisters. His father is director of the Katharina-Elisabeth colliery, his mother a dermatologist.

1956
The family moves to Essen. He spends six years at a 'strict, evangelical' school in the Black Forest. Shows great artistic talent even as a child, although he skips art classes after his teacher gives him only the second highest grade, feeling that this grade is unfair.

1967
Attempts to maintain control over his freedom of movement by going to the dance hall; aged 14, is told by dance teacher Anne Blomke, 'Herr Kippenberger, don't waggle your behind like that.' This exaggeration is a deciding factor. Cherishes ambitions thereafter to become the third best dancer in Europe.

1968
After taking his fourth-year exam three times he decides to leave school and pursue a practical career. Rejected as a trainee by the Böhmer shoe store for having 'too much talent'. Starts a course in window dressing with the Boecker clothing store.

1969
Fired from his job for taking drugs. Trip to Scandinavia.

1970
Has therapy at a farm near Hamburg. Discharged as cured.

1971
Moves to Hamburg and lives in various communes. Meets Ina Barfuss, Joachim Krüger and Thomas Wachweger.

1972
Begins studying at the Hamburg Art Academy (Hochschule für bildende Kunst). Quits after sixteen semesters.

1976
Leaves Hamburg for Florence, hoping to become an actor. Paints the first canvases in his series *Uno di voi, un tedesco in Firenze*. All these works are in the same format, 50 × 60 cm, in black and white, mainly based on postcards or on photos taken by himself. However, the project remains incomplete. The idea was for the frames of the pictures, when stacked together, to reach his own height of 189 cm, but the end result (around 70 works) falls 10 cm short.

1977
Returns to Hamburg. First one-man show of his Florence pictures at the Petersen Gallery. Meets Werner Büttner and Albert Oehlen.

1978

Moves to Berlin. Founds Kippenberger's Büro with Gisela Capitain. At the same time becomes manager of the famous S.O. 36 club, a venue for the film festivals and concerts he organises (including performances by Lydia Lunch, Wire, Adam and the Ants, and the Iggy Pop drummer). Also mounts exhibitions in the Office. Founds The Grugas punk band. Makes his first single, 'Luxus', with Christine Hahn and Eric Mitchell.

1979

Kippenberger's Büro shows the exhibition *Misery*, including works by Werner Büttner, Achim Duchow, Walter Dahn and Georg Herold. Meets Michel Würthle, the owner of the Paris Bar in Berlin. Donates works of his own to the restaurant on permanent loan. Goes on a trip to the United States, resulting in works in sound and pictures by himself and Achim Schächtele entitled *Vassals of Tourism* and shown in the Cafe Einstein, Berlin. The professional poster artist Hans Siebert paints the series of twelve works *Dear Painter, Paint for Me* from ideas by Kippenberger. Buys early works by Ina Barfuss and Thomas Wachweger for his own collection. Meets his future gallerist Max Hetzler. Acts in three films directed by women: Christel Kaufmann's *Gibby West Germany*, Ulrike Oettinger's *Bildnis einer Trinkerin* [Portrait of a Woman Drunk] and Gisela Stelli's *Liebe Sehnsucht Abenteuer* [Love Yearning Adventure], after which he abandons his career in films. His models: Albert Finney in *Under the Volcano* and Ben Gazzara in *The Killing of a Chinese Bookie*.

1980

Moves to Paris, intending to become a writer, lives in hotels on the Left Bank. Works on his first novel, excerpts from which are used in 1981 in the series of events entitled *Through Puberty to Success*.

1981

Visits Siena, then spends some time working in the Black Forest and Stuttgart. First series of paintings using colour, shown at the Hetzler Gallery in Stuttgart under the title *A Secret of the Success of Mr A. Onassis*.

1982

Collaborates with Albert Oehlen on such works as *Capri by Night* and *Orgone Box By Night*. Meets Günther Förg and admires his work.

1983

Settles in Cologne, with a studio near the Friesenplatz. Meets Martin Prinzhorn in Vienna. Spends six months with Albert Oehlen at Prinzhorn's property, the 'Thomasburg', in Editz near Vienna. In Vienna, the gallerist Peter Pakesch introduces him to Franz West. Collaborates with Albert Oehlen on several projects, including the legendary *Fiaker Race* (1st prize, Martin Kippenberger; 2nd prize, Albert Oehlen; 3rd prize withheld for lack of serious participants). Returns to Cologne. Paints *Casa Magnetica*.

1984

Publication of the catalogue *Wahrheit ist Arbeit* [Truth is Work] by Werner Büttner, Martin Kippenberger and Albert Oehlen for their exhibition in the Folkwang Museum, Essen. Stays with Michael Krebber in Santa Cruz, Tenerife. First attempts at sculpture, including the *Peter* series. Becomes a member of the 'Lord Jim Loge', acknowledging that organisation's first commandment, 'No-one helps anyone' (members: Jörg Schlick and Wolfgang Bauer). Paints pictures entitled *I.N.P.* (for *Ist Nicht Peinlich* = Is Not Embarrassing).

1985

Goes to the health resort of Knokke, Belgium, for a cure. Hires a ghost writer to record his vacation experiences there in a work entitled *How It Really Was, From the Example of Knokke*. First photographic works exhibited in the CCD Gallery, Düsseldorf, under the title of *Helmut Newton for the Poor*. Creates sculptural works in the series *Hunger Family*, and *Profit Peaks*. Meets Christian Bernard, director of the Villa Arson, Nice.

1986

Trip to Brazil ('The Magical Misery Tour'), where he buys a disused gas station and renames it the Martin Bormann Gas Station. First large-scale museum exhibition, *Rent Electricity Gas* in the Hessisches Landesmuseum, Darmstadt; catalogue under the same title published with texts by Bazon Brock and Diedrich Diederichsen. *Anti-Apartheid Drinking Congress* during the Commonwealth Games in Edinburgh: the first and only political act in the artist's work. Stays at the Hotel Chelsea in Cologne and redesigns it. Main autobiographical work of this period: the book *Cafe Central: Sketches for the Protagonist of a Novel*.

1987

First exhibition in France at the Villa Arson, Nice, with Werner Büttner and Albert and Markus Oehlen. Exhibition of sculptures, *Peter – the Russian Position*, at the Max Hetzler Gallery, Cologne; subsequently shown in Vienna, Graz and New York. Is curator of the exhibition *Broken Neon* in the Forum Stadtpark, Graz, containing works by several artists including Joseph Beuys, Georg Jiri Dokoupil, Fischli & Weiss, Franz West and Heimo Zobernig.

1988

Moves to Spain (Seville and Madrid) with Albert Oehlen. Is chiefly occupied in painting. Creates *Self-portraits with Underpants*, *Street Lamp for Drunks* and *Chicken Disco*, shown in the Aperto of the Venice Biennale.

1989

Birth of his daughter Helena Augusta Eleonore. Preparations for a tripartite exhibition *Cologne/Los Angeles/New York 1990–91*, as recorded in a catalogue from the Villa Arson, Nice. Is curator of the exhibition *Euro-stroll I–III* in Cologne and Graz, showing works by Luis Claramunt, Sven Åke Johansson and Michael Krebber. Moves to Los Angeles at the end of the year.

1990

Creates his first latex-covered pictures in the USA. Meets Mike Kelley, John Caldwell, Ira Wool and Cady Noland. Begins collecting contemporary American art more intensively. Buys 35% share in ownership of the Italian restaurant, Capri, in Venice, Los Angeles. Returns to Cologne and begins term as guest professor at the Städelschule, Frankfurt. A public uproar is caused by the carving *Fred the Frog on the Artist's Cross* during an exhibition at the Jänner Gallery, Vienna.

1991

Updates the art collection of the Paris Bar, Berlin, by adding works of artists including Louise Lawler, Laurie Simmons, Barbara Ess and Zoe Leonard. Major installation entitled *Deep Throat* in a subway tunnel on the occasion of the Wiener Festwochen (Vienna Festival Weeks). Exhibition at the Kunstverein, Cologne, of photographs of works painted and later destroyed. One-man show at the San Francisco Museum of Modern Art. Gives more interviews, particularly to Jutta Koether, Diedrich Diederichsen and Oswald Wiener. Learns the noble art of accordion playing from free-jazz musician Rüdiger Carl. Seriously considers taking time off to complete Franz Kafka's fragment of a novel *Amerika*, giving it a happy ending. Lives and works in Cologne and Frankfurt.

1992

Teaches at the Comprehensive University of Kassel, as professor of the Happy Kippenberger Class. Is a guest lecturer at Yale University and in Nice and Amsterdam (until 1995). Moves further and further away from the art world; lives and works in the Black Forest.

1993

Revises his address book, parting from several friends. Becomes increasingly convinced that the world of music is defunct and the theatre is insular. From now on, concentrates on recommendations from people previously unknown to him. Is constantly at odds with the art market (which thinks him crazy). Runs the Kippenberger Art Society in the Fridericianum in Kassel until 1995, putting on one-man shows of the works of Albert Oehlen, Ulrich Strothjohann, Cosima von Bonin, Michael Krebber, Johannes Wohnseifer, and a group exhibition entitled *Art of Women – Art of Men* with works by over thirty artists. *Announcement for a candidature to a retrospective* at the Samia Saouma Gallery; exhibition *Candidature à une rétrospective* at the Georges Pompidou Centre, Paris. Builds first subway station on Syros, linked 1995 to subway station in Dawson City West (Yukon Territory, Canada). Construction of a subway station in Leipzig (site of the 1997 Leipzig Trade Fair), a transportable underground station for documenta X, Kassel (1997), and a transportable ventilation shaft for *Sculpture. Projects in Münster* (1997). Founds the MOMAS (Museum of Modern Art, Syros). Opening exhibition featuring Hubert Kiecol, followed by annual exhibitions so far featuring works by Ulrich Strothjohann, Christopher Wool, Cosima von Bonin, Stephen Prina, Christopher Williams, Michel Majerus, Johannes Wohnseifer, Heimo Zobernig.

1994

First aluminium sculptures (*War Wicked*) and *Santa Claus disguised as frog on a fried egg with street lamp (island) disguised as palm tree*. Begins on 'art as allotment gardening' project, starting with the cycle *Don't Wake Daddy*, concluding in Madrid with *Cocido y crudo* (wooden reliefs with wooden fences). Installation, *The Happy End of Franz Kafka's 'Amerika'*, in Rotterdam, accompanied by the publication of nine books: *Amazing*, by Daniel Richter and Werner Büttner; *The Schoppenhauer. A Play*, by Walter Grond; *Bold and unusual: Kippenberger's Example*, by Heliod Spiekermann; *An Interview*, by Jörg Schlick; *The Happy End of Franz Kafka's 'Amerika', Table 3, With a View to an Interview*, by the Grässlin family; *Interview 54, Dialogue for Two Accordions*, by Rüdiger Carl; *Embauche au Balkan*, by Michel Würthle; *B: Conversations with Martin Kippenberger*, by Jutta Koether; *More smoking!*, by Diedrich Diederichsen and Roberto Ohrt.

1995

Cycle of drawings *Eroticism behind architecture in Tokyo*. Gives up spirits in favour of Californian red wine. Becomes member of the 'Club an der Grenze' (The Border Club). Moves to the Burgenland area. Plans an exhibition in the Matisse Studio, Nice: *Spiderman*. Release of CD entitled *Beuys's Best*, in new sound, freely adapted from Joseph Beuys. Second book, *Hotel-Hotel*.

1996

Marries Elfie Semotan. Makes a start on construction work for the Tower of Syros with built-in *Staircase* 1990, by Cady Noland. Returns to the subject of eggs and noodles with renewed interest. Begins *The Raft of Medusa* cycle and *J. Picasso*, his sad portraits of Jacqueline Picasso. Releases CD *Greatest Hits; 17 years of Martin Kippenberger's Music* (with Rüdiger Carl, Sven Åke Johansson, Christina Hahn, Achim Kubinski, Eric Mitchell and Albert Oehlen). Another CD made with Lukas Baumewerd, *Subway Station Noises* (international). Exhibition at the Villa Merkel, Esslingen, instead of the Krupp family's Villa Hügel, Essen. Plans to close the exhibition room Fettstrasse 7a at Birgit Küng's in Zurich (has run Fettstrasse 7a in Hamburg, with A. Oehlen, since about 1984). Is awarded the Käthe Kollwitz Prize, worth DM 10,000. Begins introducing Helmut Lang to the world of art, while Lang introduces Kippenberger to the world of fashion.

1997

28 January, opening of the final exhibition at the Fettstrasse 7a exhibition room in Zurich. 30 January, his retrospective exhibition *Respektive 1997–1976* opens at MAMCO (Musée d'art moderne et contemporain) in Geneva. 1 February, exhibition *The Eggman and his Outriggers* in the Städtisches Museum Abteiberg, Mönchengladbach.

Martin Kippenberger dies on 7 March in Vienna.

From the book *Kippenberger*, with kind permission of TASCHEN GmbH, Hohenzollernring 53, D-50672 Cologne, www.taschen.com
© Estate Martin Kippenberger, Galerie Gisela Capitain, Cologne

Selected Exhibitions

Martin Kippenberger
1953 born in Dortmund
1997 died in Vienna

G – indicates group show

2005
Martin Kippenberger, Lieber Maler male mir,
Gagosian Gallery, New York
Martin Kippenberger, Self-Portraits,
Luhring Augustine Gallery, New York

2004
Brasilien aktuell – The Magical Misery Tour,
Gagosian Gallery, London

2003
Martin Kippenberger, Das 2. Sein,
Museum für neue Kunst/ZKM, Karlsruhe
*Schattenspiel im Zweigwerk, Martin
Kippenberger, Die Zeichnungen*, Museum
für neue Kunst in der Kunsthalle Tübingen,
Tübingen
Nach Kippenberger/After Kippenberger,
Museum Moderner Kunst, Stiftung Ludwig,
Wien; Van Abbemuseum, Eindhoven
Martin Kippenberger – Multiples, Kunstverein
Braunschweig
*Martin Kippenberger, Die weissen Bilder von
1991*, Galerie Bärbel Grässlin, Frankfurt
Biennale di Venezia, German Pavilion, with
Candida Höfer, Venedig – G

2002
Documents of the Magical Misery Tour,
Galerie Gisela Capitain, Cologne

2001
Zero Gravity, Kunstverein für die Rheinlande
und Westfalen, Düsseldorf – G

2000
*Hotel Drawings and The Happy End of Franz
Kafka's "Amerika"*, The David and Alfred
Smart Museum of Art University of Chicago
and The Renaissance Society at the University
of Chicago
*Jacqueline: The Paintings Pablo Couldn't Paint
Anymore*, Metro Pictures, New York

1999
*Selbstbildnisse, The Happy End of Franz
Kafka's "Amerika", Sozialkistentransporter,
Laternen etc.*, Deichtorhallen, Hamburg
Carnegie International, Carnegie Museum
of Art, Pittsburgh – G

1998
Selbstportraits, Kunsthalle Basel, Basel
The Last Stop West, MAK Center, Schindler
House, Los Angeles
Martin Kippenberger & Freunde, Frühe Bilder,
Collagen, Objekte,
die gesamten Plakate und späte Skulpturen,
Kunsthaus Zürich, Zurich

1997
Respektive 1997–1976, Musée d'art
moderne et contemporain, Geneva;
Castello Di Rivoli, Turin
Der Eiermann und seine Ausleger, Städtisches
Museum Abteiberg, Mönchengladbach
*Memento Metropolis, The Happy End of Franz
Kafka's "Amerika"*, Hessenhuis, Antwerp
Das Floss der Medusa, Galerie Gisela
Capitain, Cologne
Metro-Net, Documenta X, Kassel – G
Skulpturen. Projekte, Münster – G

1996
L'Atelier Matisse sous-loué à Spiderman,
L'Atelier Soardi, Nice
*Kippenberger – Géricault, Memento
Metropolis*, Turbinen Halls, Copenhagen
*Vergessene Einrichtungsprobleme in der Villa
Hügel (Villa Merkel)*, Villa Merkel, Esslingen

1995
Directions: Martin Kippenberger,
Hirshhorn Museum and Sculpture Garden,
Washington, DC
*Exit of the Underground Station Dawson City
West*, Dawson City, Yukon Territory, Canada
Über das Über, Galerie Borgmann
Capitain, Cologne

1994
Pictures of an Exhibition, Metro Pictures,
New York; Printed Matter, New York
The Happy End of Franz Kafka's "Amerika",
Museum Boymans Van Beuningen, Rotterdam

A Man and His Golden Arm, Nolan/Eckman
Gallery, New York
Don't Wake up Daddy, Galeria Juana de
Aizpura, Madrid / Seville

1993
Candidature à une retrospective, Centre
Georges Pompidou, Paris
*Metro-Net, Entrance To The Subway Station
Lord Jim*, Kthma Canné, Hrousa, Syros
Museum auf Zeit (Kippenberger-Kunstverein),
Museum Fridericianum, Kassel

1992
Handpainted Pictures, Galerie Max Hetzler,
Cologne

1991
Heavy Mädel, Pace/MacGill Gallery, New York
Only Heavy, Luhring Augustine Hetzler
Gallery, Santa Monica
New Work – (Put Your Eye In Your Mouth),
San Francisco Museum of Modern Art
Kippenblinkys, David Nolan Gallery, New York
Heavy Burschi, Kölnischer Kunstverein,
Cologne
Tiefes Kehlchen, Wiener Festwochen, Vienna

1990
Martin Kippenberger, Villa Arson, Nice
*Jetzt geh ich in den Birkenwald, denn meine
Pillen wirken bald*, Anders Tornberg
Gallery, Lund
Haus-Schloss-Case, Metro Pictures, New York
Unlängst verlängerte Originale, Galerie Gisela
Capitain, Cologne

1989
*Die Hamburger Hängung, Umzüge
1957–1988, Fallende Flüge*, Galerie Gisela
Capitain, Cologne
*Bei Nichtgefallen Gefühle zurück
(En cas de réclamation les sentiments vous
seront remboursés)*, Halle Sud, Geneva
D.E.d.A. 7 (das Ende der Avantgarde),
Fettstrasse 7A, Zurich
d.E.d.A. 6 (Das Ende der Avantgarde),
PPS Galerie, F.C. Gundlach, Hamburg
VIT 89, Galerie Max Hetzler, Cologne

1988

Nochmal Petra, Kunsthalle Winterthur, Winterthur
Broken Neon, Forum Stadtpark, Graz – G

1987

Peter – Die russische Stellung,
Galerie Max Hetzler, Cologne
Peter 2, Galerie Peter Pakesch, Vienna
Sorry III, Metro Pictures, New York
Petra, Galerie Gisela Capitain, Cologne

1986

Miete Strom Gas, Hessisches Landesmuseum,
Darmstadt
Sand in der Vaseline, CCD Galerie, Düsseldorf
Nur Angst vor Frauen die Samt tragen (Seidene Schlüpfer sind keine Ausrede für hautfarbene BHs), Oldenburger Kunstverein, Oldenburg

1985

*Helmut Newton für Arme –
Selbstbeschmutzende Nestwärme bis 84*,
CCD Galerie, Düsseldorf
Acht Ertragsgebirge und drei Entwürfe für Müttergenesungswerke, Galerie Heinrich
Ehrhardt, Frankfurt
Money Forever (Hunger), Galerie Bärbel
Grässlin, Frankfurt
Selling America & Buying El Salvador,
Metro Pictures, New York

1984

I.N.P. (Ist nicht Peinlich Bilder),
Galerie Max Hetzler, Cologne

1983

Abschied vom Jugendbonus!, Vom Einfachsten nach Hause, Dany Keller Galerie, Munich
Frauen im Leben meines Vaters
(with Albert Oehlen), Galerie Klein, Bonn
Kennzeichen eines Unschuldigen,
Galerie Rudolf Zwirner, Cologne

1982

Fiffen, Faufen, Ferfaufen, Studio F, Ulm
Capri bei Nacht, (with Albert Oehlen),
Galerie Tanja Grunert, Stuttgart
Kiste Orgon bei Nacht (with Albert Oehlen),
Galerie Max Hetzler, Stuttgart
Türe bei Nacht, Dr Dacic, Tübingen
Das Leben ist hart und ungerecht,
Forum Kunst, Rottweil

1981

Lieber Maler, male mir (Durch die Pubertät zum Erfolg), Neue Gesellschaft für bildende
Kunst, Realismusstudio 14, Berlin
Kippenberger in Nudelauflauf sehr gerne,
Galerie Petersen, Berlin
Dialog mit der Jugend, Galerie Achim
Kubinski, Stuttgart

1980

2. außerordentliche Veranstaltung in Bild und Ton: AktionPißkrücke, Geheimdienst am Nächsten, Künstlerhaus, Hamburg

1979

1. außerordentliche Veranstaltung in Bild und Klang zum Thema der Zeit: ELEND,
Kippenberger's Büro, Berlin
Knechte des Tourismus (with Achim
Schächtele), Performance at Cafe Einstein,
Berlin

1978

Martin Kippenberger founded Kippenberger's
Büro together with Gisela Capitain in Berlin
Manager of the famous Club 'S.O. 36' in Berlin

1977

Al vostro servizio (with Achim Duchow
and Jochen Krüger) Galerie Petersen,
Feldbrunnenstr. 3, Hamburg

Bibliography

Monographs

1977

Al Vostro Servizio (with Achim Duchow and Jochen Krüger), Hamburg

Uno di voi, un Tedesco in Firenze, Hamburg / Florence

1979

Sehr gut – Very good, Berlin

Vom Eindruck zum Ausdruck, 1/4 Jahrhundert Kippenberger, Berlin / Paris

1980

19 Gedichte, 1 Geschichte, 1 kl. Stapel graues Papier, 15 Männer, 1 Superposter anbei, Essen

Frauen, Berlin

1981

Durch die Pubertät zum Erfolg, Neue Gesellschaft für bildende Kunst (ngbk), Berlin

Gerhard Lampersberg Kippenberger, Was immer auch sei, Berlin bleibt frei, Berlin

1982

Der Kippenberger, Thomas Grässlin, St. Georgen / Max-Ulrich Hetzler GmbH, Stuttgart

1983

Kippenberger! 25.2.53–25.2.83 Abschied vom Jugendbonus! Vom Einfachsten nach Hause, Galerie Dany Keller, Cologne / Munich

Song of Joy (with Wilhelm Schürmann), Neue Galerie Sammlung Ludwig, Aachen

Homme, Atelier, Peinture (with Georg Jiri Dokoupil), *4 Taxis* (issue 2), Bordeaux

1984

Die I.N.P. – Bilder, Galerie Max Hetzler, Cologne

Gedichte (with Albert Oehlen), Berlin

Sind die Discos so doof wie ich glaube, oder bin ich der Doofe, Galerie Peter Pakesch, Vienna

Für Albert Oehlen! 17.9.54–17.9.84 Abschied vom Jugendbonus! Vom Einfachsten nach Hause, Cologne

1985

The Cologne Manifesto (with Albert Oehlen), Edition Lord Jim Loge, Graz / Cologne / Hamburg

Martin Kippenberger – Arbeiten mit Papier 1983/85, Galerie Klein, Bonn / Oldenburger Kunstverein, Oldenburg

Martin Kippenberger, 1984, Wie es wirklich war am Beispiel Knokke, Galerie Bärbel Grässlin, Frankfurt

1986

Miete Strom Gas, Hessisches Landesmuseum, Darmstadt

23 Viergrautonvorschläge für die Modernisierung des Rückenschwimmers, Galerie Engels, Cologne

23 Vierfarbvorschläge für die Modernisierung des Rückenschwimmers, Galerie Engels, Cologne

14.000.000,- für ein Hallöchen (with Albert Oehlen), Galerie Ascan Crone, Hamburg

The Fall (with Albert Oehlen), Galerie Ascan Crone, Hamburg

No problem – no problème (with Albert Oehlen), Edition Patricia Schwarz & Galerie Kubinski, Stuttgart

Endlich 1, Galerie Erhard Klein, Bonn

Endlich 2, Galerie Erhard Klein, Bonn

Endlich 3, Galerie Erhard Klein, Bonn

Sand in der Vaseline, CCD Galerie, Düsseldorf / PPS Galerie, Hamburg

Was könnt Ihr dafür? (with Albert Oehlen), Edition Daniel Buchholz, Cologne

CALMA-Trio: 1986. Jazz zum Fixsen, Galerie Grässlin-Ehrhardt, Frankfurt

241 Bildtitel zum Ausleihen, Cologne

Martin Kippenberger. Zeichnungen über eine Ausstellung, Galerie Peter Pakesch, Vienna

1987

Peter, Galerie Max Hetzler, Cologne

Peter 2-II, Galerie Peter Pakesch, Vienna

Petra, Galerie Gisela Capitain, Cologne

Einfach geht der Applaus zugunde, Galerie Grässlin-Ehrhardt, Frankfurt

67 Improved Papiertigers Not afraid of Repetition, Edition Julie Sylvester, New York

Die Reise nach Jerusalem, Galerie Bleich-Rossi, Graz

Pop In, Forum Stadtpark, Graz

Broken Neon, steirischer Herbst 87, Forum Stadtpark, Graz.

Gedichte. Zweiter Teil (with Albert Oehlen), Berlin

Die Reise nach Jerusalem, Galerie Bleich-Rossi, Graz

Martin Kippenberger, Café Central – Skizze zum Entwurf einer Romanfigur, Meterverlag, Hamburg

1988

Nochmal Petra, Kunsthalle Winterthur, Winterthur

Psychobuildings, Cologne

1989

Input – Output, Galerie Gisela Capitain, Cologne

Collages 1989, David Nolan Gallery, New York

Crtezi, Galerija Studentskog kulturnog centra, Belgrade

En cas de réclamation les sentiments vous seront remboursès, Halle Sud, Geneva

Kippenbergerweg 25-2-53, Cologne

Martin Kippenberger – Albert Oehlen, Galerie Juana de Aizpuru, Madrid

Que calor Que Calor II 25-2-53, Museo de Arte Contemporaneo de Sevilla, Seville.

80 Unikatbüchlein, Parkett, Vorzugsausgabe Nr. 19, Zurich.

Die Fahrt ins Freilichtmuseum, Eurobummel Teil II, Galerie Isabell Kacprzak, Cologne.

Das Ende der Avantgarde, Galerie Gisela Capitain, Cologne / Thea Westreich, New York

Gelenke I, Edition Patricia Schwarz, Stuttgart

Die Welt des Kanarienvogels, Forum Stadtpark, Graz

1990

Martin Kippenberger, Villa Arson, Nice

Eine Handvoll vergessener Tauben, Galerie Grässlin-Ehrhardt, Frankfurt

Fama & Fortune Bulletin, Vienna

Heimweh Highway 90, Fundació Caixa de Pensions, Barcelona

Jetzt geh ich in den Birkenwald, denn meine Pillen wirken bald, Anders Tornberg Gallery, Lund

Schwarz Brot Gold, Galerie Bleich-Rossi, Graz

Untouched & Unprinted Paper, Printed Matter, New York

1991

Fred the frog rings the bell once a penny two a penny hot cross burns, Galerie Max Hetzler, Cologne

Give me a hand before I call you back. 2 Semester Kippenberger, Galerie Bleich-Rossi, Graz

Heavy Burschi, Kölnischer Kunstverein, Cologne

Heavy Mädel, Pace/MacGill Gallery, New York / Galerie Gisela Capitain, Cologne

I Had A Vision, Museum of Modern Art, San Francisco

Martin Kippenberger. Ten years after, Cologne

Martin Kippenberger. New Editions, AC & T Corporation, Tokyo

Virtuosen vor dem Berg, Galerie Grässlin-Ehrhardt, Frankfurt

T.K. (D.T.) Tiefes Kehlchen, Wiener Festwochen, Vienna

Die bunte Welt des Kanarienvogels, Galerie Bleich-Rossi, Graz (Blue version)

Die Welt des grünen Kanarienvogels, Galerie Grässlin-Ehrhardt, Frankfurt (Green version)

The Canary Searching for a Port in the Storm, David Nolan Gallery, New York

William Holden Company: The Hot Tour 4.6.91–3.9.91 3000 km Tanzania, Zaire, Wewerka & Weiss Galerie, Berlin

as time goes by, Karsten Schubert Ltd., London

Dieses Leben kann nicht die Ausrede für das nächste sein. Martin Kippenberger, Forum Stadtpark, Graz

1992

Martin Kippenberger, Galerie Max Hetzler, Cologne

Mensch geht mir ein Licht auf – Gut ausge-leuchtete vorweihnachtliche Ausstellung an der Leopoldstrasse, Kunstraum Daxer, Munich

Hotel-Hotel, Cologne

I.A.R. Inhalt auf Reisen, Galerie & Edition Artelier, Graz

Einer flog übers Kanarienvogelnest – One Flew Over The Canary Birds Nest, AC & T Corporation, Tokyo

Kippenberger Kippenberger Kippenberger, Galerie Bleich-Rossi, Graz

1993

Candidature à une retrospective, Centre Georges Pompidou, Paris

The Happy End of Franz Kafka's 'Amerika' – Tisch 3. – Zwecks Einstellungsgespräch – Vorschläge zur Diskussion, St. Georgen

Pictures of an exhibition, Forum for Contemporary Art, St. Louis

1994

B – Gespräche mit Kippenberger, Stuttgart

Das 2. Sein, Sammlung Grässlin, Brandenburgischer Kunstverein, Potsdam

Kippenberger fanden wir schon immer gut, Sammlung Grässlin, St. Georgen

MOMAs. Museum of Modern Art Syros, Lukas Baumewerd, Cologne

The Happy End of Franz Kafka's 'Amerika', Museum Boymans Van Beuningen, Rotterdam

Jörg Schlick, *Ein Einstellungsgespräch*, ed. Martin Kippenberger, Graz

Carl Rüdiger, *Einstellungsgespräch Tisch Nr. 54. Dialog für zwei Akkordeons zum Thema: Das Glückliche Ende von Franz Kafka's 'Amerika'*, St. Georgen

Daniel Richter, *Toll*, Hamburg

Diedrich Diederichsen & Roberto Ohrt, *Mehr rauchen! Der Zigarettenraucher im Test*, Cologne

Michel Würthle, *Embauche au Balkan. 24 elastische Seiten zum Thema Einstellungsgespräche oder 'The Happy End of Franz Kafka's 'Amerika'*, Hamburg

Heliod Spiekermann, *frech und ungewöhnlich am Beispiel Kippenberger*, Cologne

Herbert Fuchs, *Einstellungsgespräch-Roman*, no place

Walter Grond, *Der Schoppenhauer: Ein Schauspiel. Tisch 32*, Graz

1995

Hotel Hotel Hotel, Buchhandlung Walther König, Cologne

1996

Vergessene Einrichtungsprobleme in der Villa Hügel, Villa Merkel, Galerie der Stadt Esslingen / Ostfildern-Ruit

1997

Kippenberger sans peine – Kippenberger leicht gemacht, MAMCO Musée d'art moderne et contemporain, Geneva

Der Eiermann und seine Ausleger, ed. Veit Loers, Städtisches Museum Abteiberg, Cologne / Mönchengladbach

Martin Kippenberger, The Happy End of Franz Kafka's 'Amerika'. Théodore Géricault, Le Radeau de la Méduse, Memento Metropolis, Copenhagen

Käthe-Kollwitz-Preis, 1996, Akademie der Künste, Berlin

Martin Kippenberger, Cologne

Martin (Wolfgang Bauer, Jörg Schlick, Peter Weibel), Cologne

Martin Kippenberger – Prints, Peter Johansen & Niels Borch Jensen Valby, Copenhagen

Never give up before it's too late, MAMCO Musée d'art moderne et contemporain, Geneva.

The Last Stop West, MAK Center for Art and Architecture, Los Angeles

1998

Die gesamten Plakate 1979–1997, Kunsthaus Zürich, Zurich

Martin Kippenberger, Kunsthalle Basel, Basel

Roland Schappert, *Martin Kippenberger – Die Organisationen des Scheiterns*, Kunstwissenschaftliche Bibliothek, vol.7, Cologne

1999

Zdenek Felix, ed., *Martin Kippenberger, The Happy End of Franz Kafka's 'Amerika'*, Deichtorhallen Hamburg, Cologne

2000

Martin Kippenberger in Tirol: Sammlung Widauer, Ystad Konstmuseum, Cologne

Bei Nichtgefallen Gefühle zurück, Die gesamten Karten 1989–1997, Cologne

Martin Kippenberger – No drawing no cry, Cologne

Martin Kippenberger, Jacqueline: The paintings Picassso couldn't paint any more, Metro Pictures, New York

2002

Kommentiertes Werkverzeichnis der Bücher von Martin Kippenberger, 1977–1997, ed. Uwe Koch, Cologne

2003

Martin Kippenberger, Das 2. Sein, ed. Götz Adriani, Museum für neue Kunst, Karlsruhe

Martin Kippenberger, Multiples, ed. Kunstverein Braunschweig, Braunschweig / Museum van Hedendaagse Kunst, Antwerp / Cologne

Nach Kippenberger / After Kippenberger, ed. Eva Meyer-Hermann and Susanne Neuburger, Museum Moderner Kunst Stiftung Ludwig, Vienna / Van Abbemuseum, Eindhoven

Schattenspiel im Zweigwerk, Martin Kippenberger, Die Zeichnungen, Kunsthalle Tübingen, ed. Museum für Neue Kunst, Karlsruhe

Venedig 2003, Candida Höfer, Martin Kippenberger, Cologne

2004

Kippenberger, Pinturas, Palacio de Velázquez, Parque del Retiro, Museo Nacional Centro de Arte Reina Sofía, Madrid

Martin Kippenberger, The Magical Misery Tour Brazil, Gagosian Gallery, London

Martin Kippenberger, Nicht oft gesehen, Kunstverein Dortmund, Dortmund

2005

Martin Kippenberger, Lieber Maler, male mir, Dear painter, paint for me, with an essay by Alison Gingeras, Gagosian Gallery, New York

Martin Kippenberger. The Bermuda Triangle, Syros, Paris Bar, and Dawson City, Foundation 2021, New York

Martin Kippenberger, Self-Portraits, with an essay by Robert Storr, Luhring Augustine Gallery, New York

Martin Kippenberger, Friedrich Christian Flick Collection, ed. Dorothea Zwirner with a text by Manfred Hermes, Cologne

Group Exhibition Catalogues

1980

4 Taxis in Berlin (issue 6/7), Bordeaux

Finger für Deutschland, Atelier Jörg Immendorf, Düsseldorf

O sole mio, Künstlerhaus Hamburg, Hamburg

Schlau sein dabei sein (anthology), Berlin

1981

Junge Kunst aus Westdeutschland '81, Galerie Max Hetzler, Stuttgart

Rundschau Deutschland, Kulturreferat, Munich

Szenen aus der Volkskunst, Württembergischer Kunstverein, Stuttgart

Vom Jugendstil zum Freistiel (with Ina Barfuss, Hans Siebert, Thomas Wachweder), Galerie Petersen, Berlin

1982

Die junge Malerei in Deutschland, Galleria d'Arte Moderna, Bologna

Tendenzen 82, Ulmer Museum, Ulm

Über sieben Brücken musst Du gehen, Galerie Max Hetzler, Stuttgart

1983

Photocollage, Neue Gesellschaft für Bildende Kunst, Realismusstudio 24, Berlin

Wer diesen Katalog nicht gut findet, muss sofort zum Arzt (with Werner Büttner, Albert Oehlen, Markus Oehlen), Galerie Max Hetzler, Stuttgart

1984

Wahrheit ist Arbeit (with Werner Büttner and Albert Oehlen), Museum Folkwang, Essen

Die Güte der Gewohnheit, CCD Galerie, Düsseldorf

Einführung ins Denken (with Werner Büttner and Albert Oehlen), Hamburg

Geoma-Plan. Neurologisches Experiment mit der Macht (with Georg Herold), Hamburger Kunstverein, Hamburg / Galerie Max Hetzler, Cologne

Kunstlandschaft Bundesrepublik: Junge Kunst in deutschen Kunstvereinen, Stuttgart

Rawums. Texte zum Thema, Cologne

Von hier aus – 2 Monate neue deutsche Kunst, Cologne.

1985

1984–1985. Kunst in der Bundesrepublik, Nationalgalerie, Berlin

Der Blaue Berg: Köln s/w 1985, Bern

Primer Salon Irrealista, Galerie Leyendecker, Teneriffe

Tiefe Blicke, Cologne

1986

Macht und Ohnmacht der Beziehungen, Museum am Ostwall, Dortmund

Neue deutsche Kunst in der Sammlung Ludwig, Aachen, Haus Metternich, Koblenz

Anlehnungsbedürfnis 86 (with Michael Krebber and Günther Förg), Galerie Christoph Dürr, Munich

1987

Anniottanta, Galleria Gabriele Mazzotta, Milan

Berlinart 1961–1987, Museum of Modern Art, New York

Broken Neon, steirischer herbst 87, Forum Stadtpark, Graz

Camera Austria # 24, Forum Stadtpark, Graz

Kunst und Fotografie, Galerie Ralph Wernicke, Stuttgart

Le R.K. le radius kronenbourg (with Werner Büttner, Albert Oehlen, Markus Oehlen), Villa Arson, Nice

Möbel als Kunstobjekt, Kulturreferat der Landeshauptstadt München, Munich

Room Enough – Sammlung Schürmann, Suermondt-Ludwig-Museum, Aachen

Spielregeln: Tendenzen der Gegenwartskunst, Cologne

Vom Essen und Trinken, Kunst- und Museumsverein, Wuppertal

Anlehnungsbedürfnis 86 (with Michael Krebber, Günther Förg), Galerie Christian Nagel, Munich

1988

XLIII Esposizione Internazionale D'Arte, La Biennale di Venezia, Venice

Arbeit in Geschichte – Geschichte in Arbeit, Kunsthaus Hamburg, Hamburg

Made in Cologne, DuMont Kunsthalle, Cologne

Obras recientes (with Albert Oehlen), Galerie Juana de Aizpuru, Madrid

1989

I Triennal de Dibuix Joan Miro, Fundació Miró, Parc de Montjuïc, Barcelona

Neue Figuration – Deutsche Malerei 1960–1988, Kunstmuseum Düsseldorf, Düsseldorf / Kunsthalle Schirn, Frankfurt

Refigured Painting: The German Image 1960–1988, Solomon R. Guggenheim Museum, New York

Que Calor II, Museo de Arte Contemporaneo de Sevilla, Seville

1990

Artistes de Colonia, Centre d'Art Santa Mònica, Barcelona

Artificial Nature, Deste Foundation, Athens

Donald Baechler / Günther Förg / Georg Herold / Martin Kippenberg / Jeff Koons / Albert Oehlen / Julian Schnabel / Terry Winters / Christopher Wool, Galerie Max Hetzler, Cologne

Heimweh – Highway 90, Fundació Caixa de Penisons, Barcelona

Investigations, Institute of Contemporary Art, University of Pennsylvania, Philadelphia

Le désenchantement du monde, Villa Arson, Nice

Lettre, Nr.11/IV, Berlin

1991

Allegories of Modernism: Contemporary Drawing, Museum of Modern Art, New York

Artfan #5. Martin Kippenberger Special, Vienna

1992

Ars Pro Domo, Museum Ludwig, Cologne

C'est pas la fin du monde, Centre d'histoire de l'art contemporain, Université de Rennes, Rennes

Das Gute muss gut sein, Martin Kippenberger, Michael Krebber, Albert Oehlen, Jörg Schlick, Galerie Hlavního Mesta Prahy, Prague

Dirty Data, Sammlung Schürmann, Ludwig Forum, Aachen

Erfreuliche Klasse Kippenberger: Worm Works, David Nolan Gallery, New York

Malen ist Wahlen, Werner Büttner, Martin Kippenberger, Albert Oehlen, Kunstverein München, Munich

Photography in Contemporary German Art: 1960 to the Present, Walker Art Center, Minneapolis

Robert Gober / On Kawara / Martin Kippenberger / Albert Oehlen / Jeff Koons / Julian Schnabel / Cindy Sherman / Thomas Struth / Philip Taaffe / Christopher Wool, Galerie Max Hetzler, Cologne / Galerie Thomas Borgmann, Cologne

Sonne Busen Hammer (issue 4), Graz

1993

Drawing the line against AIDS, AMFAR, New York, Venice

J.F.K. 10 Punkte Memorandum, Politischer Club Colonia, Cologne

Money Politics / Sex, The Nancy Drysdale Gallery, Washington DC

Nachtschattengewächse / The Nightshade Family, Museum Fridericianum, Kassel

Photographie in der deutschen Gegenwartskunst, Museum Ludwig, Cologne

Post Human, Hamburg

Übungsgelände – Europa der Nacken des Stieres, Suhl

Zeitsprünge – Künstlerische Positionen der 80er Jahre, Sammlung Rudolf und Ute Scharpff, Wilhelm Hack Museum, Ludwigshafen

1994

A 'New Century' for City and Public Art, Faret Tachikawa Art Project, Tokyo

Cocido y crudo, Museo Nacional Centro de Arte Reina Sofía, Madrid

Das Jahrhundert des Multiple, Deichtorhallen, Hamburg

Der Stand der Dinge, Kölnischer Kunstverein, Cologne

Dessiner – une collection d'art contemporain, Musée du Luxembourg, Paris

Drawingroom – Zeichnungen und Skulpturen aus der Sammlung Speck, Neue Galerie am Landesmuseum, Graz

Don't Look Now, Thread Waxing Space, New York

Photographie in der deutschen Gegenwartskunst, Museum für Gegenwartskunst, Basel

Return of the Hero, Luhring Augustine Gallery, New York

Ross Bleckner / Günther Förg / Georg Herold / Martin Kippenberger / Jeff Koons / Paul McCarthy / Tatsuo Miyajima / Albert Oehlen / Philip Taaffe / Christopher Wool, Galleri K, Oslo

Temporary translation(s), Sammlung Schürmann – Kunst der Gegenwart und Fotografie, Deichtorhallen, Hamburg

Welt-Moral: Moralvorstellungen in der Kunst heute, Kunsthalle Basel, Basel

1995

Das Ende der Avantgarde – Kunst als Dienstleistung, Hypo Kunsthalle, Munich

Galerie Carree, Villa Arson, Nice

Images of Europe, European Cultural Month 95, Nicosia, Cyprus

Pittura / Immedia, Neue Galerie am Landesmuseum, Graz

Rainer Fetting und Zeitgenossen aus der Sammlung Martin Sanders, Russian State Museum, St. Petersburg

Reinventing the Emblem, Yale University Art Gallery, New Haven

temporary translation(s), Sammlung Schürmann, Kunst der Gegenwart und Fotografie, Deichtorhallen, Hamburg

1996

Der Rhein, Le Rhin, De Waal, Les Musées de la Ville de Strasbourg, Cologne

Everything that's Interesting Is New, The Dakis Joannou Collection, Athens

Kunst im Anschlag, Posters from the collection of the Museum für Angewandte Kunst, Cologne

Marcus Geiger, Martin Kippenberger, Peter Kogler, Franz West, Can Yasargil, Heimo Zobernig, Johann Widauer. Collectors Choice, Kunstraum, Vienna

This is about who we are, San Francisco Museum of Modern Art, San Francisco

Werke aus der Sammlung Speck, Museum Ludwig, Cologne

1997

Deutschlandbilder, Kunst aus einem geteilten Land, Martin-Gropius-Bau, Berlin / Cologne

Die Nerven enden an den Fingerspitzen, Wilhelm Schürmann Fotografien, Cologne

Display. International Exhibition of Painting, Charlottenborg Exhibition Hall, Copenhagen

Home Sweet Home, Deichtorhallen, Hamburg

KölnSkulptur 1, Skulpturenpark, Cologne

Magie der Zahl in der Kunst des 20. Jahrhunderts, Staatsgalerie Stuttgart, Stuttgart

realisation. Kunst in der Leipziger Messe, Cologne

Sehfahrt. Das Schiff in der zeitgenössischen Kunst, Altonaer Museum in Hamburg, Norddeutsches Landesmuseum, Hamburg
Skulpturen.Projekte, Münster, Cologne

1998

Double Trouble: The Patchett Collection, Museum of Contemporary Art, San Diego / Museo de las Artes and Instituto Cultural Cabanas, Guadalhara, Mexico / Museo de Monterrery, Mexico / Museo l'Universitario Contemporàneo de Art, Mexico City, Mexcio / Auditorio de Galicia and Inglesia San Domingos de Bonaval, Santiago de Compostela, Spain / Sala Amós Salvador, Logroñe, Spain

Fast Forward (Image), Hamburger Kunstverein, Hamburg

Inside.Outside, Städtisches Museum Leverkusen, Schloss Morsbroich, Leverkusen

Künstlerplakate: Picasso, Warhol, Beuys ... , Museum für Kunst und Gewerbe, Hamburg

Mai 98, Kunsthalle Köln, Cologne

Memento Metropolis, Kulturfabriken Liljeholmen Stockholm, Stockholm

Memento Metropolis, Copenhagen / Antwerp / Stockholm

1999

Apertutto, La Biennale di Venezia, Venice

Carnegie International, Carnegie Museum of Art, Pittsburgh

Das XX. Jahrhundert – Ein Jahrhundert Kunst in Deutschland, Nationalgalerie, Berlin

Die Schule von Athen – Deutsche Kunst heute, Tecnopolis, Athens

Dobles Vides / Double Lives, Arxiu Històric de la Ciutat, Barcelona

Get Together – Kunst als Teamwork, Kunsthalle Wien, Vienna

Macht und Fürsorge. Das Bild der Mutter in zeitgenössischer Kunst und Wissenschaft, Trinitatiskirche Köln, Cologne

my name – Sammlung Falckenberg, Museum der bildenden Künste Leipzig

Originale echt/falsch – Nachahmung, Kopie, Zitat, Aneignung, Fälschung in der

Gegenwartskunst, Neues Museum Weserburg Bremen

2000

12th Biennale of Sydney, Sydney

Abstrakte Kunst, Staatliches Museum für Kunst und Design in Nürnberg, Nuremberg

Ich ist etwas Anderes, Kunst am Ende des 20. Jahrhunderts, Kunstsammlung Nordrhein-Westfalen, Düsseldorf, Cologne

Kind, Parisa, Martin Kippenbergers Metro-Net im Kontext seiner Gesamtarbeiten, Frankfurt

Unfinished Past – Coming to terms with the Second World War in the Visual Arts of Germany and the Netherlands, ed. Stiftung Kunst und Gesellschaft, Amsterdam / Neues Museum für Kunst und Design in Nürnberg, Nuremberg / Pulchri Studio, Amsterdam

2001

Abbild, recent portraiture and depiction, Steirischer Herbst, Landesmuseum Johanneum Graz, Vienna / New York

Big Nothing – Höhere Wesen, der blinde Fleck und das Erhabene In der zeitgenössischen Kunst, Kunsthalle Baden-Baden, Baden-Baden / Cologne

Frankfurter Kreuz, Transformationen des Alltäglichen in der zeitgenössischen Kunst, Schirn Kunsthalle, Frankfurt

Ich bin mein Auto – Die maschinalen Ebenbilder des Menschen, Staatliche Kunsthalle Baden-Baden, Baden-Baden

Intermedia – Dialog der Medien, Museum für Gegenwartskunst, Siegen

Let's Entertain – Kunst Macht Spass, Kunstmuseum Wolfsburg, Wolfsburg

Painting at the Edge of the World, Walker Art Center, Minneapolis

Reisen ins Ich – Künstler/Selbst/Bild, Sammlung Essl, Klosterneuburg

Tele(visions) – Kunst sieht Fern, Kunsthalle Wien, Vienna

Vom Eindruck zum Ausdruck, Grässlin Collection, Deichtorhallen, Hamburg

Zero Gravity, Kunstverein für die Rheinlande und Westfalen, Düsseldorf / Cologne

2002

Kopfreisen, Jules Verne, Adolf Wölfli und andere Grenzgänger, Seedamm Kulturzentrum Pfäffikon, Pfäffikon / Kunstmuseum Bern, Bern

Los Excesos de la Mente, Centro Andaluz de Arte Contemporáneo, Seville

My Head is on Fire but my Heart is full of Love, Charlottenborg Udstillingsbygning, Charlottenborg

Neue Wilde aus der Samlung Martin Sanders, Ludwig Museum im Deutschherrenhaus Koblenz, Bielefeld

Painting on the Move, Kunstmuseum Basel, Museum für Gegenwartskunst, Basel / Kunsthalle Basel, Basel

2003

Berlin Moskau, Kunst 1950–2000, Martin-Gropius-Bau, Berlin / Staatliche Tretjakow-Galerie, Moscow, Berlin

Confronting Identities in German Art, Myths, Reactions, Reflections, The David and Alfred Smart Museum of Art, The University of Chicago, Chicago

Expressiv, Fondation Beyeler, Riehen / Basel

Grotesk! 130 Jahre Kunst der Frechheit, Schirn Kunsthalle, Frankfurt

Hotel Hotel, Landesgalerie am Oberösterreichischen Landesmuseum, Linz

Lieber Maler, male mir … , Centre Georges Pompidou, Paris; Kunsthalle Wien, Vienna / Schirn Kunsthalle, Frankfurt
Sand in der Vaseline, Künstlerbücher 1980 bis 2002, Staatliches Museum für Kunst und Design, Nürnberg, Nuremberg

talking pieces!, Text und Bild in der neuen Kunst, Museum Morsbroich Leverkusen, Leverkusen

Warum! Bilder diesseits und jenseits des Menschen, Martin-Gropius-Bau, Berlin

2004

100 Artists See God, Institute for Contemporary Arts, London

Friedrich Christian Flick Collection im Hamburger Bahnhof, Hamburger Bahnhof Berlin

Funny Cuts, Cartoons und Comics in der Zeitgenössischen Kunst, Staatsgalerie Stuttgart, Stuttgart

Krieg Medien Kunst. Positionen deutscher Kunst seit den sechziger Jahren, Städtische Galerie Bietigheim-Bissingen, Bietigheim-Bissingen / Städtische Galerie Delmenhorst, Haus Coburg, Delmenhorst / Stadtgalerie Kiel, Kiel / Nuremberg

Obsessive Malerei – Ein Rückblick auf die neuen Wilden, Museum für Neue Kunst, ZKM Karlsruhe / Ostfildern-Ruit

Krieg – Medien – Kunst. Der medialisierte Krieg in der deutschen Kunst seit den 1960er Jahren, Städtische Galerien Bietigheim-Bissingen, Nuremberg

Skulptur. Prekärer Realismus zwischen Melancholie und Komik, Kunsthalle Wien, Vienna

The Undiscovered Country, Hammer Museum, University of California, Los Angeles

Zeichenheft, John Bock, Klütterkammer, Institute of Contemporary Arts, London

A Angles Vifs, capc Musée d'art contemporain de Bordeaux, Bordeaux

2005

Bridge Friezes before Road, Gladstone Gallery, New York

Before the Sun Rises, Walter A. Bechtler Stiftung, Zurich

Les Grand Spectacles, 120 Jahre Kunst und Massenkultur, Museum der Moderne, Salzburg

Drawing from the Modern 1975–2005, Museum of Modern Art, New York

20 Anni D'arte Contemporanea, Castello di Rivoli, Turin

The Blake Byrne Collection, Museum of Contemporary Art, Los Angeles

Munch revisited – Edvard Munch und die

heutige Kunst, Museum für Kunst- und Kulturgeschichte Dortmund, Dortmund

Zur Vorstellung des Terrors: Die RAF-Ausstellung, vol. 2, Kunstwerke Berlin, Berlin

La nouvelle peinture allemande, Carré d'Art, Musée d'Art Contemporain de Nîmes, Nîmes

(my private) Heroes, Marta Herford, Herford

Perfect Painting. 40 Jahre Galerie Hans Meyer, Langen Foundation, Hombroich, Neuss

Works on paper, Galerie Max Hetzler, Berlin

List of exhibited works

In chronological order.
All measurements are given in centimetres, height before width and depth. The plate number is given at the end of the entry.

Blass vor Neid steht er vor deiner Tür /
Pale with Envy, He Stands Outside Your Door
1981
Oil on canvas
21 parts, each 60 × 50
Uli Knecht, Stuttgart
5

From left to right, top to bottom

Afro-asiatischer Spassmacher /
Afro-Asian Joker

Unter Einfluss von Spaghetti Nr. 7 gemalt /
Painted under the Influence of Spaghetti No. 7

Dorit, aus der Familie Hermann /
Dorit, from the Hermann Family

Kippermann als Neckermann bei der abendlichen Vorbesichtigung der Zick-Zack-Anlage in Nordafrika / Kippermann as Neckermann at the Evening Pre-Inspection of the Zigzag Place in North Africa

Die Schlacht um Paderborn /
The Battle for Paderborn

Samstags immer
Always on Saturdays

Elke hüpf und spring /
Elke Hop and Jump

Fünf kleine Italiener als Kaugummi getarnt /
Five Little Italians Disguised as Chewing Gum

Perdita Rogalski mit hochgesteckten Haaren /
Perdita Rogalski with Her Hair Up

Nie wieder allein /
Never Alone Again

Nur echte Neger kennen Beleidigung /
Only Real Negroes Know What Insults Are

Georg macht keine Witze /
George Doesn't Make Jokes

Uhu ist lecker – Patex schmeckt auch /
Uhu's Delicious – Patex Tastes Good Too

Zuhörer scharf machen /
Winding the Crowd Up

Giesi's Schwester Jenny Capitain /
Giesi's Sister, Jenny Capitain

Bitte, Sibille spinn nicht rum /
Please, Sibille, Don't Be Silly

Jeder Künstler ist ein Mensch /
Every Artist Is a Human Being

Untitled

Selbstmörderisches Ölschweinchen /
Suicidal Oil Piglet

Der asexuelle Salzstreuer /
The Asexual Saltcellar

Werner, ein stolzer Wurm /
Werner, A Proud Worm

Untitled (from the series *Lieber Maler, male mir* / Dear Painter, Paint for Me)
1981
Acrylic on canvas
200 × 150
Albert Oehlen
3

Untitled (from the series *Lieber Maler, male mir* / Dear Painter, Paint for Me)
1981
Acrylic on canvas
200 × 300
Estate Martin Kippenberger, Galerie Gisela Capitain, Cologne
4

Untitled (from the series *Lieber Maler, male mir* / Dear Painter, Paint for Me)
1981
Acrylic on canvas
240 × 300
Private collection
1

Untitled (from the series *Lieber Maler, male mir* / Dear Painter, Paint for Me)
1981
Acrylic on canvas
300 × 200
Collection of Adam and Lenore Sender
2

Bitte nicht nach Hause schicken /
Please Don't Send Home
1983
Oil on canvas
120 × 100
Private collection, Berlin
6

Sympathische Kommunistin /
Likeable Communist Woman
1983
Oil on canvas
180 × 150
Private collection
10

Big Until Great Hunger
1984
Oil, silicone on canvas
180 × 150
Courtesy Galerie Bleich-Rossi,
Graz and Vienna
22

For a Life Without a Dentist
1984
Oil on canvas
180 × 150
Private collection
8

Nicht zu Hause schlafen müssen /
Not to Have to Sleep at Home
1984
160 × 133
Oil and silicone on canvas
Private collection, Berlin
7

Die Mutter von Joseph Beuys /
Mother of Joseph Beuys
1984
Oil on canvas
160 × 133
Collection Gaby and Wilhelm Schürmann,
Herzogenrath
28

*Ertragsgebirge mit Wirtschaftswerten von
Joseph Beuys I /* Profit Peaks with Economic
Values by Joseph Beuys I
1985
Oil, silicone and mixed media on canvas
150 × 180
Grässlin Collection
23

*Ertragsgebirge mit Wirtschaftswerten von
Joseph Beuys II /* Profit Peaks with Economic
Values by Joseph Beuys II
1985
Oil, silicone and mixed media on canvas
150 × 180
Estate Martin Kippenberger,
Galerie Gisela Capitain, Cologne
24

Familie Hunger / Hunger Family
1985
Polystyrene, gypsum, dispersion
7 sculptures
52 × 36 × 38
61 × 44 × 39
97 × 51 × 85
150 × 103 × 51
184 × 54 × 50
204 × 100 × 102
253 × 85 × 52
Grässlin Collection
21

J.A.F.
1985
Oil and signs on canvas
180 × 150
Private collection, London
12

*Junger, progressiver Arzt bei der Betrachtung
von Unrat /* Young Progressive Doctor
Contemplating Yuk
1985
Oil and silicone on canvas
180 × 150
Friedrich Christian Flick Collection
14

Kostengebirge (Saure Gurken Zeit) /
Cost Peaks (The Silly Season)
1985
Oil and silicone on canvas
180 × 150
Uli Knecht, Stuttgart
17

Kulturbäuerin bei der Reparatur ihres Traktors /
Cultural Revolutionary Peasant Woman
Repairing Her Tractor
1985
Oil on canvas
180 × 150
Speck Collection, Cologne
9

Muttergedächtnisstube /
Shrine-to-Mother Room
1985
Oil on canvas
180 × 150
Estate Martin Kippenberger,
Galerie Gisela Capitain, Cologne
11

Garota de Ipanema III /
Harlot from Ipanema III
1986
Acrylic, silicone on canvas
180 × 150
Collection Stolitzka, Graz
15

*Nachträglicher Entwurf zum Mahnmal gegen
die falsche Sparsamkeit /* Supplementary
Proposal for a Monument Against False
Economies
1986
Acrylic on canvas
180 × 150
Maria and Alberto de la Cruz
16

*Nous n'avons pas de problèmes avec les
dépressions, tant qu'elles ne se mettent
pas à être en vogue /*
We don't have problems with depressions,
as long as they don't come into fashion
1986
Oil on canvas
180 × 150
Private collection,
courtesy Galerie Max Hetzler, Berlin
13

*We don't have problems with the Rolling
Stones, because we buy their guitars*
1986
Oil on canvas
180 × 150
Private collection
18

2. Preis / 2nd Prize
1987
Oil, rolled oats on canvas
180 × 150
Estate Martin Kippenberger,
Galerie Gisela Capitain, Cologne
19

7. Preis / 7th Prize
1987
Oil on canvas
180 × 150
Estate Martin Kippenberger,
Galerie Gisela Capitain, Cologne
20

Untitled
1988
Oil on canvas
200 × 240
Diethardt Collection, Austria
28

Untitled
1988
Oil on canvas
200 × 240
Private collection
26

Untitled
1988
Oil on canvas
240 × 200
Private collection
27

Entry to Lord Jim Loge
1989
Copper and plastic
2 parts: 150 × 60 × 35 each
Private collection
[Not illustrated]

Heavy Burschi / Heavy Guy
1989–90
Container, destroyed pictures,
wood, Plexiglas, canvas
100 × 290 × 120
51 framed photographs:
(9×) 240 × 200
(7×) 180 × 150
(10×) 120 × 100
(15×) 90 × 75
(10×) 60 × 50
Private collection
39–45

Martin, ab in die Ecke und schäm Dich /
Martin, Into the Corner, You Should Be
Ashamed of Yourself
1989
Cast, resin, pigment, metal, Styrofoam,
foam plastic, clothing
180 × 76 × 30
Daros Contemporary, Switzerland
30

Martin, ab in die Ecke und schäm Dich /
Martin, Into the Corner, You Should Be
Ashamed of Yourself
1989
Wood, clothing
175 × 80 × 40
Private collection
33

Martin, ab in die Ecke und schäm Dich /
Martin, Into the Corner, You Should Be
Ashamed of Yourself
1989
Mixed media, latex
175 × 66 × 40
Private collection
37

Sozialkistentransporter /
Transporter for Social Boxes
1989
Wood, paint, synthetic material,
metal, silicone
166 × 577 × 117
Collection Falckenberg, Hamburg
35

Sozialkistentransporter /
Transporter for Social Boxes
1989
Wood, metal, lacquer, Plexiglas
165 × 558 × 135
Estate Martin Kippenberger,
Galerie Gisela Capitain, Cologne
38

Untitled
1989
Books, offset fabric, lamp,
Screen print on tissue
178 × 142 × 35
Margaret and Daniel Loeb
34

Untitled
1989
Wood, metal, mixed media
193 × 86 × 68
Private collection
31

Untitled
1989
Wood, metal, lacquer, books, synthetic material
250 × 238 × 35
Collection Stolitzka, Graz
36

Mirror for Hang-Over Bud
1990
Wood, metal, casting resin, aluminium foil
145 × 97 × 23
Edition 5/7
Collection Eugenio Lopez,
Courtesy Gagosian Gallery
32

Mirror for Hang-Over Bud
1990
Wood, metal, casting resin, aluminium foil
145 × 97 × 23
Edition 6/7
Tiqui Atencio
32

Mirror for Hang-Over Bud
1990
Wood, metal, casting resin, aluminium foil
145 × 97 × 23
Edition Artist's Proof
Private collection
32

Peter
1990
Latex and acrylic on canvas
200 × 240
Private collection
46

Untitled
1991
[*241 Bildtitel zum Ausleihen* /
241 Picture Titles to Borrow]
Watercolour on paper
42 × 56
Buchhandlung Walther König, Cologne
90

Untitled
1991
[*Das Ende der Avandgarde* /
The End of the Avand-garde]
Watercolour on paper
42 × 56
Private collection
104

Untitled
1991
[*Die I.N.P. Bilder* / The I.N.P. Pictures]
Watercolour on paper
42 × 56
Friedrich Christian Flick Collection
96

Untitled
1991
[*Durch die Pubertät zum Erfolg* /
Through Puberty to Success]
Watercolour on paper
42 × 56
Speck Collection, Cologne
89

Untitled
1991
[*Frauen* / Women]
Watercolour on paper
42 × 56
Private collection
92

Untitled
1991
[*Heavy Mädel*]
Watercolour on paper
42 × 56
Private collection
101

Untitled
1991
[*Installation der Weissen Bilder* /
Installation of the *White Paintings*]
Oil and lacquer on canvas
11 parts:
(3×) 300 × 250
(2×) 240 × 200
(2×) 180 × 150
(1×) 120 × 100
(3×) 90 × 75
Estate Martin Kippenberger,
Galerie Gisela Capitain, Cologne
47–9

Untitled
1991
[*Kippenberger! 25.2.53–25.2.83 Abschied vom
Jugendbonus! Von Einfachsten nach Hause* /
Kippenberger! 25.2.53–25.2.83 Farewell to the
Youth Bonus! Start Simple Get Home]
Watercolour on paper
42 × 56
Collection of Pamela and Richard Kramlich
94

Untitled
1991
[*Kippenbergerweg 25-2-53* / Plakate 1 /
Kippenbergerpath 25-2-53 / Posters 1]
Watercolour on paper
42 × 56
Buchhandlung Walther König, Cologne
[Not illustrated]

Untitled
1991
[*Miete Strom Gas* / Rent Electricity Gas]
Watercolour on paper
42 × 56
Hessisches Landesmuseum Darmstadt,
Graphische Sammlung
106

Untitled
1991
[*No Problem No problème*]
Watercolour on paper
42 × 56
Friedrich Christian Flick Collection
95

Untitled
1991
[*Nochmal Petra* / Petra Again]
Watercolour on paper
42 × 56
Collection Stolitzka, Graz
100

Untitled
1991
[*Peter*]
Watercolour on paper
42 × 56
Collection Stolitzka, Graz
107

Untitled
1991
[*Peter 2*]
Watercolour on paper
42 × 56
Private collection
97

Untitled
1991
[*Petra*]
Watercolour on paper
42 × 56
Private collection
99

Untitled
1991
[*Psychobuildings*]
42 × 56
Buchhandlung Walther König, Cologne
102

Untitled
1991
[*Vom Eindruck zum Ausdruck* /
From Impression to Expression]
Watercolour on paper
42 × 56
Speck Collection, Cologne
88

Untitled
1991
[*Wahrheit ist Arbeit* / Truth Is Work]
Watercolour on paper
42 × 56
Private collection
98

Untitled
1991
[*Was immer auch sei Berlin bleibt frei* /
Whatever the Case, Berlin Remains Free]
Watercolour on paper
42 × 56
Collection Hanno Huth
91

Untitled
1991
[*Wer diesen Katalog nicht gut findet muss sofort zum Arzt* / Anyone Who Doesn't Think This Catalogue Is Good Should Go Straight to the Doctor]
Watercolour on paper
42 × 56
Collection Zwach
93

Untitled
1992
Oil on canvas
180 × 150
Private collection
London only
80

Untitled
1992
Oil on canvas
180 × 150
Private collection
81

Untitled
1993
Mixed media on hotel stationery
29.7 × 21
R. Jeffrey Edwards
57

Untitled
1993
Mixed media on hotel stationery
29.6 × 21
Friedrich Christian Flick Collection
61

Untitled
1993
Mixed media on hotel stationery
29.4 × 21
Friedrich Christian Flick Collection
59

Untitled
1993
Mixed media on hotel stationery
29.7 × 21
Private collection
62

Untitled
1993
Mixed media on hotel stationery
29.7 × 21
Private collection
60

Die Verbreitung der Mittelmässigkeit /
The Spread of Mediocrity
1994
Oil on canvas
180 × 150
Private collection
83

Keine braune Schokolade /
No Brown Chocolate
1994
Oil on canvas
180 × 150
Private collection
82

The Happy End of Franz Kafka's 'Amerika'
1994
Mixed media (chairs, tables, etc.),
electricity, green carpet painted with white lines, two bleachers
Dimensions variable
Estate Martin Kippenberger,
Galerie Gisela Capitain, Cologne
50–4

Untitled
1994
Ballpoint pen, coloured pencil,
Kafka stamps on hotel stationery
29.7 × 21
Friedrich Christian Flick Collection
55

Untitled
1994
Mixed media on hotel stationery
29.7 × 21
Friedrich Christian Flick Collection
74

Untitled
1994
Coloured pencil, pencil on hotel stationery
29.7 × 21
Collection of Galerie für
Zeitgenössische Kunst, Leipzig
66

Untitled
1994
Coloured pencil, pencil,
Letraset on hotel stationery
29.7 × 21
Collection of Galerie für
Zeitgenössische Kunst, Leipzig
69

Untitled
1994
Ballpoint pen on hotel stationery
29.7 × 21 cm
Collection of Galerie für
Zeitgenössische Kunst, Leipzig
67

Untitled
1994
Coloured pencil on hotel stationery
28 × 21
Private collection
73

Untitled
1994
Mixed media on hotel stationery
20.9 × 29.8
Thomas Borgmann, Cologne
76

Untitled (Political Corect III)
1994
Oil on canvas
180 × 150
Private collection, courtesy Marc Jancou
Fine Art, New York
84

Untitled
[*Hotel Hotel*]
1995
Watercolour on paper
42 × 56
Buchhandlung Walther König, Cologne
103

Untitled
[*Hotel Hotel Hotel*]
1995
Watercolour on paper
42 × 56
Buchhandlung Walther König, Cologne
105

Untitled
1995
Ballpoint pen, Kafka stamps on hotel stationery
29.7 × 21
Thomas Eizenhöfer, Barbara Koch
63

Untitled
1995
Coloured pencil, marker, Kafka stamps
on hotel stationery
29.7 × 21
Estate Martin Kippenberger,
Galerie Gisela Capitain, Cologne
64

Untitled
1995
Marker, collage, Kafka stamps
on hotel stationery
29.7 × 21
Estate Martin Kippenberger,
Galerie Gisela Capitain, Cologne
56

Untitled
1995
Coloured pencil, marker, ballpoint pen
on hotel stationery
28 × 21.6
Friedrich Christian Flick Collection
72

Untitled
1995
Pencil, ballpoint pen on hotel stationery
29.7 × 21
Collection of Galerie für
Zeitgenössische Kunst, Leipzig
65

Untitled
1995
Ballpoint pen, pencil on hotel stationery
29.7 × 21
Collection of Galerie für
Zeitgenössische Kunst, Leipzig
68

Untitled
1995
Coloured pencil, pencil on hotel stationery
Leipzig, 29.7 × 21
Collection of Galerie für
Zeitgenössische Kunst, Leipzig
70

Untitled
1995
Coloured pencil, Kafka stamps
on hotel stationery
29.7 × 21
F.C. Gundlach Foundation
58

Untitled
1995
Photocopy with hand-drawn additions;
mixed media on paper
29.7 × 21
Collection Herbert
78

Untitled
1995
Mixed media on hotel stationery
29.7 × 21
Collection Herbert
75

Untitled
1995
Mixed media on hotel stationery
27.6 × 20.8
Collection of Pamela and Richard Kramlich
77

Untitled
1995
Ballpoint pen on hotel stationery
29.7 × 21
Private collection
71

Untitled
1995
Mixed media on hotel stationery
left sheet 29.7 × 21
right sheet 21.2 × 13.8
Private collection
79

Untitled
1995
Marker, photographs on hotel stationery
29.7 × 21
Private collection, Berlin
[Not illustrated]

Untitled
1995
Marker on computer paper
29.7 × 21
Private collection, Berlin
[Not illustrated]

Untitled
1995
Coloured pen on hotel stationery
29.7 × 21
Private collection
[Not illustrated]

Untitled
1995
Coloured pen on hotel stationery
29.7 × 21
Private collection
[Not illustrated]

Untitled
1996
Oil on canvas
180 × 150
Friedrich Christian Flick Collection
87

Krankes Ei-Kind / Sick Egg-Child
1996
Oil, lacquer on canvas
180 × 150
Thomas Koerfer Collection
85

Untitled (from the series: *Jacqueline:
The Paintings Pablo Couldn't Paint Anymore*)
1996
Oil on canvas
180 × 150
Private collection, Frankfurt am Main
86

METRO-Net World Connection 1997
Poster, CAD print (by Lukas Baumewerd)
93.3 × 58.2
Estate Martin Kippenberger,
Galerie Gisela Capitain, Cologne
[Not illustrated]

Posters

Only those in bold are illustrated
in the catalogue. All posters are in the Tate
Collection unless stated otherwise.

*1/4 Jhdt. Kippenberger als einer von Euch,
unter Euch, mit Euch* / A Quarter of a
Century. Kippenberger as one of you,
among you, with you 1978
Offset lithograph on paper 59.5 × 84

**Einer von Euch, unter Euch, mit Euch /
One of You, Among You, With You
1979
Offset print on paper 59.5 × 42
Estate Martin Kippenberger,
Galerie Gisela Capitain, Cologne
108**

The Band is playing on Luxus 1979
Offset lithograph on paper 35.5 × 31.6

This Fellow is playing on Luxus 1979
Offset lithograph on paper 35.5 × 31.6

This Man is playing on Luxus 1979
Offset lithograph on paper 35.5 × 31.6

This Woman is playing on Luxus 1979
Offset lithograph on paper 35.5 × 31.6

This Guy is playing on Luxus 1979–97
Offset lithograph on paper 35.5 × 31.6

*1. ausserordentliche Veranstaltung in Bild und
Klang zum Thema der Zeit: ELEND* / First
Extraordinary Event in Picture and Sound on
the Theme of: MISERY 1979
Offset lithograph on paper 60 × 42

Veranstaltungsplakat S.O. 36 /
Event Poster S.O. 36 1979
Offset lithograph on paper 30 × 30

Veranstaltunsplaket S.O. 36 /
Event Poster S.O. 36 1979
Offset lithograph on paper 38.2 × 30

Veranstaltunsplaket S.O. 36 /
Event Poster S.O. 36 1979
Offset lithograph on paper 43 × 30

*2. ausserordentliche Veranstaltung in Bild und
Ton – Aktion Pisskrücke – Geheimdienst am
Nächsten* / Second Extraordinary Event in
Picture and Sound – Action Piss-Crutch –
Secrete Service on Your Neighbour 1980
Offset lithograph on paper 60.8 × 42.2

Rundschau Deutschland /
Germany Bulletin 1981
Print on paper 83.2 × 58.7

*Der Kippenberger – Das Sahara-und das
Antisahara-Programm* / The Kippenberger –
The Sahara and The Anti-Sahara Programme
1982
Offset lithograph on paper 84 × 59.3

*Kippenberger zum Thema Fiffen, Faufen und
Verfaufen* / Kippenberger on the Theme of
Fucking, Boozing and Selling 1982
Offset lithograph on paper 59.3 × 84

Kennzeichen eines Unschuldien /
Sign of the Innocent One 1983
Offset lithograph on paper 118.5 × 75.8

I Like It – Ewig junger Wilder /
I Like It – Eternal Young Wild One 1984
Screen print on paper 84.4 × 59.5

The Alma Band 1984
Screen print on paper 76 × 58.5

Deutsch-Sprechende Galeristinnen /
German Speaking Female Gallerists 1984
Offset print on paper 85 × 85

**Abschied vom Jugendbonus II /
Farewell to the Youth Bonus II 1984/5
Screen print on paper 83.6 × 58.8
110**

*Wenn du eine brauchst, musst du eine
mitbringen* / If you need one, you have to bring
one with you 1985
Offset lithograph on paper 69.5 × 49.7

Cologne Manifesto 1985
Offset print on paper 35 × 100.2

The Alma Band Live in Rio 1985
Screen print on paper 84 × 60

*Hoe kom ik in Vredestijd met Botbreuken en
Futurisme klaar (Wie komme ich in Kriegs-
zeiten mit Beinbruch und Futurismus klar)* /
How Do I Manage in Wartime with a Broken
Leg and Futurism 1985
Screen print on paper 85 × 59.2

Selling America and Buying El Salvador 1985
**Screen print on paper 87.7 × 61
109**

Architektur / Architecture 1985
Screen print on paper 84.4 × 59.2

**Helmut Newton für Arme /
Helmut Newton for the Poor 1985
Screen print on paper 42.2 × 30.2
111**

*Podria prestarte algo, pero eso no te haria
ningun favor* / I could lend you something,
but I wouldn't be doing you any favours 1985
Screen print on paper 83.8 × 59.4

Wäscheleine verkehrtrum / Washing Line
The Wrong Way Round 1985
Screen print on paper 78.3 × 60

**Familie Hunger / Hunger Family 1985
Screen print on paper 84 × 59.2
112**

*Neun Kostengebirge – Drei Entwürfe für
Müttergenesungswerke* / Nine Profit Peaks –
Three Designs for Rest Centres for Mothers
1985
Screen print on paper 83.5 × 59.5

**Was ist Ihre Lieblingsminderheit, Wen
beneiden Sie am meisten / Which is your
favourite Minority. Who do you Envy the
most 1985/6
Offset lithograph on paper 54.5 × 72.3
113**

Nur Angst vor Frauen die Samt tragen /
Fear, Only of Women Who Wear Velvet 1986
Screen print on paper 29.7 × 21

Revolution in Köln / Revolution in Cologne
1986
Screen print on paper 87.7 × 60.1

*Die Revolution in Köln muss verschoben
werden* / The Revolution in Cologne Had
to be Postponed 1986
Screen print on paper 84 × 60

*Die Revolution in Koln muss verschoben
werden* / The Revolution in Cologne Had
to be Postponed 1986
Screen print on paper 100 × 70

*23 Vierfarbenvorschläge für die Verbesserung
des Rückenschwimmers* / 23 four-colour
suggestions for the Improvement of the
Backstroke Swimmer 1986
Screen print on paper 83.7 × 59.5

**Miete Strom Gas / Rent Electricity Gas 1986
Screen print on paper 83 × 59.3**
114

Sand in der Vaseline / Sand in the Vaseline 1986
Screen print on paper 83.7 × 59

Ansprache an die Hirnlosen Teil II: Bankrotte /
Address to the Brainless Part II: Bankruptcies
1986
Screen print on paper 83.7 × 59.2

Ansprache an die Hirnlosen Teil II: Bankrotte /
Address to the Brainless part II: Bankruptcies
(2nd version) 1986
Screen print on paper 83.7 × 59.2

Die Perspektivenscheisse /
The Perspective-Shit 1986
Screen print on paper 84.3 × 59.3

Kampf dem Dekubitus /
Struggle against the Bedsore 1986
Screen print on paper 83.7 × 59.3

T.A.A.D.C. 1986
Screen print on paper 83.7 × 60

Grazzmania Vortrag über die Fotografie /
Grazzmania Lecture on Photography 1986
Screen print on paper 84 × 60.3

Die No Problem Bilder /
The No Problem Pictures 1986
Screen print on paper 85 × 59.2

*Albert Oehlen und Diedrich Diederichsen
präsentieren: Die vier besten Filme der Welt* /
Albert Oehlen and Diedrich Diederichsen
present: The four best films in the world 1986
Screen print on paper 83.8 × 59.2

Plakat für Weltweit/Haumann Modeschmuck /
Poster for Worldwide/Haumann Costume
Jewellery 1987
Screen print on paper 83.5 × 59.2

Fräulein Fischer / Miss Fischer 1987
Screen print on paper 85.3 × 61

Der Stolz in der Sentimentalität /
Pride in Sentimentality 1987
Screen print on paper 83.8 × 59.2

Der Stolz in der Sentimentalität /
Pride in Sentimentality 1987
Screen print on paper 83.8 × 59.2

**Peter 1987
Screen print on paper 82.6 × 60.2**
115

Einfach geht der Applaus zugrunde /
The Applause Simply Dies 1987
Offset lithograph on paper 97.8 × 68.6

*Multiples – Die Kunst ist immer gut verkauft
worden* / Multiples – Art has always sold well
1987
Screen print on paper 83.8 × 59.4

Broken Neon 1987
Offset lithograph on paper 84 × 59

Polytexte – The Words Meet the Objects /
Polytexts – The Words Meet the Objects 1987
Screen print on paper 83.4 × 60.2

9 Gründe, die Preise zu erhöhen /
9 Reasons to Raise the Prices 1987
Screen print on paper 82.7 × 58.3

Die Reise nach Jerusalem /
Journey to Jerusalem 1987
Screen print on paper 88 × 61.8

The Alma Band 1988
Screen print on paper 60 × 84.5

Jazz in Flammen / Jazz in Flames 1989
Offset lithograph on paper 68.8 × 47.8

*Das Medium der Fotografie ist berechtigt
Denkanstösse zugeben* / The Medium of
Photography is Justified in Provoking Thoughts
1989
Screen print on paper 84 × 59.3

Millionen Feuerwerk/Jackie /
Fireworks for Millions/Jackie 1989
Screen print on paper 84.2 × 59.2

Markus Oehlen 1989
Screen print on paper 83.8 × 59.5

Eurobummel I / Euro Stroll I 1989
Screen print on paper 84 × 59

Angst / Anxiety 1989
Screen print on paper 86 × 60.8

Stefan Mattes 1989
Screen print on paper 83.5 × 59.2

Ce Calor 2 / The Heat 2 1989
Screen print on paper 84 × 59.3

Disco Bombs 1989
Screen print on paper 84 × 59

*Die Hamburger Hängung – Umzüge 1957–1988
– Fallende Flüge* / The Hamburg Hanging –
Moves 1957–1988 – Falling Flights 1989
Screen print on paper 84 × 59.3

Das Pferd und die Tiefe Künstlerbücher /
The Horse and the Depths Artists' Books 1989
Screen print on paper 84 × 59.2

VIT 89 1989
Screen print on paper 119 × 84.2

Präsentation Plakate/Buch /
Presentation Posters/Book 1989
Screen print on paper 84 × 59

Casa Anti Magnetica 1990
Screen print on paper 121.4 × 75

*We were anchored at the coast of Sansibar
and had a manifesto on board* 1990
Screen print on paper 84.6 × 59.8

Roger 1990
Offset lithograph on paper 85 × 60

*Martin Kippenberger is Great,
Tremendous, Fabulous, Everything* 1990
Screen print on paper 94.7 × 68.8

Unlängst verlängerte Originale /
Recently Extended Originals 1990
Screen print on paper 100 × 70

**Martin Kippenberger 1990
Offset lithograph on paper 88 × 59.5
116**

Schwarz-Brot-Gold / Black-Bread-Gold 1990
Offset lithograph on paper 42 × 87

Buchholz + Schipper 1990
Screen print on paper 84 × 59.3

Wolfgang Bauer Lesung /
Wolfgang Bauer Reading 1990
Screen print on paper 85 × 60

Eine Handvoll vergessener Tauben /
A Handful of Forgotten Pigeons 1990
Screen print on paper 137.8 × 70.4

Day in Dub 1991
Screen print on paper 67 × 97

Once Again the World is Flat 1991
Screen print on paper 80 × 62.2

Heavy Burschi / Heavy Guy 1991
Offset print on paper 84 × 59.5

Heimo Zobernig 1991
Screen print on paper 99 × 69.2

Kippenblinkys 1991
Offset lithograph on paper 78 × 59

Fallen und Fallen lassen /
Fall and Let Fall 1991
Offset lithograph on paper 59.5 × 84

*Gut ausgeleuchtete vorweihnachtliche
Ausstellung an Leopoldstrasse /*
Well-lit Pre-Christmas Exhibition in Leopold
Road 1991–2
Screen print on paper 87.7 × 63

Was Gott im Herrschen, bin ich im Können /
As God is in Domination, I am in Ability 1992
Screen print on paper 84.5 × 64.2

Kippenberger 1992
Offset lithograph on paper 87.3 × 62.1

Melancholie / Melancholy 1992
Offset lithograph on paper 108.3 × 84

Hand Painted Pictures 1992
Screen print on paper 84 × 59.4

The Beginning was a Retrospective 1992
Screen print on paper 67.8 × 87

Aquarelle und Publikationen /
Watercolours and Publications 1992
Screen print on paper 92 × 70

**Candidature à une Retrospective /
Candidature for a Retrospective 1993
Offset lithograph on paper 70 × 50
117**

Candidature à une Retrospective /
Candidature for a Retrospective 1993
Offset print on paper 70 × 50

Happy to be Gay 1993
Screen print on paper 84 × 59.3

Grafica I / Graphics I 1993
Offset lithograph on paper 84 × 59.3

The 5 Arbeiterjungs vom Wahrheitshof /
5 Working Class Lads from the Courtyard of
Truth 1993
Offset lithograph on paper 70 × 50

The Happy End of Franz Kafka's 'Amerika'
1994
Offset lithograph on paper 84 × 59.2

**L'atelier Matisse sous-loué à Spiderman /
Matisse's Studio Sublet to Spiderman 1996
Offset lithograph on paper 58 × 39.8
118**

Nix Rugula / No Rocket 1996
Offset lithograph on paper 90 × 60

*Vergessene Einrichtungsprobleme in
der Villa Hügel /* Forgotten Interior
Design Problems in the Villa Hügel 1996
Offset print on paper 84 × 59.2

*Vergessene Einrichtungsprobleme in
der Villa Hügel /* Forgotten Interior Design
Problems in Villa Hügel (2nd version) 1996
Offset lithograph on paper 84 × 59.2

Kippenberger/Géricault Memento Metropolis
1996
Screen print on paper 96.5 × 67.8

Bitte nicht auf die Bilder setzen /
Please don't sit on the Pictures 1996
Offset lithograph on paper 70 × 50

Windowshopping bis 2 Urh Nachts /
Window Shopping Until Two in the Morning
1997
Offset lithograph on paper 84 × 59.2

**Respektive 1997–1976 /
Respective 1997–1976 1997
Offset lithograph on paper 100 × 68.1
119**

Der Eiermann und seine Ausleger /
The Eggman and his Outriggers 1997
Offset lithograph on paper 84 × 59.4

Lenders

Public collections
Collection of Galerie für Zeitgenössische
 Kunst, Leipzig
Hessisches Landesmuseum Darmstadt,
 Prints and Drawings Collection

Private collections
Tiqui Atencio
Courtesy Galerie Bleich-Rossi,
 Graz and Vienna
Thomas Borgmann, Cologne
Buchhandlung Walther König, Cologne
Maria and Alberto de la Cruz
Daros Contemporary, Switzerland
Diethardt Collection, Austria
R. Jeffrey Edwards
Thomas Eizenhöfer, Barbara Koch
Estate Martin Kippenberger,
 Galerie Gisela Capitain, Cologne
Collection Falckenberg, Hamburg
Friedrich Christian Flick Collection
Grässlin Collection
F.C. Gundlach Foundation
Collection Herbert
Collection Hanno Huth
Uli Knecht, Stuttgart
Thomas Koerfer Collection
Collection of Pamela and Richard Kramlich
Collection Eugenio Lopez,
 courtesy Gagosian Gallery
Albert Oehlen
Collection Gaby and Wilhelm Schürmann,
 Herzogenrath
Collection of Adam and Lenore Sender
Speck Collection, Cologne
Collection Stolitzka, Graz
Collection Zwach
Private collection, Berlin
Private collection, Frankfurt am Main
Private collection, courtesy
 Galerie Max Hetzler, Berlin
Private collection, courtesy Marc Jancou
 Fine Arts, New York
Private collection, London
Private collection

Photo Credits

Plates
Thomas Ammann Fine Art Gallery 37
Galerie Gisela Capitain, Cologne 1, 2, 3, 4, 5,
 6, 7, 8, 9, 10, 11, 12, 13, 15, 16, 17, 18, 19,
 20, 21, 22, 23, 24, 25, 26, 27, 28, 29, 30, 32,
 33, 34, 35, 38, 40–5, 46, 47–9, 55, 56, 60, 64,
 72, 73, 74, 75, 76, 78, 79, 80, 81, 82, 83, 84
 85, 86, 87, 88, 89, 90, 91, 92, 93, 94, 95, 96,
 97, 98, 99, 100, 101, 108
Thomas Eizenhöfer, Barbara Koch 63
Friedrich Christian Flick Collection /
 A. Burger, Zurich 14, 59, 61
Galerie Bärbel Grässlin, Frankfurt 49
F.C. Gundlach Foundation 58
Buchhandlung Walter König, Cologne 103, 105
Lothar Schnepf, Cologne 50–4
Tate Photography 109–119
Galerie für Zeitgenössische Kunst Leipzig /
 Hans-Dieter Kluge 65, 66, 67, 68, 69, 70

Figures
Galerie Gisela Capitain, Cologne figs.1–6, 10,
 12, 14–18, 20, 21, 23, 25
Jannes Linders fig.7
The Saatchi Gallery, London fig.22

Copyright

Index

Supporting Tate

Tate relies on a large number of supporters – individuals, foundations, companies and public sector sources – to enable it to deliver its programmes of activities, both on and off its gallery sites. This support is essential in order to acquire works of art for the Collection, run education, outreach and exhibition programmes, care for the Collection in storage and enable art to be displayed, both digitally and physically, inside and outside Tate. Your donation will make a real difference and enable others to enjoy Tate and its Collection both now and in the future. There are a variety of ways in which you can help support Tate and also benefit as a UK or US taxpayer. Please contact us at:

The Development Office
Tate
Millbank
London SWIP 4RG
Tel: 020 7887 8945
Fax: 020 7887 8098

American Patrons of Tate
1285 6th Avenue (35th fl)
New York, NY 10019
USA
Tel: 001 212 713 8497
Fax: 001 212 713 8655

Donations

Donations, of whatever size, from individuals, companies and trusts are welcome, either to support particular areas of interest, or to contribute to general running costs.

Gifts of Shares

Since April 2000, we can accept gifts of quoted share and securities. These are not subject to capital gains tax. For higher rate taxpayers, a gift of shares saves income tax as well as capital gains tax. For further information please contact the Development Office.

Gift Aid

Through Gift Aid, you can provide significant additional revenue to Tate. Gift Aid applies to gifts of any size, whether regular or one-off, since we can claim back the tax on your charitable donation. Higher rate taxpayers are also able to claim additional personal tax relief. Contact us for further information and a Gift-Aid Declaration.

Legacies

A legacy to Tate may take the form of a residual share of an estate, a specific cash sum or item of property such as a work of art. Legacies to Tate are free of Inheritance Tax, and help to secure a strong future for the Collection and galleries.

Offers in lieu of tax

Inheritance Tax can be satisfied by transferring to the Government a work of art of outstanding importance. In this case the amount of tax is reduced, and it can be made a condition of the offer that the work of art is allocated to Tate. Please contact us for details.

Tate Annual Fund

A donation to the Annual Fund at Tate benefits a variety of projects throughout the organisation, from the development of new conservation techniques to education programmes for people of all ages and abilities.

American Patrons of Tate

American Patrons of Tate is an independent charity based in New York that supports the work of Tate in the United Kingdom. It receives full tax exempt status from the IRS under section 501(c)(3) allowing United States taxpayers to receive tax deductions on gifts towards annual membership programmes, exhibitions, scholarship and capital projects. For more information contact the American Patrons of Tate office.

Membership Programmes

Tate Members enjoy unlimited free admission throughout the year to all exhibitions at Tate Britain, Tate Liverpool, Tate Modern and Tate St Ives, as well as a number of other benefits such as exclusive use of our Members' Rooms and a free annual subscription to *Tate Etc*.

Whilst enjoying the exclusive privileges of membership, you are also helping secure Tate's position at the very heart of British and modern art. Your support actively contributes to new purchases of important art, ensuring that the Tate's Collection continues to be relevant and comprehensive, as well as funding projects in London, Liverpool and St Ives that increase access and understanding for everyone.

Tate Patrons

Tate Patrons are people who share a strong enthusiasm for art and are committed to giving significant financial support to Tate on an annual basis. The Patrons support the Tate Collection, helping Tate acquire works from across its broad collecting remit: historic British art, modern international art and contemporary art. The scheme provides a forum for Patrons to share their interest in art and to exchange knowledge and information in an enjoyable environment. United States tax payers who wish to receive full tax exempt status from the IRS under Section 501 (c) (3) may want to pay through our American office. For more information on the scheme please contact the Patrons office.

Corporate Membership

Corporate Membership at Tate Modern, Tate Liverpool and Tate Britain offers companies opportunities for corporate entertaining and the chance for a wide variety of employee benefits. These include special private views, special access to paying exhibitions, out-of-hours visits and tours, invitations to VIP events and talks at members' offices.

Corporate Investment

Tate has developed a range of imaginative partnerships with the corporate sector, ranging from international interpretation and exhibition programmes to local outreach and staff development programmes. We are particularly keen for high-profile business to business marketing initiatives and employee benefit packages. Please contact the Corporate Fundraising team for further details.

Charity Details

The Tate Gallery is an exempt charity; the Museums & Galleries Act 1992 added the Tate Gallery to the list of exempt charities defined in the 1960 Charities Act. Tate Members is a registered charity (number 313021). Tate Foundation is a registered charity (number 1085314).

Tate Modern Donors to the Capital Campaign

Founders
The Arts Council of England
English Partnerships
The Millennium Commission

Founding Benefactors
Mr and Mrs James Brice
The Clore Duffield Foundation
Gilbert de Botton
Richard B. and Jeanne Donovan Fisher
Noam and Geraldine Gottesman
Anthony and Evelyn Jacobs
The Kresge Foundation
The Frank Lloyd Family Trusts
Ronald and Rita McAulay
The Monument Trust
Mori Building Co.Ltd
Peter and Eileen Norton, The Peter Norton
 Family Foundation
Maja Oeri and Hans Bodenmann
The Dr Mortimer and Theresa Sackler
 Foundation
Ruth and Stephan Schmidheiny
Mr and Mrs Charles Schwab
Peter Simon
London Borough of Southwark
The Starr Foundation
John Studzinski
The Weston Family
Poju and Anita Zabludowicz

Benefactors
Frances and John Bowes
Donald L Bryant Jr Family
Sir Harry and Lady Djanogly
Donald and Doris Fisher
Lydia and Manfred Gorvy
The Government Office for London
Mimi and Peter Haas
The Headley Trust
Mr and Mrs André Hoffmann
Pamela and C. Richard Kramlich

Major Donors
The Annenburg Foundation
The Baring Foundation
Ron Beller and Jennifer Moses
Alex and Angela Bernstein
Mr and Mrs Pontus Bonnier
Lauren and Mark Booth
Ivor Braka
Melva Bucksbaum
Edwin C. Cohen
Michel and Hélène David-Weill
English Heritage
Esmée Fairbairn Charitable Trust
Tate Friends
Bob and Kate Gavron
Giancarlo Giammetti
The Horace W.Goldsmith Foundation
The Government of Switzerland
Mr and Mrs Karpidas
Peter and Maria Kellner
Mr and Mrs Henry R Kravis
Irene and Hyman Kreitman
Catherine and Pierre Lagrange
Edward and Agnes Lee
Ruth and Stuart Lipton
James Mayor
The Mercers' Company
The Meyer Foundation
Guy and Marion Naggar
The Nyda and Oliver Prenn Foundation

The Rayne Foundation
John and Jill Ritblat
Barrie and Emmanuel Roman
Lord and Lady Rothschild
Belle Shenkman Estate
Hugh and Catherine Stevenson
David and Linda Supino
David and Emma Verey
Clodagh and Leslie Waddington
Robert and Felicity Waley-Cohen

Donors
The Asprey Family Charitable Foundation
Lord and Lady Attenborough
David and Janice Blackburn
Mr and Mrs Anthony Bloom
Mr and Mrs John Botts
The British Land Company PLC
Cazenove & Co.
The John S. Cohen Foundation
Sir Ronald and Sharon Cohen
Sadie Coles
Carole and Neville Conrad
Giles and Sonia Coode-Adams
Alan Cristea
Thomas Dane
Julia W Dayton
Pauline Denyer-Smith and Paul Smith
The Fishmongers Company
The Foundation for Sports and the Arts
Alan Gibbs
Mr and Mrs Edward Gilhuly
Helyn and Ralph Goldenberg
The Worshipful Company of Goldsmiths
Pehr and Christina Gyllenhammar
Richard and Odile Grogan
The Worshipful Company of Haberdashers
Hanover Acceptances Limited
Jay Jopling
Howard and Lynda Karshan
Madeleine, Lady Kleinwort
Brian and Lesley Knox
The Lauder Foundation – Leonard and
 Evelyn Lauder Fund
Ronald and Jo Carole Lauder
Leathersellers' Company Charitable Fund
Lex Service Plc
Mr and Mrs Ulf G. Linden
Anders and Ulla Ljungh
Mr and Mrs George Loudon
Nick and Annette Mason
Viviane and James Mayor
Anthony and Deidre Montague
Sir Peter and Lady Osborne
Maureen Paley
William A. Palmer
Mr Frederik Paulsen
The Pet Shop Boys
David and Sophie Shalit
William Sieghart
Mr and Mrs Sven Skarendahl
Mr and Mrs Nicholas Stanley
The Jack Steinberg Charitable Trust
Carter and Mary Thacher
Insinger Townsley
The 29th May 1961 Charitable Trust
Dinah Verey
The Vintners' Company
Gordon D. Watson
Mr and Mrs Stephen Wilberding
Michael S. Wilson

and those donors who wish to remain anonymous